Slippery Slopes
& Other Deadly Things

Also by Nancy Tesler

THE CARRIE CARLIN BIOFEEDBACK MYSTERY SERIES
Pink Balloons
 and Other Deadly Things

Sharks, Jellyfish
 and Other Deadly Things

Shooting Stars
 and Other Deadly Things

Golden Eggs
 and Other Deadly Things

Slippery Slopes

& OTHER DEADLY THINGS

A CARRIE CARLIN BIOFEEDBACK MYSTERY

Nancy Tesler

Nancy Tesler

2003 · PALO ALTO / SANTA BARBARA
PERSEVERANCE PRESS / JOHN DANIEL & COMPANY

Copyright © 2003 by Nancy Tesler
All rights reserved
Printed in the United States of America

A PERSEVERANCE PRESS BOOK
Published by John Daniel & Company
A division of Daniel & Daniel, Publishers, Inc.
Post Office Box 21922
Santa Barbara, California 93121
www.danielpublishing.com/perseverance

Book design by Eric Larson, Studio E Books, Santa Barbara
www.studio-e-books.com
Set in Bembo

Cover image: Jack Sheffler

10 9 8 7 6 5 4 3 2 1

LIBRARY OF CONGRESS CATALOGING-IN-PUBLICATION DATA
Tesler, Nancy.
 Slippery slopes and other deadly things : a Carrie Carlin biofeedback mystery / by Nancy Tesler.
 p. cm.
 ISBN 1-880284-58-8 (pbk. : alk. paper)
 1. Women psychotherapists—Fiction. 2. Biofeedback training—Fiction. 3. Ski resorts—Fiction. 4. Vermont—Fiction. I. Title.
 PS3570.E825 S58 2003
 813'.6—dc21
 2002011302

For Ben and Nate

with love

ACKNOWLEDGMENTS

David Beckman for his thoughtful critique and generous sharing of ideas.

Jack Sheffler for offering his talent and time to create this eye-catching cover, and Joan Sheffler for her help in making it happen.

Dr. J. Peter Rosenfeld for allowing me to borrow from his research. Any inaccuracies are the fault of the author, whose comprehension of his scientific work may be incomplete.

Dr. Mary Jo Sabo for sharing her biofeedback expertise.

Rick Levine, R.N. for medical information.

Diana Gaiso and Lisa King for cover research.

My agent, Grace Morgan, for her unflagging belief in me.

My perceptive and discerning editor, Meredith Phillips, who promised me a fun publishing experience, and has delivered.

And as always, thanks to Michael and my family and special friends for their continuing love and support.

Slippery Slopes

& Other Deadly Things

Prologue

IT WAS THE FLASH of blue that caught my eye. It stood out against the blood red of the jacket as jarringly as a pumpkin on a Christmas tree.

I was bundled up like an Alaskan fur trader, standing on the terrace of my Vermont ski condominium in anticipation of the running of the torchlight parade. It was Saturday night, nine P.M. A light snow was falling, a pyramid of cumulonimbus clouds masking the mountain top.

Decked out in red jackets and black stretch ski pants and carrying unlit torches, a group of ski instructors was riding the lift in preparation for their conga-line schuss down the mountain. My rented condominium was located closest of all the condos to the slope, and I was just able to make them out as they dismounted at the mid-station, skied down the ramp, and melted into the fog. Along with the crowd milling around at the base, I focused on the mid-station,

waiting for the explosion of fireworks, the flashing torches to burst out of the mist, the crimson line to slice through virgin powder.

The torchlight parade at Snowridge was an event that I'd encouraged my colleagues attending our biofeedback convention not to miss. Some, I knew, would find it hokey, a glittering show put on for tourists. But I'm a confirmed romantic, and pyrotechnic displays are right up there with love, sex, and sushi on my list of "must-haves" in my life. My ex-husband, Rich, and I had often vacationed at this resort with our children. Allie and Matt had skied Stonycreek Mountain almost from the time they could walk. Watching the torchlight parade had become a family tradition. My only regret was that this year neither the children nor Ted Brodsky, the man now in my life, were here to enjoy it with me.

The first burst of fireworks lit the sky, followed by applause and *oohs* and *ahhs* from below. It wasn't Macy's Fourth of July on the Hudson but in some ways it was more dramatic, the backdrop of frosted evergreen-coated mountains adding Nature's glory to the man-made kaleidoscopic eruptions.

When the skiers came, flashing torches in hand, I was so caught up that several seconds passed before it registered that the lift was still running—that the sounds from the crowd had muted, transformed from excited shouts to a ragged, puzzled near-silence. The red line broke, the pieces scattering like Pick Up Sticks, all eyes riveted on the mountain. I looked up and saw that a ski instructor had remained on the lift and was riding back down with the safety bar in the up position. He was huddled in one corner of the chair, causing it to tilt dangerously. Seeing the man's peril the operator slowed the lift, shouting and waving at him to lower the bar, but the skier seemed not to hear. The weight of the dangling skis and boots was dragging him to the edge of his seat. As the lift jerked to a stop he was hurled from the chair, the bar crashed down, and he hung suspended, held for an electrifying millisecond by what looked like a blue scarf wrapped around his neck and tied to the bar. Then the scarf gave way and he dropped, slamming into the mountain with force enough to shatter every bone. As the crowd watched aghast,

the figure tumbled downward, like a snowball gathering speed with the momentum of its descent. The skis separated from the boots and caught on the moguls; the body sped past them, smashed into the lift-line poles at the base, and lay sprawled, legs and arms askew, crumpled up like a broken mannequin.

Chapter One

MY FIRST ENCOUNTER with the eminent Doctor Hubert Freundlich was the evening before the lift disaster, in the Innsbruck Condo hot tub. It was twenty-five heart-stopping degrees on the icy deck where I stood clad only in my bathing suit, gazing with trepidation into the swirling cauldron of steaming water below. As a result of a couple of traumatic experiences in my past, I'm phobic about any body of water deeper than the ten inches I run every day in my bathtub. My inner child was shouting at me to get the hell out of there, but my adult self felt compelled to behave like the mental health professional I am, especially in front of my colleagues. I inhaled a lungful of frozen air that nearly paralyzed me, and took the plunge.

The jolt that electrified my body had less to do with the change in temperature than with the feel of a large male hand stroking my thigh. Rigid with shock, I struggled to find a logical explanation.

Perhaps this was some new form of healing hands/touch therapy. Dr. Freundlich was, after all, a guru in the field of alternative medicine. Possibly he'd gotten me confused with his wife, an amply endowed Amazon who was standing only a few inches to his right. A considerable amount of alcohol had been consumed at the welcoming reception that afternoon, and although it wasn't yet six o'clock, the moon had slipped behind the mountain peak leaving us cloaked in a shadowy haze. Anxious to give the man the benefit of the doubt I gently shook him off, submerged up to my neck, and floated six inches to the left. He placed his drink on the ledge, stepped on my foot to keep me stationary, and allowed the offending hand to settle on my hip and creep south. No confusion there.

Hubert Freundlich, Ph.D., QEEGT, CNP, BCIA, was this year's key speaker and honoree at the convention of the International Association of Biofeedback Practitioners. A man of distinction, highly thought of in the professional circles in which I travel, Dr. Freundlich was renowned for his work using magnets combined with EEG Neurofeedback in the treatment of chronic pain. He'd published numerous papers describing his impressive results. As a biofeedback professional I'd been using EEG brain wave training primarily for my Attention Deficit Disorder patients, so I'd read his findings with a good deal of excited interest. My objective in coming to this convention had been to meet him and to hear him speak. The reason I was wearing a bathing suit in December, and having my body scalded while my nose turned the color of Rudolph's, was because this had seemed like a golden opportunity to introduce myself.

There are several methods of dealing with a man who is making an inappropriate pass. If, however, the pass-maker happens to be a respected individual who is coming on in a way that isn't obvious to anyone but the recipient, your choices are limited. Screaming invectives while kicking him in the groin would be tacky. Imagine the gossip that would have generated among my fellow hot-tubbers, in addition to which they'd probably have concluded that it was wishful thinking on my part. I've been divorced for almost two years and Dr. Freundlich was a brilliant and famous man. And at an imposing six-three, with penetrating smoky blue eyes and silver-streaked

blond hair, not at all hard to look at into the bargain. Letting one's husband or significant other challenge him to a duel would have worked in the Old South, but this was the frigid North and my significant other, who happens to be a homicide cop, was four hundred miles away keeping Bergen County, New Jersey, crime-free while baby-sitting my twelve-year-old son, my fourteen-year-old daughter, and our four animals.

What to do? Grinding my fingernails deep into the offending extremity came to mind, but my nails hadn't grown back since I'd bitten them to the quick the last time my stepmother visited. Besides, I didn't want to antagonize the man. I'd come all this way to pick his brain. The problem was that his brain didn't seem, at the moment, to be residing where it should.

I opted to go with the mistaken-wife scenario even though he'd have had to be totally blotto to have mixed us up. Frau Freundlich was Germanically blond while my hair is brown, short, and curly; she's about five-foot-ten to my five-three, at least ten years my senior, and definitely a cup-size or three larger.

Extracting my foot with some difficulty from beneath his, I nearly knocked over a frowning redheaded woman, with a build like a linebacker and lips like parallel bars, who was standing on my other side. She turned a malevolent gaze on me.

"Watch it," she snapped.

"Excuse me, sorry," I apologized, grabbing for the wayward hand still creeping toward its destination. I yanked it to the surface and vigorously shook it.

"Dr. Freundlich," I said, trying my best not to appear flustered. "I'm Carrie Carlin. I have a small biofeedback practice in New Jersey. I've read about your work and I've been looking forward to talking with you. And your lovely wife," I added, determined to include Brunhilde in any discussions we might have.

There was a muffled snort of derision from the redhead on my left.

From his height a foot above me, Freundlich favored me with a benevolent glance, as though I were a schoolgirl with a crush instead of a female colleague with whose thigh he'd just become overly

familiar. He removed his hand from mine and smiled, displaying perfect, had-to-be-bleached white teeth.

"You must come to my lecture tomorrow morning," he said, taking care to enunciate clearly so as, I surmised, not to slur his words. "I'll be speaking before the award ceremony and there will be a question-and-answer period following the demonstrations. If you suffer from any sort of chronic pain, please feel free to participate."

Then he looked me full in the face and winked broadly, making it clear exactly what sort of demonstration he had in mind.

"Actually, I've been lucky," I replied sweetly. "I've never had a problem with chronic pain."

"Well, I'd like to participate," piped up Dr. Nadine Claughton, my roommate for the conference's duration, from her perch on the underwater bench across the tub. Nadine was a psychologist in her late thirties, cheerleader cute, with ash-blond hair, peaches-and-cream skin, no encumbrances, and an eye for every eligible guy within a fifty-mile radius. "I get migraines. Can't figure out what triggers them. They're cramping my style." She smiled seductively. "If you can work some magic that'll send me home cured, I'll be your eternal slave."

Freundlich focused hypnotic eyes on Nadine, drawing her to him like one of those powerful magnets he uses in his work. I'd be willing to bet that slavery was a concept he found as attractive as champagne and caviar.

"I promise no miracles," he said, in a silky voice. "But I believe you'll be amazed at the results."

Nadine fluffed up her hair and floated over to us, wedging herself between me and Freundlich.

"I have to tell you," she gushed. "I found your article on combining thermal biofeedback with EEG for migraines absolutely fascinating."

I, too, was fascinated. I was wondering if, below the waterline, Nadine was receiving the same warm welcome I had. If she wasn't at the moment, she was certainly setting herself up.

"My work will revolutionize the treatment of chronic pain," Freundlich went on expansively. He leaned past his oblivious wife

and splashed some water on a scrawny figure seated in the corner. "Isn't that right, Scarborough?"

"Yes sir. The pain work is extremely exciting," came a robotic voice. It belonged to a small gnome of a man, about fifty, with a caved-in chest, sparse graying hair, metal-rimmed glasses, and a flat face that looked like someone had sat on it. He wasn't smiling as he wiped hot water off his bifocals. I remembered seeing him standing with the Freundlichs at the reception. He hadn't been smiling then either. Maybe it's hard to smile if you have a pushed-in face.

"What you're going to see tomorrow is cutting edge," Freundlich continued. "A historic breakthrough. And I promise you, it will reverse forever the way our medical colleagues and third-party payers view us."

I was all for that, provided he could deliver. My patients have to pay me out of pocket. Because I'm not an M.D. or a Ph.D., Managed Care looks on me as though I were one step removed from a counterfeiter.

"Historic, my ass," said the redheaded snorter. "Do you have controlled clinical studies this time, Doctor, or are your results all anecdotal as usual?"

Freundlich reached across me and cupped the woman's face in his hand. I had to do a fast backpedal to avoid being knocked underwater, which almost gave me one of those panic attacks I treat other people for. I hooked my arm around a ladder rung to assure maximum safety in case the upcoming exchange got ugly.

"Ah, my dear Dr. Zimmer," he replied. "I am well aware that you have come here to shoot me down, but believe me, after tomorrow, even you will be converted."

"Hah," snarled Dr. Zimmer, tossing her head and dislodging his hand. "When pigs fly."

"Who the hell is that?" Nadine whispered in my ear.

Suddenly it came to me. "Flo Zimmer," I muttered. "President of DAHM."

DAHM (Doctors Against Holistic Medicine) is an organization based in Ohio whose entire raison d'être seems to be to discourage any interest in alternative forms of medical treatment. Biofeedback

practitioners who teach the theory of mind/body/spirit connection are number one on its hit list.

"Liebling," cooed Frau Freundlich, hoisting her full-figured body out of the tub and onto the platform without so much as a flinch as butt met ice. "Ve must to dinner go and then early to bed. You need your rest. At half after eight in the morning you are speaking. Vat vill people say if you sleep through your award ceremony?"

"Can't have that," Nadine said, turning her back on Dr. Zimmer, thus leaving no doubt as to whose camp she was in. "He's all that's keeping these snow bunnies off the mountain and in the auditorium."

She wasn't kidding. We were less than one day into the convention and already it was becoming clear that the slopes were proving more enticing than many of the speakers. It was one of those rare Vermont weeks when the weather had cooperated, fulfilling every skier's fantasy. Currier & Ives couldn't top the view from our window. The snow had fallen heavily during the night, spray-painting the trees and blanketing the slopes with just enough soft powder to make turning one's skis a snap even for the novices.

All of the condominiums at Snowridge are nestled at the foot of the mountain. Nadine and I were staying at Mountainside, the unit that Rich and I used to rent. The condo is located so close to the lifts, one can practically see the faces of the skiers as they zoom past the picture window. Staying there made me feel nostalgic for the old days. At least it did until Dr. Freundlich's roving hands reminded me of my ex's roving dick, and my nostalgia evaporated like snowflakes in the rising steam.

I joined my colleagues in a round of polite good-nights and watched half-intrigued, half-repulsed, as Dr. Freundlich helped his wife on with her robe and ushered her inside as though he had eyes only for her.

"Coming, Scarborough?" he called over his shoulder, and the unsmiling man hauled himself out of the tub and followed his mentor without a word of good-night to any of us.

"Imagine heading early to bed with that," sighed Nadine.

"Scarborough?" I asked, poker-faced.

"Yuck. Not him. The man himself."

Be careful what you wish for, pal, I thought. The man's magic wand is for rent only.

Joe Golden laughed. "He certainly is charismatic."

Joe is a psychiatrist and one of the few M.D.s I know who believes in biofeedback therapy as an adjunct to conventional medical treatment. He's one of a small group of doctors who sends me patients. In his late thirties, he hides warm Bambi-brown eyes behind horn-rimmed glasses. Those eyes are a window into why he's so good at what he does. When my husband left, he was the therapist who got me through the worst period of my life. Over the years we've become good friends.

"He's as phony as a three-dollar bill," said Flo Zimmer, coming up with her second cliché in fifteen minutes. "But then so are most of you."

I couldn't let it go. That sort of rudeness deserves a great put-down. None came immediately to mind so I resorted to one of my father's favorite proverbs.

"Dr. Zimmer," I said haughtily. "A narrow mind has a broad tongue."

She looked at me as though I were speaking Swahili. "What in Christ are you talking about?"

"She's telling you in a polite way to shut your mouth," said Nadine. With women, Nadine doesn't pull any punches.

Zimmer stared at her open-mouthed, which allowed water to flow in, making her choke, which effectively did shut her mouth.

Nadine nudged me aside and climbed up the ladder. "Come on, Carrie, let's go eat. I'm famished."

I boosted myself up onto the deck and grabbed my robe.

"Anybody know if the food at The Cove is any good?" asked Joe, the peacemaker, changing the subject before Zimmer could recover. Shivering, he followed me up onto the deck and wrapped himself in his towel. "Christ, this is insane. We'll all catch pneumonia."

"Think of it as invigorating," I replied through chattering teeth. "The Cove's okay if you just want burgers, but I'm for pizza at The

Boat Shack. If it's still under the same management, I'll vouch for the food."

"Sounds good to me," came a deep voice from the other end. I looked up and saw a good-looking string bean of a guy, who I guessed to be in his midthirties, materialize out of the mist. His hair and mustache were so Scandinavian light, they almost blended in with his fair complexion. In striking contrast, his eyes were the color of bittersweet chocolate, dark and brooding. He'd been introduced to me at the reception as one of Dr. Freundlich's associates but I couldn't remember his name. He was helping a pretty, twentyish brunette into her robe. She was the lucky possessor of one of those dynamite figures, the kind just made for the bikini she was wearing. I'd noticed the couple earlier but they'd been deeply absorbed in each other and hadn't entered into the general conversation.

The young woman gazed down at Flo Zimmer, who by now was holding a lonely vigil in the hot tub. "Why don't you and your colleagues at DAHM open your minds for once, Dr. Zimmer?" she asked coldly. "Dr. Freundlich is a genius. You're not going to refute his findings."

"You think not?" retorted Zimmer. "Come and watch the show if you've got the guts. I'm going to take that egomaniac apart tomorrow morning."

"I wouldn't miss it for the world. I'll be there with bells on."

The blond guy took the girl's arm and hustled her inside. "I wonder if Paul will," I heard him mutter as he passed.

Chapter Two

I LOVE TO SKI. Whipping down a mountain, I'm filled with a skittery exhilaration, something akin to the way I feel when I fly, only in this case I'm in control. Well, sort of in control. Having learned in my thirties, late for this sport, I'm far from expert. I consider myself an intermediate skier, although from time to time I have attempted an expert trail or two. My children, who like most children know no fear, have knees made of rubber, and were relatively close to the ground height-wise when they learned to ski, were skiing intermediate slopes by their second season. They bomb the mountain with the ease and form of racers. My knees are made of cartilage, and I have a healthy respect for what could happen to my forty-one-year-old body if I placed those long fiberglass boards in the fall line. Only in ideal conditions do I bomb. In icy conditions I tend to muscle my skis around the moguls with all the grace of a toddler learning to walk.

Snowridge is a Swiss look-alike ski resort located in the tiny village of Sunnyville, and sprawled at the base of three sister mountains; Stonycreek Mountain where the beginners learn to snowplow, Bristol Mountain for the intermediates, and Rolly's Peak where the experts gravitate. Each mountain, however, has beginner, intermediate, and expert trails, clearly marked so you don't find yourself tumbling head first down a slope way beyond your ability.

The Boat Shack is perched on a hillock just outside the perimeter. The restaurant bears no resemblance whatsoever to a boat. Or to a shack. They don't serve seafood and there is no nautical décor. I can only surmise that it had started out small and nondescript like a dinghy maybe, and grew into something larger, like a galleon, as the resort developed and the trickle of customers became a flood. I stick to their pizza, which is awesome. So are the calzones and the heros.

Nadine and I had dried off and layered ourselves with long johns, ski pants, sweaters, jackets, hats, face masks, boots, and mittens, which was a good thing because we were laughing so hard as we slogged through the snow that we kept falling down.

"I think we made a vicious enemy," I said, gasping for breath.

"A narrow mind has a broad tongue. For God's sake, Carrie, where'd you get that?"

"My dad. I was brought up on stuff like that. I was trying to be clever without being as rude as she was."

"Well, what you were was obscure. With people like Zimmer you have to be direct. You notice she only shut her mouth when I told her to."

I giggled as I opened the door to the restaurant. "It was only to keep from drowning, but I bow to your superior methodology."

The blond guy, whose name turned out to be Charlie Anders, and his friend, Kate, had held a table for us directly in front of the massive fireplace where a roaring fire promised to defrost our fingers and toes in record time. Nadine and I began unpeeling the layers. Joe joined us a few minutes later, stamping the clumps of snow off his boots.

"Wow," he said to me, gazing at the moose's head hanging over the fireplace. "I'm amazed you haven't picketed the place."

"It's fake," I said. "And they don't serve venison so I've made my peace."

Lots of restaurateurs in this part of the country figure the more dead animal heads you see hanging on their walls, the more dead animals you'll eat. A faulty philosophy at least as far as I'm concerned, although I admit to being a bit of a hypocrite in that I'm not a vegetarian. Still, I always fantasize hanging the hunter's and chef's heads right alongside the stag's.

We drank beer and wine and stuffed ourselves with a variety of pizzas topped with spinach and ricotta, pineapple and Canadian bacon, and the traditional sausage, peppers, and onions. The conversation centered mostly around the great skiing conditions and how pretty the resort was. No one brought up Dr. Freundlich's altercation with Dr. Zimmer. Charlie and Kate seemed to be deliberately avoiding any reference at all to Dr. Freundlich, which I found odd. I was interested in knowing what it was like working with him, and Charlie's parting remark had piqued my curiosity, but they didn't give me an opening. After polishing off two glasses of Chardonnay on top of what I'd consumed at the reception, I decided to let it go. I was afraid I might let something slip about Freundlich's touchy-feely underwater caper, and the last thing I wanted was to be the subject of gossip at this convention. Nadine, however, had no such compunctions.

"So tell us what it's like to work with the great Dr. Freundlich," she said to Kate, after we'd finished dividing up the bill. "Are you madly in love with him?"

Kate looked startled, her face coloring. "I—he's fantastic, a wonderful teacher," she said. "I guess you could say there's a bit of hero worship in all our relationships with him."

"Have you both been involved in the pain work?" I asked.

"Charlie's been there longer than I have, so—"

"Therefore Charlie isn't quite as impressed with the big guy as is the new kid on the block," Charlie finished for her.

"I've been there long enough to see Mr. McDougal walk out of the office when six weeks before he had to be carried in," she protested hotly. "And I saw Jessica Lawrence when her migraine was so

bad she couldn't lift her head, and now she's so much better she's stopping treatment. You know what your problem is, Charlie? Your problem is, you're pissed you weren't there when—"

"No, my sweet. That is not what my problem is." Charlie signaled the waiter to take the check and turned to me. "Tell us about the parade tomorrow night. Is it worth standing out in the cold for, or should Kate and I stay in and fool around?" Which he playfully began doing, pushing her wavy hair back and nuzzling her neck.

So he's not talking and they're an item, I thought. A short-lived thought, because she slapped his hand away and moved her chair. "Quit it, Charlie," she snapped.

Charlie scowled, his tone suddenly turning nasty. "Give it up, dreamer," he muttered. "Not gonna happen."

What should she give up? What wasn't going to happen? Charlie was just full of enigmatic remarks and my antennae were going up. The air was practically crackling around me. But when Kate suddenly rose and told him to fuck off, Nadine, Joe, and I simultaneously reached for our jackets. It was time to call it a night.

"You don't want to miss the parade," I said as I began relayering. "It's beautiful. Most people watch from the lift line at the base. The instructors ski down the mountain holding flashing torches. Sometimes they set off fireworks before they start. On a clear night against the background of ice-covered trees, it's a sight you won't forget."

Joe jumped in, doing his bit to smooth things over. "Our Carrie here has a ringside seat. She isn't going to freeze her butt off like the rest of us peasants. She was smart enough to reserve a unit near the mountain."

"You're all welcome to come watch with me," I said. "You get a great view from my terrace. You can see almost to the mid-station, which you can't from below."

"Thanks but I'd like to see it from the lift line," Kate said. "I hear they have a bonfire and do a barbecue in the pit. Charlie'll take you up on it, though. He hates the cold. He hasn't even been skiing yet."

"I'm not about to chance going home with a broken leg, thanks," Charlie replied. "I'll be sticking to the beginner's trails."

"Chicken," Kate taunted.

"Better a live coward than a dead hero."

"Your credo, I'm sure."

Ouch! Charlie's fair skin turned scarlet. "Don't push your luck," he said.

Before Kate could reply, Joe took Charlie's arm and eased him toward the door. "Say, Charlie, you think that protocol would work on violent patients? I read an article by this guy who does Neuro-feedback with juvenile prison inmates and his results were really interesting. If you'd like to see it, I have it back in my room in my briefcase."

Nadine pulled on her hat. "I've gotta get out of here. I'm dying of the heat. I'll see you back at the condo, Carrie. God, I hate all this dressing and undressing."

From what I'd come to know of Nadine in the short time since we'd become acquainted, I had the impression it was the dressing part she disliked most.

I called home as soon as I made it back to the condo and had peeled down to my long johns. Ted answered the phone on the second ring. A detective with the Bergen County Violent Crimes Unit, Lieutenant Ted Brodsky had led the murder investigation of Erica Vogel, my then-husband Rich's intended, the murder I'd been accused of committing. That he's now my live-in lover is a long, convoluted story and a miracle in itself, but suffice it to say we've come quite a long way over a very rocky road. Even now we occasionally hit a few potholes.

"How's it going, Cookie?" he asked.

He was teasing, pushing my buttons. Cookie was my father's pet name for me when I was a child and Ted had latched onto it when my dad and stepmother visited us several months before. Over the past few years I've become somewhat sensitive about the men in my life calling me by pet names. I've run the gamut from Cookie to Kitten to Cat to Nudnik (from Rich), to Curious Georgette, which Ted had taken to calling me as a result of a couple of unfortunate situations in which I'd become involved. I've made it clear that unless he

feels comfortable with Wonder Woman, he'd be wise to stick with Carrie. Tonight I decided to play it cool.

"Not gonna be dull," I replied, and filled him in on the Freundlich saga. I omitted the hand-on-thigh thing.

He laughed. "I wouldn't expect anything to be dull where you are."

"I hope they're dull where you are."

"As dishwater. The kids are being so good I'm wondering what you threatened them with. Horty hasn't attacked Shadow or vice versa, and nobody in the county has killed anybody in the last two days."

Horty is my monster dog who wouldn't attack a mosquito. Shadow is the black cat who lives next door, and acts like Horty's King Kong every time she sees him. We have three Siamese cats who are far more dangerous than Horty but there's no convincing Shadow of that.

"I threatened the kids with not letting you bring them up on Sunday if they gave you any trouble," I said.

"Well, it's worked like a charm."

"What time do you think you'll get here?"

"About five if we leave on time," Ted said. "You'll be finished by then, won't you?"

"Last panel's at two and Nadine's leaving right after that, so Allie can have her room. The couch in the living room opens up and Mattie'll sleep there."

At that moment Nadine dashed past me, surprised me by grabbing her jacket and ski pants off the hook, and started to layer again. She was wearing a black turtleneck that showed her assets to advantage, her makeup was redone, and her hair was freshly combed.

"Hold on a minute, Ted. Nadine, where're you going? With the wind chill, it's below zero out there."

"Party in one of the Copenhagen units," came the muffled response as she pulled her neck gaiter over her head. "Wanna come?"

The only person I wanted to party with was on the phone.

"I'll pass. Have a good time and don't stay out late," I said jokingly. "Remember, you have to be up early in the morning."

"Yes, Mother." And grabbing her hat and mittens, she flew out the door.

"Sounds like you're missing all the fun," Ted said.

"I'm waiting for you."

"Ah, I love a faithful woman."

"And vice versa." I hesitated, then decided to chance it. Given my history, the words came hard, but I was getting better at it. "I really miss you," I whispered.

"What? Didn't hear you."

"You did, too."

"Didn't. Say it again."

"Bastard. I said I really miss you," I shouted.

He laughed. "See? Didn't hurt a bit. Miss you, too. See you Sunday."

I was smiling as I wandered into my bedroom, peeled out of the rest of my clothes, and ran my ten-inch bath.

Chapter Three

I'D HEARD NADINE creeping in around four A.M. I was awake because I'd had one of my spooky dreams, which had caused me to thrash around to such a degree I'd bounced myself out of my king-size bed. At home, my bed is queen-size and no matter how crazy the dream, and there have been more than a few, I've never fallen onto the floor. Of course, that could be because I'm usually wedged in with Horty on one side, and if Ted's working, either Luciano, Placido, and/or José, our Siamese cats, on the other.

The dream was right up there with the one I'd had about Erica, Rich's mistress, in which I'd seen her floating half-naked in our swimming pool, definitely in no condition to enjoy either swimming or sunbathing. I try not to think about that dream because by some bizarre quirk of fate, I seem to have had a moment of clairvoyance. I say that because I want to believe that anyone can have one ESP experience, but if I thought I possessed the power to wish

31

someone dead and make it happen, I'd be afraid to walk out the door in the morning for fear of finding my doorstep littered with bodies. Not that my enemies' list is that long. Actually, aside from Rich, Erica was it, but oddly, in the past couple of years, I've run across more than my fair share of corpses. One might think that's because I'm romantically involved with a homicide cop. Ted thinks it's because I can't keep my nose out of his or anyone else's business. To be fair, it's probably a combination of both.

Anyway, in this dream, I was standing at the foot of Stonycreek Mountain watching Allie and Matt and a bunch of other kids sliding down the hill on those round flying saucer things that look like garbage can lids. It was below zero and windy and getting dark. Suddenly there was a loud noise like a freight train, and I looked up to see a huge chunk of snow at the top of the mountain shear off and cascade down. I started to run toward the children, shouting for them to get out of the way, but I was wearing heavy ski boots and walking like Frankenstein's Monster through the thickening snow. As white powder blanketed them, Allie and Matt melted into the group till I couldn't tell one child from the other. And then an instructor appeared out of the swirling snow skiing down the mountain. He had no poles and he was pulling the sleds of two of the children, and I saw that they were my children. They were laughing and calling to me. Then the avalanche hit and the instructor fell and he and the children and the flying saucers all came tumbling down the hill and crashed into me, and I toppled back, landing hard on my shoulder.

That's when I fell off the bed and landed hard on my shoulder. While doing my diaphragmatic breathing in an attempt to quiet my thumping heart, and vowing never to let Allie and Matt out after the lift shut down, I heard the front door open and close. I glanced at the clock; it was five minutes past four. Nadine bumped into something and cursed.

In the morning she had two huge rings under her eyes, the result of excessive partying and only three hours' sleep. I lent her my tube of Covermark but it didn't do the job. It wasn't designed to cover rac-

coon rings. Trudging over to the convention center for the award ceremony, I remarked that she must've had quite a night. She mumbled something inaudible, so I dropped the subject, though I had every intention of picking it up at a more auspicious time.

By eight thirty-three the auditorium was packed and it was standing room only in the back. Great ski conditions or not, no one who'd come to this convention was going to miss seeing our guru receive his award and give us the lowdown on his miracle protocols and treatment strategies for pain. Also, the news of the hot-tub fracas between him and Flo Zimmer had made the rounds and the expected showdown was being eagerly anticipated.

Nadine and I had arrived a half hour early and found the auditorium nearly full. We were forced to sit in folding chairs that had been set up behind the stationary cushioned chairs for additional seating. The stage had been set up with a reclining chair and a table containing the credit-card-sized three- and five-hundred-gauss magnetic pads and strips, plus the leads, creams, and gels that Dr. Freundlich would need for the demonstrations. On a stand next to the table were a computer and two monitors, the largest one facing the audience.

"Where do you suppose the Freundlichs are?" I whispered, after I'd sat on one of those hard folding chairs long enough for my left foot to fall asleep. "I would've thought he'd get here early to work the room."

"He probably overslept," Nadine replied. "The amount of booze that man consumed last night would've killed a lesser being."

"He was at the party?"

She giggled. "He *was* the party."

I swiveled around to look at her. "No kidding. Was Brunhilde there?"

"Brunhilde?"

"The wife."

She shot me a puzzled look. "Her name's not Brunhilde. It's Gerta."

I got up and began stamping on my prickly foot. "Was she there?"

"No."

"What happened to '*Ve must to dinner go and early to bed'?*"

"I guess she was using *we* in the royal sense."

"I see. So the queen slept in and the king…"

"Dr. Freundlich and Kate and I—spent some time together."

Why did the word *threesome* pop immediately to mind? When I was married I used to think of a threesome as three couples going out to dinner. Since my divorce everything seems to have taken on a more prurient connotation.

"Where was Charlie while you and Kate were playing with the king of the mountain?"

"I don't know. Maybe he had a date," Nadine said offhandedly, then glanced down at her watch. "My goodness, it's quarter to nine. They *are* late."

A low murmur escalated into a buzz as the conferees moved restlessly and whispered to one another. Above the buzz Flo Zimmer's strident voice could be heard, believe it or not, actually squawking.

"*Bawk, bawk,* looks like the big guy's chickened out."

I glanced around looking for Kate, half expecting her to get up and make a speech in Freundlich's defense. I couldn't see her. She wasn't sitting next to Charlie, who was a row in front and a few seats to the left of us. There was more shuffling, the buzz grew louder, and then Paul Scarborough got up from his seat in the front row and walked to the podium. He thumped on the microphone a couple of times and self-consciously mumbled, "Testing, testing, one, two, three." He cleared his throat, adjusted the height of the mike downward, and attempted a smile that looked more like a grimace. He nodded at the front row where, from my position standing in the aisle, I could see Dr. Garson Geissing, the president of our organization, who was to have presented the award to Dr. Freundlich, squirming uncomfortably in his seat.

"Dr. Geissing, my fellow colleagues," he began, and cleared his throat again. "Thank you for your patience. It's quite unusual for Dr. Freundlich to be late for a demonstration and there must be an excellent reason why he isn't here yet. I'm sure he was unavoidably

detained, perhaps ministering to someone in pain. After all," he said, "injured extremities are undoubtedly epidemic here. Heh, heh."

No one laughed. The man simply had no stage presence.

"Uh," he continued, his pale face reddening. "If you'll just bear with me and keep your seats for a while longer, I'll attempt to find out what has delayed him." He scurried off the stage and practically ran up the aisle to the door, pausing only long enough to grab his jacket.

I sat down and looked at Nadine. "I think the combination of you and Kate was too much for the good doctor. You didn't give him a heart attack, did you?"

An odd look crossed her face. "Don't be ridiculous."

Hmm. "Where's Kate?" I asked.

"How the hell should I know?"

"Charlie," I stage-whispered.

He looked over at me.

"Where's Kate?"

"How the hell should I know? I'm not her keeper."

Hmm again. I faced my companion. "Who else was at that shindig last night?"

"Oh, you know, some of Freundlich's people, Scarborough and the techie, Jeremy, and a bunch of people I didn't know. And your buddy, Joe Golden, hanging on Freundlich's every word."

That surprised me. "Really."

"He's kinda cute, ya know. Is he married?"

"No."

"He gay?"

"Not that I'm aware of."

"Would you be aware? Or did you and he have something going, maybe?"

"Of course not. He was my therapist. Besides, I'm involved with someone else."

"You were just getting divorced when you were in therapy, right? You weren't seeing anybody then. You were in the market."

In the market? Did she mean displayed on a shelf like a can

of peaches? "When I was seeing Joe," I said, "it was strictly on a professional basis. Besides which, I was an insane person who spent the hour evenly divided between having hysterics over Rich and cursing him out. Believe me, neither one of us was thinking romance."

"You ever notice any pictures on his desk? He have a girlfriend?"

"I don't know." Actually, now that I thought about it, I never had seen any pictures on Joe's desk.

She got up and looked around the room. "I wonder where he is. I don't see him."

The huntress was on the loose. I watched her eyes sweep the auditorium picking out, by some uncanny sixth sense, any attractive, unattached male. Did she have special X-ray vision able to seek out left hands bare of wedding bands? Maybe she didn't care if the hands wore wedding bands or not, so long as there was an appendage between the legs. Maybe I should warn Joe. I was thinking it was a good thing she'd be gone before Ted arrived (not that I don't trust him but why put temptation in his path?) when Flo Zimmer walked up to the podium. She wore an oversized black ski sweater and black pants and looked like she was in mourning, which maybe she was because it appeared that the blood sport she'd been anticipating might not take place this morning.

"For those of you who don't know who I am," she announced, "I'm Florence Zimmer, *M.D.*—" she emphasized the initials "—and I'm president of DAHM."

Somebody at the back of the room booed. A couple of people applauded.

"Yesterday," Zimmer went on, "I challenged Dr. Freundlich to a sort of duel. An intellectual duel if you will, in which I suggested that this morning it would be my pleasure to refute those bogus findings he's been publishing in order to make a name for himself within the legitimate scientific community."

There was clapping and some jerk called out, "Hear, hear." Zimmer must've brought her own cheering section.

"Well, it appears," she continued, "that Dr. Freundlich is afraid to pick up the gauntlet."

More boos, much less applause.

"Indeed, not only has he not picked up the gauntlet, he's been too cowardly to even show his face and admit that he's a phony!"

The booers out-shouted the clappers, fifty to one.

"I know most of you at this convention are biofeedback practitioners and are therefore committed to methods similar to those espoused by Dr. Freundlich," she shouted over the jeers. "But you're doing more damage than good. People can't think themselves out of a disease. You can't brain-wave or magnetize them out of pain, and you can't relax them out of it! There's no such thing as the mind curing the body. Attention Deficit Disorder children should be on Ritalin, depressed patients should be on antidepressants or tranquilizers, and pain patients should be on analgesics or narcotics!"

I joined the booers.

"You are disseminating false information and giving false hope to the public. The proof of the pudding is that your mentor, your guru, has refused to stand before this group and defend his findings. And the reason he hasn't is that he can't. Because he has no supportive data, no double-blind control studies to back up—"

There was a blast of frigid air as the door at the rear of the hall opened and there, dressed in a navy blue hood and matching jacket, open and flying in the wind, stood our hero. Behind him, in a skintight green-and-black ski suit was a slightly disheveled Kate Donovan, and bringing up the rear, a shivering Paul Scarborough. Freundlich strode up the aisle and bounded onto the stage. An uproar greeted his arrival. Then the room grew so quiet you could almost hear yourself breathe. Dr. Zimmer moved from behind the podium, microphone in hand, chest puffed out like a peacock at mating season, and stood facing him. While she was a hefty lady, there was a bizarre David-and-Goliath quality to the confrontation. In this case, despite my antipathy to his roaming hands, my sympathies lay with Goliath.

"Well, well, Dr. Freundlich," Zimmer sneered. "Better late than never. I'm sure I'm not alone in waiting with bated breath to hear what detained you."

If there was a cliché to be spouted, Dr. Zimmer could be counted

on to spout it. Not so our self-assured Dr. Freundlich. He reached out and took the mike from her.

"My dear Dr. Zimmer," he said in the friendliest of tones. "I'd like to say that as a gentleman, I've decided to give you the floor and let you have a crack at me unopposed, but the truth is, I'm not that much of a gentleman. It's going to give me the greatest pleasure, after you've read the data on my empirically validated treatment interventions and viewed a demonstration of my new technique, to watch you and your closed-minded associates at DAHM crawl out of the auditorium on your bellies like the reptilian antediluvians you are."

Ouch! Clearly no more Mr. Nice Guy. The gauntlet had been picked up and the gloves were off. The audience gave a collective gasp. Dr. Zimmer turned crimson. I almost felt sorry for her, but overcame it as Freundlich brushed past her and walked to the podium. He shrugged out of his jacket and tossed it at Scarborough who caught it from his front row seat, one-handed.

"Holy shit," Nadine whispered in my ear. "I know I bring out passion in men, but this is beyond the beyond."

I stared at her. "You're taking credit for this? What the hell went on at that party last night?"

"Shh. He's not finished."

"I do apologize," Dr. Freundlich continued, "to my esteemed colleagues for my tardiness this morning, but an emergency arose, something to which I had to give my undivided attention."

I looked around for Gerta, whom I'd have thought a swarm of killer bees couldn't have kept from her husband's award ceremony. She was among the missing. Then I looked at Kate, standing in the wings in her second-skin ski outfit, gazing at her mentor with an expression of rapt adoration. I took a wild guess as to what emergency Freundlich had had to give his undivided attention this morning.

There was a moment of silence and then the applause rang through the hall. Like Moses on the Mount, Freundlich held up his hands to silence the throng, and after a moment the hall quieted.

"And now I'd like to ask my associate, Ms. Donovan, to pass out the literature I have prepared for you."

Kate took a stack of documents from a carton behind the curtain and began moving up the aisles. When she got to Charlie's row their eyes locked. Something she read there caused her to drop the pile she'd been about to send down his row. She bent to retrieve them, handed them to the person in the aisle seat, and moved on without a backward glance.

Chapter Four

IT WAS NO CONTEST. It was like watching a boxing bout between Woody Allen and Muhammad Ali in his prime. Zimmer was down for the count before the first-round bell. Oh, she made a few determined but pathetic attempts to rise to her feet, but she was totally outclassed. After the episode in the hot tub I have to admit my faith in our guru had begun to shred a bit around the edges, but whatever his sexual peccadilloes, Freundlich was a champion. He'd come armed to the teeth, ready to do battle for God, the biofeedback community, and the Freundlich mystique.

His data were impeccable, indisputable. He'd hit on a pain-relief method that required no drugs and had no side effects—a combination of brain wave training that released nature's own anesthetics, seratonin and endorphins, into the bloodstream, along with the delivery of static magnetic fields from a magnetized device directly applied for forty-five minutes to a pain trigger point, or to a localized

pain area. Recently, he'd been published in a prestigious scientific journal, a rare happening in the biofeedback world. It was going to make him famous and was the reason, I was certain, that he'd been selected to receive the IABP award. I'd attempted to do something similar with brain wave training, putting the patient into an alpha state and using guided imagery exercises, and I'd occasionally had some success. Some doctors I knew had had good results with magnets. But Freundlich's method, combining Neurofeedback with magnet therapy, was indeed a breakthrough, just as he'd bragged yesterday in the hot tub.

After the demonstration and the award ceremony were over, Joe, a grim-faced Charlie, and I trudged through the deepening powder to The Boat Shack for lunch. Nadine had elected to join Kate and the Freundlich entourage at The Cove, which was on the resort premises. The snow was falling so heavily my glasses could have used windshield wipers. By the time we reached the restaurant, my eyelashes were stuck to my sunglasses and Charlie's mustache had frozen into a whisk broom. Like rain-soaked puppies we shook ourselves off, covering the floor with snow, and headed for a booth near the back.

Joe and I ordered heros and hot cider with rum, and began to unlayer. Charlie ordered a double scotch. We didn't talk until the drinks came and we'd had a couple of swallows to defrost our vocal chords.

"I swear to God the man's a damned Svengali," Joe said, more to himself than to us. "I hope he's planning to share that protocol."

"He'll have to," I rejoined. "If he doesn't, after all this hoopla, he'll be lynched."

Charlie tilted his head back, polished off his drink, and signaled the waiter. "Garçon," he called loudly. "Again. Same poison."

Joe eyed the younger man curiously. "What's the matter, Charlie?"

"What makes you think somethin's the matter?"

"For one thing, why're you here? Freundlich demonstrated that his methods work, at least with muscular pain. He had the data, the double-blinds, everything. He chopped Zimmer up into pieces and

ate her for breakfast. And he blew a permanent hole in DAHM that'll make all our lives easier. You've been working with him for the past two years. I should think you'd be up at The Cove in the winner's circle knocking down the Dom Perignon with your buddies."

Charlie put his glass down. "Yeah, you would, wouldn't you?"

"Weren't you an integral part of it?" I asked him. "I was under the impression that you were Freundlich's right-hand man."

"The operative word here is *were*," Charlie said bitterly.

So that's what this was about. Kate had probably come on to Charlie, used him to get in with Freundlich, then shoved the poor besotted guy, along with the lovely Gerta, out of the loop. Devious bitch. Obviously that hadn't been just a lover's quarrel last night, and theirs wasn't the kind of relationship I'd originally guessed it to be. I wanted to ask Charlie what he thought about Gerta's absence, but decided that was a button I'd best not push at this particular moment.

The waiter put another double scotch in front of Charlie and he downed it in three gulps.

"Don't you think you should go easy on that stuff, Charlie?" Joe said. "You haven't eaten anything. You're gonna have one helluva headache."

"Then I shall call my mentor, the man of miracles, to make it magically disappear."

I felt a sudden strong urge to change the subject, searched my mind for an innocuous topic. "Remember, you guys," I said. "Tonight's the torchlight parade. The invite's still open for you to watch it from my place. You'll freeze your butts off watching from the lift line."

Charlie shook his head. "Can't. Somethin' I gotta do."

"I might take you up on it," Joe said. "Nadine gonna be there?"

Could Joe be interested in Nadine? I wouldn't have thought she was his type, but then I really didn't know what his type was. Maybe something had clicked between them at the party. But what about that tête-à-tête she'd indicated she and Kate had had with Dr. Freundlich? Of course, Nadine hadn't said anything specific, and she could have been exaggerating this morning about her effect on the

man. It could've been perfectly innocent, and it really wasn't any of my business. Joe was a big boy. He could take care of himself.

"I don't know," I said noncommittally. "Why don't you ask her?"

"Might do that."

I wanted to inquire how long the party had lasted but that might've precipitated a discussion about what time Nadine had wandered in, so I let it drop.

Our heros arrived just then and Joe and I concentrated on filling our stomachs. I was sitting facing the door, watching table after table taken by people from the conference. I could hear snippets of excited conversation. Everyone was talking about Dr. Freundlich and the astounding demonstration they'd just witnessed. I waved halfheartedly to a few of the conferees I recognized, but hoped no one would come over to us. Charlie wasn't in a mood to join in the kudos.

"Geissing's an ass," he mumbled.

"Excuse me?"

"Geissing. IABP president. Made the award speech."

"I know who he is," I said. "Why is he an ass?"

"Sucks up. Knows better. Don't like his kind."

"What kind is that?" Joe asked, a frown suddenly furrowing his brow.

Charlie didn't answer. He just sat there twisting the ends of his defrosting mustache into points. But he'd piqued my interest and I wasn't about to let it pass. This was about more than his relationship with Kate. Something wasn't kosher and I wanted to know what it was. Ted hadn't labeled me Curious Georgette for nothing.

"What're you talking about, Charlie?" I asked. "What's going on?"

"Forget it. Crocked. Don't know what I'm sayin'."

I leaned forward in my chair, jabbing a finger into his chest. "You know something the rest of us don't, and I say you're honor bound to tell us."

Charlie lurched to his feet. "Oh, no. You'll never get it out of me. My lips're sealed."

People glanced curiously at our table. Joe grabbed Charlie's arm. "Sit down, Charlie," he said.

Charlie shook him off. "Don't touch the merchandise."

"Here, eat something," I said. "You've been drinking on an empty stomach."

Charlie sank back into his chair and I placed a few pieces of sausage from my hero in front of him. I waited till he'd taken a few bites, just enough to soak up a bit of the alcohol but not enough to sober him. I leaned forward in my chair and patted his hand.

"Never mind," I said. "I understand. You're upset about Kate taking your place as Dr. Freundlich's assistant. Who wouldn't be? You did so much of the work and now they're getting all the credit. He didn't mention your name once. Who wouldn't be pissed off?"

"Tha's not it." He shook his head and laid it down on the table. "Worse, mush worse. Gotta CMA, know what I mean?"

"No. What do you mean?"

Joe shot me a warning glance. "Back off, Carrie. Leave the guy alone."

But I wasn't to be stopped. I was on to something. I've often been accused of butting into things that aren't any of my business, but this *was* my business. "What is it, Charlie?" I whispered. "Something's bothering you. Something important. You'll feel better getting it off your chest."

There was a long pause and then Charlie lifted his head. He looked right at me and I held my breath as he opened his mouth to speak. At that moment, the front door flew open and Dr. Freundlich, arm around his smiling wife, paused on the threshold. I saw his eyes search the room. A second passed before the diners realized who it was, and then wild applause broke out. Freundlich gave a slight bow in acknowledgment, then his gaze came to rest on us. Releasing Gerta, he strode up the aisle and grasped Charlie by the shoulders.

"Chaz, my boy, what're you doing here? Everyone's been asking for you. We're all up at The Cove and I promised we wouldn't pop another champagne cork until you joined us." He pulled Charlie to his feet. "I'm sure, this being such a big day for us, your friends will excuse you."

Freundlich gave me a distant smile as though I were a complete

stranger, as though he hadn't had his hand crawling up my thigh less than twenty-four hours earlier. Maybe he didn't recognize me with clothes on.

The French have an expression: *La nuit tous les chats sont gris.* All cats are gray in the dark. I guess that applies to thighs as well.

No one took me up on my invitation to watch the parade from my condo. I would've been mildly insulted if it weren't that the dynamics were becoming abundantly clear. Nadine had somehow insinuated herself into the victors' circle. They were eating barbecue and milling around the bonfire near the base of the lift. It seemed, everywhere that Nadine went Joe was sure to go, which pleased Nadine no end, I was certain. Me, not so much, only because I'm very fond of Joe, and Nadine's activities the night before struck me as a red flag. I assumed Charlie was off doing whatever he had to do. So I polished off the burger I'd picked up earlier at The Cove, half filled a wineglass with Southern Comfort, put on my ski clothes, and went out onto the terrace to await the start of the parade. Looking out at the glistening pines and the swaying lift, and with the snowflakes kissing my face, I was overcome by an unexpected wave of melancholy. I was suddenly glad no one was here to see the tears that froze on my cheeks.

When I'd first learned that the convention was going to be held at this resort, I'd agonized over the decision to attend. Only my desire not to miss the opportunity to meet the great man himself had persuaded me to come. I'm a firm believer in the adage, "You can't go home again." Rich has a habit of taking his younger and younger inamoratas to the same places he and I had vacationed together, a quirk of his that I find inexplicable. It's as though he's trying to recapture or reinvent the happy days of his youth. What he refuses to accept is that no matter where he goes or who he brings with him, Father Time is relentlessly going to go on etching those lines, graying that hair, and eventually wilting that overused member, although that may take a bit longer with Viagra flooding the market.

My attitude is the opposite. I don't want to revisit old family haunts, wallow in memories best left undisturbed. I search out new

playgrounds, different eateries, making them exclusively Ted's and mine, wanting the history we build together to be solely ours. Ted feels the same way. When he and I went skiing last year, we discovered a romantic resort hidden away in the Berkshires, a place neither of us had ever been. The trails weren't as challenging as those in Vermont, but we didn't do much skiing anyway. And hallelujah for that.

So despite Snowridge having been the setting for many happy holidays with Rich and the children, my tears weren't because I wanted Rich back. Those days were long gone. I guess they were more about the finality of things broken—marriages, promises, dreams, and worst of all, families. And because I know that "All the king's horses and all the king's men can never put Humpty-Dumpty together again." It struck me that that nursery rhyme never really was about an egg.

My attention was caught by the starting up of the lift. I wiped away the tears and focused on the excitement below, the blur of red and black over pristine white, illuminated by the fireworks and flashing torches, and that odd streak of blue. And then there was the moment when the lift shuddered to a stop and my glass fell from fingers gone limp as I watched in horror the tumbling, broken body of the ski instructor—a body that all of Vermont's most talented surgeons were never going to be able to put together again.

Chapter Five

"CHARLIE ANDERS?" I gasped. "Oh my God, I can't believe it. That was Charlie?"

"Yes, ma'am," the uniformed cop replied.

"I don't understand. What was he doing in the parade dressed like an instructor?"

"We don't know that yet, ma'am. The body has only just been identified."

The temperature had been dropping steadily and despite my down-filled skiwear, I was shivering as I stood outside the entrance to the convention center where I'd come after I'd called 911. Everything around me seemed surreal—Charlie's smashed body, the screams followed by flashing lights, and now the waves of police and the hushed, frightened voices, all so out of place against the backdrop of this peaceful Alpine village. I was having trouble catching my breath.

47

The center is just opposite the lift line and I had a good view from there of the melee going on at the foot of the mountain. The police and ambulance had arrived within minutes but some time had elapsed before the homicide cops came on the scene. Understandably, the suspicion that this could be a murder hadn't crossed anyone's mind, including mine, until the paramedics had looked at the body. But the hair on the back of my neck stood up when I saw the uniforms back off, and two unmarked cars pull up, followed by a van. From past experience, I recognize a crime scene unit when I see one. Alarm bells went off in my head as Charlie's drunken words at dinner came back to me. "You'll never get it out of me. My lips are sealed." Had someone made certain that Charlie's lips were sealed permanently?

The uniforms were doing crowd control, careful not to panic the guests, but they weren't allowing anyone to return to their rooms either. They were rounding everyone up who had been in the area and sending them to various conference rooms in the center to be interviewed.

"Were you a friend of the deceased?" the cop asked me.

"Not a friend, exactly," I replied. "I met him for the first time here at the convention."

"And what is your name, please?"

"Carrie Carlin. I'm the person who called 911."

The cop signaled to one of the plainclothes detectives, who made his way over to us. "This is the lady who made the first 911 call," the uniform said. "Says she knew the deceased. Name's Carlin."

The two turned their backs on me and spoke briefly while I stood there stamping my feet to keep them from freezing, wishing I'd kept my big mouth shut. I watched as the troop of ski instructors, Dr. Freundlich, Paul Scarborough, and Kate Donovan were separated from the rest of the crowd and taken to the office. I tried to spot Joe and Nadine but I couldn't find them.

Then the detective beckoned to me. "Would you mind coming with me please, Ms. Carlin?" he said.

I fell into step behind him, fitting my boots into the large imprints his Nor'easters made in the deep, crunchy snow. It looked as

though I was being taken, not to one of the center's conference rooms with the other guests, but to the office where possible suspects were being interviewed.

Shit! I thought. Ted is never going to believe this.

"Excuse me, Detective," I called. "I was in my condominium, Mountainside forty-one, watching the parade from the terrace. I saw the accident from there. That's when I made the 911 call. I wasn't down at the base, so there's not much I'm going to be able to tell you."

He didn't bother to turn around. "We'll need to take your statement," he said, opening the door to the reception area. "Wait here."

The only other person in Reception was a bosomy young African American girl standing behind the counter. She wore a lavender sweatshirt with a Snowridge logo on the pocket, and a nametag pinned to it that read CORY ELLEN. Her frightened gaze followed the detective as he opened and closed the door to the inner office. Then she turned to me.

"Were you a witness?" she whispered. "Did you see it?"

"Only from a distance," I replied, pulling off my mittens and hat. "I was on my terrace."

"Was it ghastly?"

I swallowed hard. "Yes, I would say it was ghastly."

"Do they know how it happened? People are saying his scarf got caught. You're not supposed to wear scarves on the lift, ya know. There're signs up all over the place. Because, like, they can get caught and strangle you. Why would an instructor of all people be wearing a scarf?"

I didn't want to talk about it. "I don't know," I mumbled.

"Did they say which instructor it was? Omigod, I hope it wasn't anyone I knew."

"I think they have to let the next of kin know before they can release the name." I took off my jacket and sank into one of the chairs, hoping she'd shut up. But she was all wound up and needed to talk.

"The cops're making us call all the guests who're supposed to arrive this week," she whispered. "Like, they aren't going to allow anyone to come or go. My boss is gonna go ballistic."

Oh, boy. I hadn't thought about that. My three bosses were going to go ballistic, too.

"Listen," I said, getting up. "Would it be okay if I used the phone?"

"Oh, jeez, I don't know. We're not supposed to—"

"I'll put it on my phone card," I wheedled. "My children are driving up tomorrow. I need to let them know that they won't be let in. They wouldn't be on your list to call because they would've been staying with me in my condo."

"I—I guess it would be okay, then." She pushed a phone across the counter. "Make it quick, though. I don't want to get in trouble."

I nodded and pressed in my home phone number and the number of my calling card. My fingers felt like blocks of wood, and I hit a wrong button and had to redial when I got someone's fax machine.

Ted answered on the second ring. "Hello?"

"It's me," I whispered.

"Why're you whispering?" he whispered back.

"Something's happened."

There was silence on the other end of the line.

"Ted? You still there?"

"Ye-es," he drawled. "But I'm considering ripping the phone out of the wall."

"Don't be funny." And I filled him in on the evening's events. More heavy silence. Then—

"You're pulling my leg, right? You've fallen in love with the great Dr. Freundlich and you're planning to run off together. You made this up to get rid of me."

"Ted, I'm not kidding." I lowered my voice and turned away from the counter. "They've brought in the crime scene unit. I'm being interviewed because I was a witness and because I know— knew the victim. Plus, when I saw what happened from my terrace, I called 911."

"Jesus Christ."

"The girl here in the office tells me they're stopping any new guests from arriving. I thought I'd better let you know."

"Je—esus Christ," he said again.

"Stop saying that!" I began biting my nonexistent nails, an old habit that recurs at times of crisis.

"Sorry. It's just—shit, the kids're going to go ballistic."

"I know," I moaned.

"How do these things keep happening to you?"

That did it. Hearing the exact same words from him that my best friend, Meg, had said to me not so many months back when my stepmother, Eve, found a corpse with his head in a bowl of soup and dragged me kicking and screaming into her mess, made everything worse. Tears of frustration formed behind my eyes. I gave him the answer I gave Meg then. "How the hell should I know? Someone's put a curse on me!"

He heard the distress in my voice. "Okay, okay, chill. Crime unit must be from Montpelier or Burlington. I'll see what I can find out."

Some people think having a doctor or a lawyer in the family is a great thing. Given the way my life has gone the past couple of years, my being involved with a homicide cop is absolutely serendipitous.

"They can't keep people there more than a day or so. I'll drive up tomorrow afternoon. Meanwhile, what about the kids? What do you want me to tell them?"

"Call Meg. She'll stay with them. Just say there was a bad accident and they're closing the resort. I'd prefer that they don't know the whole story just yet."

"Gotcha."

The door to the office opened and a uniform beckoned to me.

"Gotta go," I said. "Call you later."

There were two detectives in the office. The one who had brought me here got up from behind the desk. Now that I was able to get a good look at him, he reminded me a little of Ted when I'd first met him. He was about the same age, dark-haired, forties, tall but with a broader build than Ted's. Or maybe it was that he wore a similar expression to one I'd seen at times on Ted—the cop face—aloof, impassive, giving nothing away. He wore his hair long, reaching almost to his square chin. His checked flannel shirt and jeans wasn't the

attire the detectives at home usually wore, but hell, he'd probably been watching TV with his wife and kids when he got called out.

The other detective was a woman whom I guessed to be in her late thirties, dark hair caught up in a knot on top of her head, stocky build, horsey face, wearing navy wool pants and a sweater. I bet she'd gotten rousted out of the shower. She said something to the uniform and he left the room.

"Have a seat, Ms. Carlin," instructed Cop Face.

I sat.

"I'm Detective Sergeant Patrick, that's Detective Mayer. We'd like to ask you a few questions." He sat down, picked up a pen, and opened his notebook. "So you knew Mr. Anders."

"Only slightly. I met him last night. A group of people from the biofeedback convention were using the hot tub in Innsbruck after the opening reception. Some of us had dinner at The Boat Shack later, and lunch there again today. He was there both times."

"Who else was in the group?"

I rattled off the list.

"Was anything discussed in the hot tub or at the restaurant that, thinking back on it, seemed to indicate someone had a gripe with Mr. Anders?"

Was there! Hell, he and Kate were at each other's throats, and there was the whole "my lips are sealed" thing. I knew I should be up front with the cops. Ted would expect it of me. After all, Charlie was dead. I still couldn't quite believe it. In my mind I saw him sitting at the table across from me, and bile rose in my throat. He was young and good-looking and bright with a promising future, and somebody had snuffed out his life as though he were no more important than a West Nile disease-carrying mosquito. I wondered, though, why the police were so certain he hadn't strangled accidentally. There was a reason they warn you not to wear a scarf on the lift.

Then it hit me that maybe he hadn't strangled. Maybe he'd died some other way. Whatever the cause of death, if he had been murdered I certainly wanted his killer found, didn't I? So why should I feel the need to protect people I didn't even know, one of whom

might possibly be a killer? What was holding me back? Maybe it was a residue from the days when everyone was so quick to accuse me of Erica's murder just because I seemed like the logical suspect, having wished her dead a thousand times a day. I decided to give them only what I knew they would get from the others. My own deductions were, after all, only that and what the legal system calls hearsay.

Patrick's brows drew together in a frown. "Ms. Carlin?"

"Sorry. I was trying to think back. There was a little argument between him and Kate Donovan last night. I think Charlie would have liked her to be more interested in him romantically, but it was really no big deal. And at lunch he'd had too much to drink and said some dumb things. I got the impression he felt left out of the victory celebration. But then Dr. Freundlich showed up and took him to the party, so I guessed it was okay."

Mayer came around from behind and got so close to me I could see the pores on her skin.

"What victory were they celebrating?"

"Dr. Freundlich had received an award for his work in pain management. Charlie was part of the team."

"So it was your feeling he was upset that the rest of the team had started without him."

"No. He'd chosen not to go."

"What kinds of dumb things did he say?"

I wondered what Joe would tell them. "I don't remember exactly. You don't give a lot of credence to anything a person says when he's drunk. He was muttering about knowing something the rest of us didn't."

Patrick came around the desk and stood on my other side. I felt surrounded. I wouldn't have been surprised if one of them whipped out a flashlight and shone it in my eyes.

"Can you be more specific?"

"He never told us what it was. I think he was about to, but that's when Dr. Freundlich came." There. Let's shine the bright light on the right person. Let Freundlich sit in the hot seat.

Patrick and Mayer exchanged glances. I was sure they thought I was hiding something.

"You made the first call to 911, is that right?" Mayer asked.

"I assume it was the first call. I was watching the parade from my terrace. As soon as I saw what happened, I ran inside and called."

"What exactly did you see? You would've had a better view than the people standing below. Tell us everything you remember even if it doesn't seem important to you."

I went over it in detail. "He and the other instructor were on the last chair," I finished. "I noticed him because of the blue scarf. It was so out of place. The color stood out because the instructors' jackets are red, and it was odd that an instructor would wear a loose scarf on the lift anyway." And without thinking, I added, "It stuck in my mind because it reminded me of the one my kids gave me for my birthday."

"You have a blue scarf?" Patrick asked. "Did you bring it with you?"

I knew immediately that I'd made a big boo-boo. "Yes, but it's back at the condo. I never wear it when I ski because, well, you're not supposed to wear scarves on the lift. Besides, it's cashmere."

"Which means?"

I got nervous. When had I last seen that scarf? "Which means I usually only wear it if it's very cold or if I'm going out and I want to dress up. Like in the evening for dinner or—or if I'm going to a party," I finished lamely.

There was another exchange of glances.

"When was the last time you wore it?"

"I—I'm not sure."

"Since you've been here?"

"Well—yes."

"Is your scarf unusually long and fringed on the ends?"

I blanched. "Um—yes, but I'm sure lots of people have scarves like that."

Patrick reached in his pocket and involuntarily I jumped, expecting him to produce my scarf the way a magician pulls out a stream of colored handkerchiefs. Instead he took out a card and handed it to me. "That's all for now, Ms. Carlin. We're asking all the

guests to stay around for the next couple of days. The management here is cooperating. You won't be charged extra. And you will look for your scarf and let us know if you have it, won't you." He left off the rising inflection at the end of his sentence. "You can call me anytime. Leave a message if I'm not there."

I nodded, rose to my feet, and got the hell out of there as fast as my legs would carry me.

Chapter Six

TRUDGING BACK to my condo, ice particles biting my face, I passed Gerta Freundlich being led to the office by a stone-faced uniform. She didn't acknowledge me. I'm not entirely sure she saw me through the veil of falling snow or that she would have recognized me wearing anything other than a bathing suit if she had. Anxious to get back to my condo to assure myself that my scarf was still there, I lowered my head and hurried past her.

Back in the apartment I tossed my jacket and hat onto the nearest chair, kicked off my boots, and started with the pegs in the front hall, hoping I'd hung the scarf under my car coat or my ski vest. It wasn't there. I turned the coat's pockets inside out and came up with Allie's leather gloves, an old lift ticket, two tissues, a quarter, and a theater ticket stub. I ran into my bedroom and emptied every drawer, looked in every closet, went into Nadine's room and checked the closet and drawers, got on my hands and knees and searched under

every piece of furniture. By the time I'd finished I knew the scarf was gone and I had a problem. When Nadine came in some time later I was close to tears.

"I think they think he was strangled with my scarf," I wailed. "And maybe he was because I can't find it."

Her eyes opened wide. "Did they say for sure he was strangled?" she asked.

"No, but I could tell that's what they think. The M.E. will make a final determination as to the cause of death."

She stared at me. "My God, you sound like a pro."

I didn't want to bring up my checkered past. "My boyfriend's a cop," I said. "Did they interview you?"

She'd seen them talking to the Freundlich entourage, she told me, but they hadn't approached her. She'd been ushered to the center and asked for her name, home address, and Snowridge room number, and told she would have to stay around for the next day or two. Afterwards, she'd joined several of the guests at The Cove where rumors were flying about the accident victim being Charlie Anders. And about the accident maybe not being an accident.

We sat in the living room and tried to retrace my steps since I'd arrived. We concluded that I must have worn the scarf when we went to the sauna last evening and that I'd probably lost it in the snow when we were having the laugh fest over our put-down of Zimmer on the way to The Boat Shack. Whatever I'd done, it was clear it wasn't here.

"Someone could've taken it before we went to get dressed," Nadine said. "It could've been anyone. We were in that tub for a good hour, at least."

"Possible. But why take my scarf? To implicate me? I just met Charlie. There's no way I'd have a motive."

"Maybe it was a spur-of-the-moment thing. The scarf was there. They didn't know or care who it belonged to."

That made sense. Except why use a scarf at all when a rope would've been more effective? And why do it on the lift on parade night where there was a chance that a struggle would be observed by dozens of people?

"Who would've gone into the dressing room after we did?" Nadine asked.

"The Freundlichs left before us," I replied. "So did Charlie and Kate. The only person who was still in the tub was Zimmer."

"She's built like a sumo wrestler but somehow I can't see her strangling Charlie."

"No, if she was going to strangle anyone it would've been Freundlich."

"Or you, after that 'narrow mind, broad tongue' remark."

"Or you after you told her to shut her face." We looked at each other and suddenly burst into laughter, until we doubled over and fell off the couch and tears came streaming down our faces. Then we stopped, because nothing was funny and the tears weren't tears of mirth and we knew we were on the fine edge of hysteria. We lay quietly on the floor for a couple of minutes trying to bring ourselves under control. I reached into my pocket, pulled out a tissue, and blew my nose. "I feel sick," I said, sitting up. "What a hideous ending to the conference."

Nadine wiped her eyes and face with the back of her hand and got to her feet. "I can't believe Charlie's really dead. Why would anyone do such a terrible thing? And after everything went so well for them."

Jealousy, maybe, I thought. There's a lot of that in academia. But more likely because he knew something that someone wanted kept quiet. I kept my thoughts to myself.

"Did anything happen when the Freundlichs brought Charlie up to The Cove this afternoon?" I asked her. "He'd been drinking. Did he say anything he shouldn't have or get into a hassle with anyone?"

"No. But at the barbecue he was knocking down the beers, and he and Joe started mixing it up."

"Joe? Joe's the last person on earth to hassle anyone."

She gave me a superior half smile. "I don't think you know Joe as well as you think you do."

"What's that supposed to mean?"

"Joe threw the first punch. I don't know what Charlie said to

him, but it pissed him off big-time. Someone said they were fighting over me, but I think it was something else because Joe really got bent out of shape."

"I'll be damned."

"I think Joe likes me," she purred and did that annoying thing with her hair.

I tried my best not to grimace. "Do you like him?"

She shrugged. "He's sweet but, I don't know, there's something about him. I guess he's just not my type."

I almost made a catty remark about how I thought all men were her type, but I caught myself. "You certainly seemed more than a little interested yesterday. And take it from me, you couldn't find a nicer guy than Joe."

"Nice men bore me. It's a flaw of mine. I need excitement. I go for the movers and shakers."

I could've told her about movers and shakers and about the price you can pay for that excitement, but that's a lesson we all have to learn for ourselves. "Did Kate and Charlie talk at the barbecue?"

"I don't think so. She tripped over somebody's ski pole and twisted her ankle. Geissing took her over to the first-aid station to get an Ace and an ice pack."

"What about Gerta? Was she there?"

"She was till the fight started. Then she left."

"Before the parade? Don't you think that's odd?"

"Hubie said she wasn't feeling well."

"Hubie?"

She had the grace to blush. "Dr. Freundlich."

"Jesus, Nadine, you've known him for less than two days and you're on cutesy first-name terms already?"

"What's the big deal? I've only known Joe and you for two days and I call you by your first names."

"Freundlich's a different story and you know it. What in God's name went on at that party last night?"

She didn't answer, just got up, walked over to the window, and stared out into the night. Finally she said, "The police cars are leaving."

"Damn it, Nadine, those detectives aren't stupid. Charlie's dead and they're going to question you and everyone else who was at that party about everything that went on. They're looking for a motive. You're not going to be able to keep it quiet if you and Kate were fooling around with Dr. Freundlich. It'll come out."

"I don't know," she mumbled.

"What?"

She swung around to face me. "I don't know what went on," she shouted. "I don't know if I was fooling around. I don't remember!"

I was so stunned I almost lost the ability to speak, which for me is unheard of. When I found my tongue I said, "Were you drunk? How could you not remember something like that?"

Tears trickled down her cheeks. "Oh, God, I don't know. I remember part of the evening and then I don't. I had a headache. Maybe I blacked out."

"Were you mixing drinks, like say, champagne and gin or something?"

"I think I only had a couple of glasses of champagne."

"Are you on migraine medication? Maybe the combination—"

"I'm not taking anything now but aspirin."

I sank down on the couch and patted the cushion beside me. "Come and sit."

She hesitated, then wiping the tears away, complied.

I took her hand. "Listen to me, Nadine. I've had some experience with homicide cops. They're pit bulls. These guys are going to find your story pretty lame. Particularly, if you tell them you hadn't been drinking heavily. So you'd better rethink it. For a start, what was all that stuff you were telling me this morning about bringing out the passion in Dr. F?"

She didn't answer right away.

"I—I think we had sex," she stammered finally.

I like to think I'm relatively sophisticated, that nothing can rattle me anymore. But I was rattled.

"You think? You don't know?"

"There was—evidence but I can't remember doing it."

"You must've drunk a helluva lot more than you thought. Was

some kind of orgy going on?" Somehow I couldn't picture Joe Golden participating in a sex orgy, but then my history indicates I tend to be naïve where the men I care about are concerned.

"I—I'm not sure. Maybe it was just me and Kate and Freundlich."

"But—"

"I told you what I remember. It's not your business anyway. Quit badgering me."

"Goddammit, Nadine, if you think this is badgering, wait till the cops I met tonight start in on you."

"Oh, God, I know," she moaned. "And if this gets back to my office…"

"This ever happen to you before?"

"No." She turned those big baby blues on me. "Please, don't tell the police. Maybe they won't ask."

Yeah, and maybe Charlie'll show up for breakfast.

"I know I flirt," she said, and paused.

I let it hang. No way was I going to contradict her.

"I enjoy it. It's fun. But honestly, I wouldn't get it on with a married man. Not if I knew what I was doing. There's no percentage in it."

That's what kept going around in my head. If she was so out of it that she didn't know what she was doing last night, did she know what had transpired tonight? And who else was so out of it that they didn't know what was going on? And how could that possibly happen?

Chapter Seven

PLEADING THE ONSET of another headache, Nadine took some aspirin and went to bed, leaving me with an incipient ache in my temples that escalated the more I thought about what she'd told me. I took two of her aspirin and looked around for something to eat. I was surprised to find I was hungry. I opened the refrigerator hoping the last occupants had left something, but if they had the cleaning team had disposed of it. Nadine and I hadn't bothered to stock up because we were eating all our meals out. There wasn't even a crumb of my burger left. I debated going over to The Cove but I couldn't face those arctic temperatures again. I wasn't hungry enough to chance frostbite or a murderer who just might be a nutcase and who wasn't choosey about his victims.

I wandered into my bedroom and dug around in my purse, came up with some TicTacs, gobbled four of them, and decided to go to bed. I was taking off my socks when the phone rang.

"Hello?"

"Carrie, it's Joe."

"Oh. Joe. Hi." I suppressed the impulse to ask what the hell had gone on at that party last night.

"Nadine there with you?"

"She's sleeping. Can I have her call you in the morning?"

"I didn't call to talk to her."

He sounded uptight. I'd never heard cool Joe this upset, but then I supposed this was a new experience for him. I wished I could say the same for me.

"D'you know they're saying it was Charlie who had the accident tonight?"

"It was. I've talked to the detectives."

I heard the sharp intake of breath. "Homicide detectives?"

"Yeah."

"They think someone—they think he was—he was murdered then?"

"Seems like it."

"Christ."

"You okay?"

"Why'd they want to talk to you?"

"I was the first person to call 911, but I think they're interviewing everyone who knew Charlie."

His breathing sounded ragged.

"I need to talk to you," he said. "Can you come over?"

This was a switch. My father confessor wanting to unburden himself to me. "What unit are you in?"

"Mountainside thirty-seven. It's the studio in the far corner of the building."

I'd have to go outside again but only for a few minutes, and I didn't hesitate.

"I know where it is. I'll be right there."

I pulled on my socks, thrust my feet into my toasty after-ski boots, grabbed my jacket, hat, and mittens off the chair, and quietly closed the door behind me. I made it to Joe's room in less than two minutes, which was enough time to color my nose and cheeks

geranium red. He must've been standing by the door because he opened it as soon as I knocked.

He looked frazzled. I was used to a neat, always-together Joe sitting behind his desk and dispensing sage advice. This Joe was walking around in his socks and long johns with his hair standing straight up, Kramer-style.

"Thanks for coming," he said.

I pulled off my mittens and blew on my fingers. "Man, it's cold out there. You owe me one."

He nodded absently. I could see my feeble attempt at levity hadn't registered because what I usually say is that I owe him, and he didn't notice the reversal.

"What's the matter, Joe?"

"Grab a chair."

There were four straight-backed Breuer chairs placed around a card table and a reclining rocker next to a floor lamp by the window. An open box of Mallomars in the center of the table enticed me to forgo the rocker. Joe sat on the edge of the bed.

"Help yourself," he said, catching me eyeing the cookies.

"Thanks."

I fished out a couple and wolfed them down.

"Talk to me," I said, as I reached for a third. "What's going on?"

"It's about—what's happened."

All of a sudden I wasn't hungry anymore. I put the untouched cookie back in the box and closed it. I suspected I was going to hear about the orgy and I was sure I wasn't going to like it.

"Go on."

"I'm in deep shit. I figured with everything that's happened to you, and you being with a cop now, you'd be able to—you might have an idea how I should handle things." He began cracking his knuckles, which I found so unnerving and out of character, I finally reached over and placed my hands over his.

"C'mon, Joe. It can't be that bad. You weren't on that lift with Charlie, were you?"

I said it as a joke, admittedly a bad one because he got a weird

expression on his face. For one horrible moment I thought he was going to say he was.

But he shook his head. "I've got to ask you something and I hope to God you're going to give me the right answer," he said.

"Okay."

"You know that blue scarf your kids gave you for your birthday?"

Uh-oh. "What about it?"

"Do you have it?"

"No. I lost it. Did you find it?"

"I was hoping you'd— You left it in the dressing room at Innsbruck. I stuck it in my pocket planning to give it back to you at dinner but I forgot and—"

I'm normally not a screecher but my voice went up an octave. "What're you trying to tell me? You don't have it anymore?"

"Just listen. After lunch today I went into the demo room to get my brain mapped. I left my jacket on one of the chairs while I got hooked up. I didn't even think about the scarf again till after I heard about Charlie. Somebody said there was a blue scarf around his neck, so that's when I checked my jacket and your scarf was gone. I was hoping that maybe you came by and saw it there and took it."

"How would I have known to look in your jacket pocket if I had come by?" I demanded. "I didn't know you had it."

"I know," he said, miserably. "It was wishful thinking."

I didn't know who I was more upset with, Joe or myself for forgetting the scarf in the first place.

Joe echoed my thoughts. "I don't know if I should mention it to the cops because I'm afraid they'll think I— I mean, I keep thinking that the person who stole the scarf may be the person who—well, it's possible they used it to—to..."

"To strangle Charlie."

"I don't want you involved," Joe said. "I'll tell them what happened and hope they believe me." He got up and took a bottle of vodka off a shelf, filled a tumbler, and swallowed half of it down. "I always thought I understood how it was for you when Erica was murdered and the cops came after you. I kept telling you drink

wouldn't help." He gave me a twisted smile and took another gulp. "But I didn't have a clue, did I? It's a whole different ball game when it happens to you."

I felt ashamed. Here I was worrying about myself when Joe was in trouble. I went over to him, took the glass out of his hand, and put it on the table. "The cops won't be coming after you," I said. "Somebody obviously took the scarf out of your pocket. You didn't ride the lift with Charlie. You were watching from the lift line. I'm sure a lot of people saw you."

"I haven't told you everything," he said, picking the glass up again. His hand shook and a few drops spilled onto the carpet.

"Hey, go easy," I said. "Boozing's not your style."

"Maybe you don't know me as well as you think you do."

Funny. That's what Nadine had said.

"Maybe I'm not always Mr. Cool Hand Luke, like you're used to seeing in my office. Maybe there's a whole other side to me."

"Yeah, sure. You're a regular Dr. Jekyll and Mr. Hyde. What terrible thing did you do?"

"I got in a fight with Charlie at the barbecue. It got nasty. A lot of people saw. They had to pull me off him."

Men and their stupid testosterone. From what Nadine had told me, I hadn't realized the fight was that bad. "What were you fighting about?" I asked.

"He was a fucking mean drunk. He said something I—something insulting and uncalled-for and I lost it. But now it's going to look like there was bad blood between us."

"How long before the parade started did this happen?"

"About an hour. And I didn't stay for the parade. I came back here."

This wasn't good. "Did anybody see you come in?"

"I don't think so."

"Why didn't you come to my condo? You knew I was there."

He sank down on the chair next to me and dropped his head in his hands. "We were rolling around in the snow. I got soaked through. I came back to change. I didn't have any other ski stuff and I didn't feel like going out again."

I looked at my friend, Joe, as good and decent a guy as I've ever known, who was being sucked into a maelstrom of ugliness and violence that had nothing to do with him. I felt a surge of pity. I could relate to every emotion he was feeling, the fear, the rage at whoever had done this hideous thing, all mixed with grief and even guilt over having behaved badly toward Charlie when it was now clear that Charlie had been drunk and probably hadn't even known what he was saying. And now Charlie was dead. No way to make amends.

"Okay," I said. "Let's not panic. Let's think this through. Maybe you don't have to tell the cops you had the scarf. Maybe I can suggest to them that Charlie himself may have picked it up in the dressing room, planning to ask whose it was at dinner."

"Won't fly. Charlie and Kate left before you."

"Okay, let's forget about the scarf for a minute," I said. "Let's approach this the way Ted would. It's a puzzle and we need to find the missing pieces. The killer was dressed like a ski instructor. So was Charlie. Let's think about who would've had the opportunity to get hold of those outfits, and how Charlie could've ended up skiing in the parade."

"We don't know any of these people well enough. We don't know who hated who. We don't know the dynamics of their relationships."

"We know Kate had displaced Charlie as Freundlich's assistant. We know Freundlich's a womanizer. And we know Charlie knew something that somebody didn't want spread around."

I saw the panic leave Joe's eyes as he began thinking about what I was saying. "How do we know Freundlich's a womanizer?"

I looked at him in surprise. Granted, I hadn't told him about the hand-on-thigh thing, but he'd been at that party. I wondered if he, like Nadine, had somehow blocked out what had gone on. "You were at the party last night, weren't you?" I asked.

"Yeah."

"And Gerta wasn't there?"

"She'd gone to bed early. What're you getting at?"

"Were you aware that in the wee hours of the morning Kate and

Nadine and Dr. Freundlich all mysteriously disappeared from the party?"

Joe shook his head. "God, you make it sound Machiavellian. What happened was, Nadine had an aura. She felt a migraine coming on. Kate and Freundlich took her over to Scarborough's unit where they had the computer set up, so they could hook her up and do the pain protocol. It worked. She was fine afterward. Disoriented, but the pain was gone. I know, because I brought her back to your apartment."

They say Cupid's blind and I believe it. I was sitting here looking at an intelligent, normally perceptive man who seemed to have totally lost his powers of observation. True, Joe didn't know what Nadine had told me about having had sex and not remembering with whom. But he was a professional. He should have picked up vibes that something wasn't right. The problem was that, with an arrow having pierced whatever part of his anatomy blind Cupid had been aiming for, my friend Joe was making one hell of an unreliable witness.

Chapter Eight

"GEISSING'S AN ASS."

Charlie's voice cut through the fog of my dreamy theta state, bringing me bolt upright in bed. I'd been hovering in that no-man's-land where fantasy and reality intersect and you're not quite certain if you're awake or asleep. In that fuzzy place Charlie Anders was vigorously alive, and if not kicking, definitely talking. I'm not psychic and thank God, I've never been contacted by the dead or had one of those weird out-of-body experiences. But I am by nature intuitive, so when my subconscious talks, I listen.

I closed my eyes and struggled to recall what Charlie had said yesterday in The Boat Shack about Dr. Geissing knowing something—no, knowing better. And there was something about Geissing sucking up. To Freundlich? He hadn't said, but that's who he must have meant. If Charlie had been killed because he was about to blow the whistle on a shady deal, it was logical to assume that it was

work-related. What could be so potentially detrimental to someone that he or she would kill to keep it from getting out? If that was the motive I could think of only one possibility—there was something not kosher about those double-blind control studies on which Dr. Freundlich had based his findings, and Charlie couldn't be trusted to keep his mouth shut. He may have been seen by the perpetrator as a threat.

Could Dr. Freundlich be the killer? Impossible. He hadn't been riding the lift last night. At least a dozen people had seen him watching the parade. What if Kate were involved? Charlie might have kept quiet because he had a thing for her, but when she dumped him and displaced him at work he was seriously pissed off and he wasn't keeping it a secret. Even if Charlie's own part in the plot would have kept him in line, he was a bit of a lush. And when he drank he talked.

If Geissing suspected a fraud had been committed by his A-number-one-award-winning honoree, would he try to cover it up? That part stuck in my craw. As president of the association, he stood to lose too much. No scientist would take a chance on destroying his own reputation to cover for another's dishonesty. Unless, of course, he'd been paid off. But Charlie had called him an ass, not a crook. Or—and this gave me pause—suppose Geissing had been duped and was afraid the damage to his credibility would cost him his career if he admitted to having been taken in. Distasteful as it was, that scenario played better in my head. I began wondering if being afraid of one's career going down the tubes could lead an otherwise non-violent individual to commit murder.

I shivered, more from my ruminations than from the chill in the air, and reached for my robe. Thrusting my feet into my fleece-lined slippers I pattered over to the window and lifted the blind.

"Oh, ugh."

Sunday had dawned dark and dismal. Ominous thunderclouds swirled overhead obscuring the mountain peaks and sending down a veil of sleet to coat the motionless lift chairs with bone-chilling Vermont black ice. The one silver lining to those threatening clouds was that my children weren't missing anything. Only the most

dedicated and fanatic skiers would have braved the slopes in this weather.

I dreaded calling them. I was afraid they were beginning to think of me as the harbinger of death and destruction. This never happened when they were on vacation with their dick-head father. A couple of years ago Rich had taken them and his then-playmate to Aspen and no one there had killed anyone. Of course, somebody had killed someone in Key West where I was, but in my defense, it had happened before I got there.

Wrapping my robe tightly around me I headed for the kitchen. I filled the teakettle and took my jar of instant coffee from the cabinet where I'd stashed it on my arrival. I'll leave home without American Express travelers cheques, but never without my Folgers. I'd stolen a few miniature containers of cream from The Boat Shack and I carry Equal in my purse so I was able to down two cups of the life-sustaining liquid before picking up the phone. Doubly fortified, I, like E.T., did what I was programmed to do. I phoned home.

"Hello?"

Meg's voice. Ted must have already left.

If I had a sister, which I don't—I'm an only child—and if I could choose from all the people in the world who that would be, it would be Meg Riley. When I flew to Key West it was to be with Meg, whose husband had gone missing and whose brother-in-law was the victim of what had appeared to be a boating accident. Meg has been my mainstay through some of the most traumatic events of my life, which include my divorce and a homicide or three in which, to a greater or lesser extent, I was implicated.

"Hi," I said. "Thanks for staying with the kids. Are they taking this okay?"

"If you call tears and sulks like I've never seen from either of them before taking it okay. Ted and I had to swear on pain of eternal damnation that I'd put them on a plane to Burlington if the resort reopens in the next couple of days. Carrie, what kind of mess have you gotten into this time?"

See what I mean? That tiny hint of blame even from Meg. I chose to ignore it and stuck to the facts. There weren't many beyond what

I'd told Ted, except the part about Joe and my scarf. I filled her in on that, adding that I thought the kids should be able to fly up in a day or two because *this time* (and I emphasized the phrase) I was clearly an innocent bystander.

"You're smoking something."

"What?"

"If your scarf was the murder weapon you're not going to be schussing any slope in a day or two and neither is Joe or the Freundlich crew. Even if they do reopen the resort, you don't want the kids in the middle of that."

She was right, of course. Meg is nearly always right.

"Then I guess I'll just have to see what I can do about nailing the bastard who did the dirty deed."

The minute the words were out of my mouth I regretted making light of Charlie's death. Despite his drinking I'd liked him. I tend to relate to people who've been dumped.

I sighed. "Sorry. I'm getting callous in my old age."

"Not really. You're living with a homicide cop and you're learning to distance yourself, which is a damned good thing considering your history. You want to talk to the kids?"

"I'd better. Put them on."

I heard Meg call their names and Allie picked up.

"Mom, why would they close the resort just because there was a ski accident?" demanded my daughter. "Skiers are always crashing into things. Ted said he didn't know the details but I thought he was bullshi—"

"Hey! Watch it!"

But there was no getting around it. They were bound to find out sooner or later. "Someone was killed this time, Allie. In the torchlight parade."

She gasped. "An instructor? What happened? He hit a tree?"

"No." The *no* covered both the instructor and the tree question and I didn't elaborate. I was being deliberately vague but I was determined to avoid the M-word at all costs. I went on to what is always a safe subject. "The weather has turned really foul, honey. You wouldn't've been able to ski anyway."

"But we didn't make any plans," she complained. "And nobody's around."

"Maybe you could make some money helping Meg in the café. You could be a server and Matt could bus. Word is, her customers are great tippers."

Silence. Then, aggrieved, "Mom, we're on vacation."

Fourteen's a tough age, but where there's a will and an experienced mom there's a way out. "How about I ask Meg to take you to whichever mall you want on Friday and you can spend a hundred—" I gulped and bit the bullet "—a hundred fifty dollars above and beyond what you make in the café. That's from me, and only if you don't get to come skiing."

I could hear the cash register in her brain clicking as she contemplated the mega-shopping spree she could go on with a hundred fifty-plus dollars at her disposal. She'd be the envy of all her friends.

"Cool," she said grudgingly.

There was some whispering while she passed on what I'd said to her brother.

"Matt wants to talk to you."

"Hi, Mom."

"Hi, sweetie."

"This sucks."

"I know, Mattie. I'm sorry, but I have a counter-offer for you." Sometimes bribery's the only way. I went over the same ground I had with Allie, substituting for clothes, video games and CDs dear to the heart of a twelve-year-old male. Surprisingly I got a different response.

"I don't care about that stuff. I want to ski. You promised. Can't you do something?"

Supermom was at a loss. "I don't know, honey. I'm at the mercy of the people in charge of the investigation."

"Maybe Ted can talk to them."

"We'll do what we can."

"Swear?"

"I swear."

After I hung up, I sat at the table calculating my losses and feeling

miserable. Considering the cost of lift tickets and last-minute air fares, financially I'd come out ahead, but it didn't begin to make up for the loss of a family vacation to which we'd all been looking forward. I felt awful about disappointing the kids, but what could I do? Some things are beyond my control. Well—maybe not. Maybe there was something I could do to hurry things along. And help Joe out at the same time. Possibly I could do what I'd so flippantly suggested to Meg. I wasn't without experience after all, and Ted was on his way up here. Between the two of us we could put the pieces of the puzzle together. We're good at puzzles.

Ted has often told me that in a murder investigation, "quick" is the operative word. The more time that elapses, the harder the crime is to solve. Soon the police would have to begin letting the resort guests go home and the killer could slip through their fingers. Besides, I had an advantage the police didn't have. I had socialized with many of the people in question. I was a colleague and I could worm my way into their confidence without raising suspicion or hackles.

Where to start? I picked up the roster of speakers and panel members who were probably never going to get their finest hour on the podium, and ran my finger down the list. Two of the most prominent names jumped out at me: Hubert Freundlich and Garson Geissing. I didn't want to get within pinching distance of Dr. Freundlich or any of his entourage just yet. They, along with Joe, had to be at the top of the local constabulary's list of suspects, and the last thing I wanted was to have even a smidgeon of guilt by association rub off on me. Which left Dr. Geissing, who already occupied a prominent place on my list of people who, at the very least, had some explaining to do. I'd start there.

I was dressed and layering on outerwear when Nadine opened her bedroom door and staggered into the living room.

"Coffee. I need coffee."

"The kettle's boiled and there's instant coffee in the cupboard."

"Instant? Yuck."

"Sorry. I don't carry my own ground beans. It's a character flaw."

She collapsed on the couch. "Please, would you mind making me a cup? I'm trying to ward off a migraine."

Caffeine works in odd ways on migraine sufferers. Sometimes a little staves off an attack, but too much can bring one on. The way alcohol affects the general population: a little is good for the heart, but overdo it and you can end up dead like Charlie Anders. I dropped my jacket on the chair and went into the kitchen.

"How do you take it?" I called.

"Black. Where're you going?"

"To see a man about an ass."

There was a brief silence. "Did you just say you had to see a man about a horse?"

No point in trying to explain. "Something like that. I'm going to get some breakfast at The Cove. Can I bring you anything?"

"No thanks. I'm just going to stay here and relax. It's disgusting out there."

Relax. The word set off bells in my head. Relaxation training is part of what we biofeedback therapists do, but I've had some really interesting results combining it with alpha/theta brain wave training. That time in Key West when Meg couldn't remember certain crucial details about what had happened on the day her brother-in-law had the accident, I'd helped her bring the memory to the surface by putting her in a sort of semihypnotic trance. I've used the technique a few times when a patient has blocked a traumatic event from his or her conscious mind because it had been too painful to deal with. I didn't think that was the case with Nadine's difficulty in recalling what had gone on at the party. If she'd had more to drink than she thought, I doubted the technique would work at all. Alcoholic blackouts are usually just that—big black holes. And drunk or sober, something told me Dr. Freundlich wouldn't have had to rape her. Nevertheless something bizarre had occurred that night and the technique might work if she'd be willing to give it a chance. I picked up the coffee mug and took it to her in the living room.

"Here's your fix," I said brightly. I waited for her to down a few sips before dropping the bomb. "What say we try alpha/theta to help you with that memory lapse of yours?"

"What memory lapse?"

Had she forgotten that she'd forgotten? Time for shock therapy.

"The party. You had sex, and the whole experience seems to have slipped your mind."

"Oh, that."

"Yeah, that."

"I'm not sure I want to remember."

Denial. Soon she'd convince herself it never happened at all and then it'd become one of those deeply buried memories that cause all sorts of problems down the line. "Might be nice to know if it was protected sex."

I'd opened up a Pandora's box, and God only knew what might fly out. She didn't answer. I tried a different tack.

"I keep wondering if you might have heard or seen something that had to do with what happened to Charlie."

"Don't be ridiculous. Charlie wasn't even there."

"I know but—"

"Leave me alone. I don't want to talk about it."

We were all unnerved by Charlie's murder. I decided she needed space, and I backed off. For now. I got to my feet and picked up my jacket. "Well, if you change your mind I'll be back in an hour or so."

"Take your time."

Chapter Nine

DR. GEISSING didn't look happy to see me. Of course, I was wearing a ski mask, so if he wasn't the murderer, maybe he thought I was, and was concealing a dagger in my mitten. He opened the door only about six inches and scowled down at me.

"Yes. What is it?"

"Hi, Dr. Geissing," I said. "Can I speak to you for a minute?"

He started to close the door. "I have no comment for the press."

I stuck a boot in the narrow opening. Fortunately, it was a hard rubber boot. "I'm not from the press." I pulled off my mask and hat. "I'm one of the conferees. Carrie Carlin from New Jersey? We met at the welcoming reception."

"Oh, yes." I was fairly certain he didn't remember me, but he released my boot from the vise. "Why didn't you say so? Can't tell who anyone is in those Eskimo outfits. Come in, come in."

He was still in his pajamas and robe. A big man just short of

77

corpulent, he seemed to have suddenly shrunk. There were deep caverns under his eyes as though he hadn't slept all night, and his normally ruddy complexion was a close match to his short, gray Mephistophelian beard. I stepped inside and removed my jacket to indicate that I intended to stay awhile, then said, "Sorry to drip all over your carpet. I'll just hang up my jacket out here in the hallway." Which I did, and stepped past him into the room and sat down on the couch.

"If you've come to find out when you'll be able to leave," he said, following me, "sorry, I can't tell you. I realize people have families and practices to get back to, but I haven't been given any information by the authorities regarding their intentions."

Searching my mind for a subtle way to lead into the reason for my coming, I noticed that his picture window fronted on the mountain. "What a great view," I remarked.

He glanced at me sharply. "Yes," he replied. "A perfect view of the lift."

Oops. Wrong opener. Or maybe not. Sometimes it's best to jump right in. "My unit faces the mountain, too," I said. "I was watching the parade from my terrace. I saw everything. It was horrible."

He sank into the chair opposite me. "Unbelievable. A young man and so talented. A rising star. Who would've done a terrible thing like that?"

"I can't imagine. I can't understand why he was on the lift at all. I had the impression he wasn't much of a skier."

"I wouldn't know," he said. "I don't ski myself. Never had the opportunity to learn when I was young and I'm in my fifties now. Too late to take up a dangerous sport."

Whoever had killed Charlie would have had to ski well enough to take a back trail down the mountain, maybe one that hadn't even been groomed. Was the gentleman protesting too much?

"Have the police talked to you?" I asked.

"For about an hour last night, and they made it abundantly clear they weren't through with me."

"You think they have any suspects?"

"We're all suspects." His hand wandered up to his chin and he began nervously stroking his beard, his permanently attached security blanket. "They acted like I should know everything about everyone who attended the conference. I didn't even organize it."

"I thought you were the one who selected Dr. Freundlich as the honoree."

"No, that was done by committee on the basis of his published work. Coincidentally, when I visited his lab in North Carolina I discovered that we'd taught at the same university, but I hadn't made the connection."

"I suppose you met Charlie Anders and the rest of the staff when you were there," I said.

"Of course."

"Did it seem like there was any trouble—any dissension or jealousy, anything like that?"

"I really didn't—well, there was…" He cleared his throat and got to his feet. "Would you like a cup of coffee? I have a fresh pot made."

"No, really, I'm fine. You were saying?"

"You mind if I smoke then? I've been trying to give it up but at a time like this…"

"No, no, go ahead." I'd've tolerated a roomful of chain smokers to get him to finish that sentence.

He reached into his bathrobe pocket and extracted a pack of Marlboros. "You know, this is secondhand and I don't like spreading rumors.…"

"I understand."

He lit up, sat down next to me, and spoke in a low voice as though he was afraid the room might be bugged. "I haven't mentioned this to anyone, but maybe I should."

He took several short nervous puffs on his cigarette. I suppressed a cough, anxious not to interrupt the flow.

"When I was at the lab," he went on, "I got to talking to Paul Scarborough's assistant, a Ms. Wiley. She said everyone thought highly of Charlie, thought he was brilliant. Said he was doing a bang-up job."

He stopped, waited for me to say something.

"So then why did Dr. Freundlich replace him?"

"She said Kate Donovan buried him."

"Buried him?" In light of what had happened to Charlie the term made me shiver.

"She meant figuratively, of course. My take on it was that Kate had gotten him removed from the project."

I knew Kate had replaced Charlie as Freundlich's first assistant. But Charlie had let slip that there was more to it than that, and he'd been about to tell us when Dr. Freundlich had shown up and whisked him off. "How would she have done that? Why would she have done it?"

"She wanted his job, obviously. It's unfortunate, but ambition sometimes makes people do ugly things."

I'm a feminist. It infuriates me when someone intimates that a woman has risen in the corporate or academic hierarchy because she's used her feminine wiles on the boss. But Kate was young, in her early twenties, and she was a knockout. You need to have a lot of power to have someone who's doing a bang-up job bumped from a project. Knowing what I did from personal experience of Freundlich's proclivities, I hate to admit that the thought did cross my mind that Kate's power may have derived from talents other than those scientific.

It was my turn to clear my throat. "Did anything else happen while you were there?"

"That Zimmer woman showed up with her cohorts and set up a picket line outside the premises. Freundlich told me that wasn't unusual, she's been a constant thorn in his side."

"Well, at least Charlie got to see him put her in her place yesterday. That had to have given him satisfaction."

"I suppose so, for whatever it's worth."

From what Geissing was saying I couldn't figure out why Charlie had felt about him the way he had. The man seemed to be as disturbed and baffled over what had happened as the rest of us. I decided to bait him. I leaned in.

"I had a couple of meals with Charlie, Dr. Geissing, and both times he drank too much. He kept hinting that he knew some sort of secret and that you knew about it, too. I got the impression it had to do with Dr. Freundlich, or something you'd told him and he told Charlie."

Geissing's face turned pale. "No, I can't think what—did he say what it was?"

"I don't want to repeat rumors. I suppose I will have to tell the police about it, though."

Tiny beads of sweat exploded like popcorn on his forehead. At that moment I'd have given anything to have him hooked up to my computer. I'll bet his EDR (that's his fight-or-flight response) would've gone off the screen. He snuffed out his cigarette in a little enameled dish that wasn't an ashtray, stood up, and began pacing around the small room, muttering to himself. I had to listen hard to catch the words.

"Stupid, stupid—should've refused—can't believe after he promised…"

"Promised what?"

He went on as though he hadn't heard me.

"…gets out—destroy everything."

"If what gets out, Dr. Geissing?"

He stared at me as though trying to remember who I was and what I was doing there. Then after a long pause he said, "The murder. I meant the murder. Sorry, you'll have to leave. There's something I must do."

Which rang another bell. Those were almost the words Charlie Anders had used just a few hours before he took that fateful lift ride up the mountain to his death.

Minutes later, as I was on my way to breakfast at The Cove, a familiar female voice stopped me in my tracks.

"Hey, Carrie. Carrie Burnham, wait up."

Waving a ski pole in the air, a figure from my married past ski-skated up the incline toward me.

"Julie Morgan," I called out in delight. When she caught up with

me she dropped her poles, and we threw our arms around each other. "Long time. How are you?"

"I'm great. And it's Julie Aston now. Jim and I got married last spring."

"Oh, congratulations. I always thought you were perfect for each other. I hope you'll be very happy."

"Lookin' good." She giggled in that engaging way she had that had made all of us love her the first season Rich and I and the children had started taking our vacations here. Dark-haired, pixie-faced Julie had been our ski instructor. I hadn't seen her and Jim in four years. Both were born-and-bred Vermonters. They'd spent their lives on skis and now, Julie told me, they were running the resort ski school.

"By the way," I said. "I'm back to using Carrie Carlin now. Rich and I were divorced a couple of years ago."

"Oh, gosh, I'm sorry," she said. "Are you okay?"

"I am now."

"You two always seemed so—I wondered why you weren't coming up anymore but I thought maybe now the kids were older, you'd decided to vacation out west."

"No."

"So," she said, after an awkward pause that she filled by whacking the clumped snow off the bottom of her skis with her pole. "Are the kids with you?"

"I'm here with the biofeedback convention. Allie and Matt were supposed to join me yesterday, but the police closed the resort."

She grimaced. "I was in the parade last night," she said. "It was awful."

"I know. I saw it from my terrace."

I began stamping my feet in a futile attempt to keep the circulation going. Julie bent to retrieve her poles.

"I've gotta go. I have a class."

"You're kidding. In this weather?" I asked.

She grinned. "It's the four-to-six-year-olds. They're tougher than their mommies and daddies. Will you still be here tomorrow?"

"Looks like it."

"What say we meet at The Cove tomorrow night and catch up over a hot cider?"

"What time?"

"A bunch of us usually hang out there after dinner. Say around seven-thirty or eight?"

"Sounds good."

"See you then." She pushed herself off and in one graceful fluid S motion, glided to the bottom of the slope. Ungracefully, in a good imitation of a landlocked walrus, I lumbered along after her. The snow had developed a thin crust that cracked and crunched under my feet as I fought my way across the open expanse between the condos and the restaurant. Inspired by a fear of galloping hypothermia, I arrived at The Cove in record time.

I've been in Vermont when, with the wind chill factor, the temperature was thirty or more below, but today the wind seemed to pierce through all my layering. By the time I pushed open the door I was panting as though I'd run a marathon. I tugged off my down-filled mittens that had failed to do what the manufacturer promised, and with fingers that had lost all feeling, struggled to unclip the ice-encrusted chin strap on my hat. Blinking the sleet out of my eyes, I looked around the room and saw Kate Donovan sitting alone at a corner table.

"Cold enough for ya?" giggled the turtle-necked, ponytailed teenager who greeted me.

I was tempted to take the block of ice I'd been wearing on my head and smack her with it. Instead I grimaced and stamped my feet, sending a shower of tiny icicles over her chic après-ski boots. Didn't faze her a bit.

The restaurant was about half-full. The adults at the tables were subdued, their conversation muted. The children were boisterous, happily oblivious to the anxieties of their parents.

"One for breakfast?" asked the girl.

I glanced over at Kate and hesitated. She was sitting with her head in her hands, a lone cup of coffee in front of her. Sometimes

I'm ashamed of the impulses I get to seize the day at every opportunity, and this morning my conscience did give me a slight pang. But I was urged on by what Geissing had said Scarborough's assistant had told him. If it were true, I wouldn't mind taking advantage of someone who was capable of screwing over a coworker. Especially when that coworker had mysteriously ended up dead. Besides, Kate knew what had happened to Nadine at the party. She'd been there. If she'd been shaken up by Charlie's murder and was possibly feeling remorse over what she'd done to him earlier, she just might open up to a sympathetic colleague.

"I'll sit with that lady over there," I said, and followed the girl's tight little stretch-panted butt as it wiggled its way through the maze of tables.

"Hello, Kate," I said when we arrived. "May I join you?" Plopping myself down before she could refuse, I reached over and touched her arm. "Are you all right?"

I don't know what I expected her to say.

After a short pause she murmured, "Not really."

I struggled to find the right words. "I'm so terribly sorry," I said awkwardly. "I can't imagine what you must be feeling." I figured that covered the territory whether what she was feeling was genuine grief, horror, remorse, or guilt.

"Thank you."

Our hostess intruded, handing me a menu. "Steve will be your server this morning," she said cheerily. "I'll send him over. Enjoy your breakfast." And signaling to a young man my Allie would have called a hunk who was setting down a heavily laden tray on a nearby station, she trotted back to her position by the entrance where she began an animated conversation with a ponytailed, turtle-necked clone.

"Think that young lady has noticed anything amiss here today?" I asked, watching Kate closely for her reaction. "Seems to be business as usual."

"I wish I could change places with her," Kate replied. "I'd love to blank it all out."

My pang became a stab. "I'm sorry," I said, half rising. "If you'd rather be alone…"

"No, it's okay. You're Carrie, right?"

I nodded, and sank back into my seat. "We had dinner together Friday."

"With Charlie. I'm not good with names when things are normal. Today—well, I could barely remember my own. It's been a nightmare."

Either she was a superb actress or she was really rattled.

"Morning, ladies." A smiling Steve loomed over us, coffeepot in hand. "Coffee?" he asked me.

I nodded and he proceeded to pour, then noticed Kate's half-empty mug. "Let me freshen that for you. Can I take your order?"

I was starving. Trudging over here I'd worked up an appetite and had been looking forward to pigging out on a half dozen pancakes floating in thick, gooey Vermont maple syrup. Watching Kate sitting opposite me seemingly unable to swallow, I felt compelled to control my gluttony. "I'll have the continental breakfast," I murmured.

"Nothing for me," Kate said.

"Maybe you'll have one of my muffins," I said, after Steve had left. "You should try to eat something."

"I'm not hungry."

I understood that. I'd totally lost my appetite when Rich left and I was accused of whacking his bimbo. Dropped fifteen pounds in three weeks. That was the first time I'd seen ninety-nine pounds in twenty years. Also the last. Some people gorge themselves in crises; some of us go on an involuntary hunger strike. I was beginning to feel uncomfortable about my decision to play detective under the guise of offering consolation.

Keep your eye on the ball, girl, I told myself. Remember you're doing this for Joe. If she's for real she'll thank you for trying to find Charlie's killer.

"Were you and Charlie—very close?" I asked.

"No. Well, he wanted us to be."

"I got that impression at dinner Friday."

"God, I was bitchy to him, wasn't I?"

If pressed I would've had to agree that she'd risen to new bitch heights. Fortunately, she didn't press me.

"He was acting like a jealous lover and we weren't lovers," she went on. "I can't stand that. I can't stand being smothered. But now I—"

"Now you feel guilty. You shouldn't, unless there's more to it than just not wanting someone who happens to want you." I let the words hang, hoping she'd blurt out that she'd stabbed him in the back and stolen his job or something even more damning. But just then Steve, whose propensity for arriving at the wrong moment was beginning to bug me, appeared at my elbow.

"Here you go," he said, placing a basket filled with warm, aromatic rolls and muffins in front of me. "Can I get you anything else?"

"No, we're fine, thanks." I waited for him to leave but he topped off the coffees and seemed reluctant to move until he saw at least one of us eating. I broke off a piece of blueberry muffin, smeared it with butter, and popped it in my mouth. I made *mmm* sounds as I chewed. "Delicious," I said.

"Aren't they great? We get them homemade from a nice old lady in Sunnyville."

"They're wonderful." I broke off another piece but still he hung around. Finally, assuming he was waiting for Kate's rave review, I said apologetically, "She's allergic to wheat."

But that wasn't it. He bent down and whispered, "Are you ladies here with that bio-whatever convention, you know the group where the guy was—"

"No," I said firmly. "Don't know a thing about it. We're locals, faculty from UVM."

"Oh," he said, disappointed, and finally moved off hoping, I suppose, to have better luck with the couple who'd just come in.

I devoured the rest of the muffin, which was scrumptious, and washed it down with my coffee. Almost four cups of coffee and it wasn't even noon. No sleep for me tonight.

I handed Kate a muffin. "Have a piece, Kate. You'll get sick if you don't eat something."

She made an effort, managing two or three bites before pushing her plate away. She was antsy, unable to keep her hands still. I was afraid she'd take off before I could find out anything.

"I imagine Dr. Freundlich's taking it hard," I said, all compassionate concern. "I understood Charlie was his right-hand man."

"Who said that?"

"It wasn't true?"

"Well, yes, in a way." She crumbled the leftover muffin into bits, making piles on her placemat. "Charlie'd been there for a couple of years. But he wasn't around when we tallied the results. He had some surgery, was out for a few weeks, and I took his place."

"I see."

"He resented it. I guess he was upset that the work had gone on without him. But he should've understood that everything couldn't stop dead because he wasn't available. He shouldn't've gone around threatening people."

"Who'd he threaten?"

She glanced away. "He was just ticked off and he let everyone know it."

"Well," I said, hoping to shock her into spilling the beans about her own part in Charlie's fall from grace. "He obviously scared someone badly enough for that person to want him out of the way. You have any thoughts who?"

Her hand shook as she reached for her mug. "Of course I don't."

"It had to be somebody he worked with," I persisted. "Who were his associates on the pain project beside you and Dr. Freundlich?"

"Only Paul and his assistant, Janet Wiley."

"Is she here?"

"No. She left. I don't think it had anything to do with us. Maybe he got into a fight with one of the locals or maybe that Joe Golden went nuts. They had a fight."

My heart flip-flopped. I could only hope she hadn't mentioned that to the police. "Joe Golden is the sweetest, least aggressive man

I've ever met," I said. "If he took a swing at Charlie I'm sure it was deserved. And he probably missed anyway. Besides, Joe's not a skier."

"Neither was Charlie."

"So what was he doing on the lift in an instructor's jacket?"

"I don't know." She got to her feet. "I have to go."

I thought fast. "You know, both times I was with Charlie he was drinking and running off at the mouth. Did he have an alcohol problem?"

A worry wrinkle appeared on her forehead. She sank back into her chair. "He drank, but I never saw him behave the way he did up here. He acted like a complete jerk the other night at dinner but I don't remember him saying—"

"We had lunch after the award ceremony. I got the impression that he wasn't particularly fond of Dr. Geissing. Do you know why that was?"

"Oh, that's because Charlie was kind of homophobic, and when he found out Geissing swings both ways, well, you know how some men are about that sort of thing."

"I hadn't heard that about Dr. Geissing. So you don't think it had anything to do with Geissing having selected Dr. Freundlich for the award."

"No. Why? What did he say?"

"It was just a feeling I got. I thought something having to do with the project had upset him. Like the final tally was off or something. Could that have been it?"

"Absolutely not. I was working with Paul and he's extremely precise." She got to her feet again. "I've really got to get back."

"I'll walk over with you." I grabbed the remaining roll and wrapped it in a napkin. "I'll take this for Nadine. She had a headache this morning and hasn't eaten. Probably could use another treatment from Dr. Freundlich like the one she had at the party."

No reply.

"I wonder what kind of treatment that was," I went on, going for broke. "Nadine was totally bonzo after that wild party the other night. She wouldn't tell me about it, but I wouldn't be at all

surprised if something went on between her and Dr. Freundlich." I kept my expression neutral as though I found this behavior par for the course.

Kate looked at me with an expression I couldn't read. "What do you mean?"

"Well, he's hot. I suppose women are constantly falling at his feet."

"He's married."

Well, duh. Nice she'd noticed.

"People tend to ascribe things to him," she continued, anger now flaming her cheeks, "because he's such a presence. It's horribly unfair." And she grabbed her jacket, dropped a few bucks on the table, and fled.

I was dumbfounded. I could still feel the imprint of Casanova Freundlich's beefy hand on my thigh, and here this gorgeous young woman, who had worked side by side with him for a month, was acting like he was Saint Peter and she was Miss Goody Two-Shoes. And what about that party? Did Kate have selective amnesia, too?

I was thoroughly confused. I wasn't getting the answers I expected. Both she and Dr. Geissing seemed mystified about what had happened to Charlie, and they'd been relatively convincing; still I wouldn't stake my life on their truthfulness because neither had been completely forthcoming. I wasn't eliminating either of them from my list of possible suspects. Nevertheless, I was no further along in my investigation than I'd been when I started out this morning.

Suddenly, I couldn't wait for Ted to get here. I needed to plug into his brain. And I was looking forward to other nice things that his being here would make available to me. I shrugged into my jacket and picked up my hat. It had defrosted, but was still soggy. My face mask was soaked through. I put the hat on, but I shoved the mask into my pocket. As I did, my hand touched something soft. I pulled out a square green wool scarf that I remembered borrowing from Allie last winter when I was shoveling the front walk. Congratulating myself on always being prepared, I made a triangle and wrapped it around my nose and mouth.

Steve had strolled over and was placing the check on the table when I looked up and saw him staring at me.

"Something wrong?" I asked.

"That guy who was killed on the lift last night," he said. "They said he was strangled with a scarf."

"Not like this," I replied without thinking. "That one was long and cashmere. And it was blue."

I picked up the check and made for the cashier, leaving a very puzzled young man scratching his head, wondering, I was sure, how the professor from the University of Vermont who'd claimed not to know a thing about yesterday's tragedy on the mountain, had known so much about the shape and color of the murder weapon.

Chapter Ten

WHEN TED ARRIVED at four, I was alone in the condo. Nadine had decided that the only cure for her attack of nerves was a shopping spree, and the only place available for that was the ski shop. After hours of listening to her rant on about the unfairness of our being held in this godforsaken ice prison, the cure for my nerves was having Nadine anywhere but here. I talked up the fashions in the ski shop and breathed a sigh of relief when she decided that she just had to have a pair of horsehair after-ski boots. That wasn't the only reason I wanted her gone. I wanted Ted to myself for a couple of hours.

I heard him open the outer door and take the steps two at a time. I would never admit this even to Meg, and my instinct for self-preservation cautions me not to let Ted in on it, but often, when he's had to work late, I find myself listening for his footsteps on the stairs. When I hear them my heart rate accelerates to a dangerous level,

and my entire body sort of liquefies. That's partly because the physical aspect of our relationship just seems to get better and better, something that, in my marriage, seemed to work in reverse. Like too many women, instead of asking my husband what was happening to us, I accepted that after a certain amount of time there are no surprises. But something did change dramatically at the end, and the sporadic lovemaking began to feel like rape. I know now that was because Rich was somewhere else in his head, and love was no longer part of the equation.

Ted isn't as good-looking as Rich. He's not anyone my teenage daughter's friends would swoon over. He's tall and lean with a serious demeanor and Lincolnesque features, things that when I first met him I'd found intimidating. Of course, the circumstances of our introduction weren't what you would call ideal in that he suspected me of being another Lady Macbeth. Two years down the line he gets my vote for sexiest man on the planet. It's nothing tangible; it has to do with what's the real erogenous zone for many women, our brains. It's obvious that Ted likes women, something I've figured out that Rich, despite his womanizing, probably doesn't. Ted can arouse me with a look or a joke—his sense of humor is probably what gets him through the worst parts of his job. Hearing him in the shower trumpeting "There is Nothin' Like a Dame" off-key makes me want to race in there and give him something to yodel about. Which I sometimes do.

But the heart rate acceleration goes deeper. Ted *gladdens* my heart. I hear those footsteps and I can feel something deep inside opening up, letting go as if an internal band binding my chest were being released. Scares the hell out of me. Not sensible for someone who, after an agonizing divorce, had determined never to allow herself to be vulnerable again. Ted, with some help from Meg, pushed me till he wore down my defenses and zapped away the self-imposed blinders I'd been wearing so that I could finally see the difference in the worth of these two men. He made me understand that there are some risks you have to take or you might as well turn in your joie-de-vivre license.

Ted's a homicide cop. He rarely talks about what he does but I

know what he faces in his job, and I fought hard to keep from needing him in my life because I simply could not deal with the possibility of another loss. I still can't, but when he forced me to face losing him through distancing myself, I capitulated and he moved in. We've been living together for almost a year now and we're making it.

Truthfully, I'm loving it. He gets along great with my kids most of the time, and with my friends, my wonderful proverb-quoting father and even my father's looney-tunes wife, Eve, who thank God, lives up in Worcester, Massachusetts. Horty adores him and he's ingratiated himself with the cats by sneakily rubbing all those places cats love to have massaged. Rich has made grumbling noises about my having a live-in lover but he hasn't taken it any further.

My major problem is me—keeping things in perspective. There's a conventional part to Ted that would like us to legitimize the whole thing, and there's a part of me that wants to throw caution to the winds and walk down that aisle. But the practical side keeps warning me to leave things as they are. "If it ain't broke, don't fix it," is one of my dad's favorite axioms and it works for me. Ted's been okay about putting up with my split personality, and we've reached a point where we only get into hassles when one or the other of us gets involved in a situation that shoots our stress levels into the stratosphere beyond the help of all my biofeedback expertise. Such as a murder investigation into which I've insinuated myself.

Standing in the doorway, he was the best thing I'd seen in days.

"Christ," he said, dropping his duffel and wrapping his arms around me in a bear hug. "You guys really used to come up to this frozen tundra for pleasure?"

I rubbed my cheek against his frosty one and planted a lingering kiss on it. "You're not dressed for it, and it's not always like this. It was beautiful earlier in the week. How was the trip?"

"Black ice from Vergennes on. Slid all over the damned road." He pulled off his boots and shed his jacket. "And I had to talk my way past the roadblock they've set up at the gate. So I'm giving you fair warning, I'm tired and grouchy and need lots of TLC."

"I stopped at the country store and I've got hot buttered rum in the kitchen. It'll cure all your ills."

He grabbed me as I passed. "You're the cure for all my ills. Where's your roommate?" His mouth came down hard on mine and it took me a minute to remember where she was or even who she was.

"At the ski shop," I murmured after some time. "Due back any minute."

He released me. "Shit."

I smiled seductively. "She probably has plans for the evening. She likes to party."

He grinned. "Are you suggesting—"

I smacked him on the shoulder. "I am not. She parties with a crowd. I like mine one-on-one."

"Well, if you insist." His hand rumpled my hair. "Right now, that buttered rum sounds real good."

"If they hadn't let you in, you could've used your skis and schussed over from Stowe," I jokingly called from the kitchenette.

"You mean the same way your killer probably schussed out?"

His words stopped my hand as I was sprinkling cinnamon into his buttered rum. Some detective I am. That hadn't even occurred to me. I'd been focused on the Freundlich contingent and they were all present and accounted for. If an outsider, an experienced skier, were familiar with the trails, it would've been possible to ski all the way to Stowe. If that were the case, I couldn't imagine how he would ever be found. I took a deep breath, filled a mug with the steaming brew, brought it into the living room, and handed it to Ted, who was standing by the terrace doors looking out over the mountain.

"Awesome view," he said.

"Spoiled forever for me," I replied, pulling the drapes closed. "You're talking about a hired gun, aren't you?"

"One possibility."

"I just never thought of it. I've been so certain this was all tied up with Dr. Freundlich's research."

"You may be right."

"But there wouldn't be a trace of the killer. The sleet will have washed away the tracks."

"True, but it's all about motive. A hired gun has to be hired by

someone. Who wanted the guy dead and why? Was it revenge? Money? Or did somebody want to shut him up permanently?"

"I told you what he said when he was drunk."

"Okay. Who benefits from his silence?"

"I was hoping you'd have some ideas." I brought him up to date on the cast of characters and my conversations with Dr. Geissing and Kate, and was in the middle of describing Nadine's peculiar behavior after the party when he stopped me.

"Roofies," he said.

"What?"

"Rohypnol. The date rapist's biofeedback. Sounds like your roommate may have been given a treatment for her migraine that relaxed her, all right, but not in the way you'd do it. And it'd account for the temporary amnesia."

I was stunned. "But that doesn't make sense. These aren't crazy college kids. They're highly intelligent consenting adults."

"Take it from me, highly intelligent adults take drugs, have sexual hang-ups, and sometimes even commit murder."

"But I don't think Freundlich would've had to drug Nadine to have sex with her. Of course, she says she doesn't fool around with married men and Kate swears he's as faithful as Lassie but—"

"Why're you so sure it was Freundlich who raped Nadine?"

"Because I heard the verbal foreplay. And he can't keep his hands off women."

"How do you know that?" He caught the expression on my face. "Don't tell me. Personal experience?"

"Actually—"

"Shit, am I going to have to kill the guy?"

My laugh had a nervous edge. "Don't worry. I grabbed his hand before it reached its objective." Briefly, I described the encounter in the hot tub. I tried to make it sound funny but Ted wasn't amused. I figured I'd get all the bad news out at once so I filled him in on my scarf as the murder weapon and Joe's position, somewhere near the top, on the suspect list.

Talk about pregnant pauses.

"So what do you think?"

He knocked off the cider in two gulps. "You asking me that seriously?"

I glowered at him. Was he blaming me for any of this? "Of course."

He caught my expression. "I think—I think that my life would be boring as hell without you."

"Yeah?" I said belligerently. "How's that?"

He set his mug down on the table, pulled me to him, and started nuzzling the place just behind my ear that makes me crazy.

"I think, the hell with your roommate. There's a lock on your door, isn't there?"

There was, and I was hard pressed to put an end to that nice stuff he was doing to my ear and then my neck, but there are times when the record has to be set straight even if it means ignoring the cavernous longing. At least, for the time being. I put my hands against his chest and pushed him away.

"I didn't have anything to do with any of this, you know. It just happened that I—"

"I know." He pulled me back and there was something that definitely wasn't his gun jabbing me just south of my stomach. I'm a lot shorter than Ted is so I often get jabbed where Nature didn't intend. I gave in, pulled out his shirt, unsnapped his jeans, and reached down intending to reposition things when I heard the outer door open and footsteps come up the stairs. I jumped back. "That's Nadine."

Ted groaned. "Point me toward your bedroom or you're going to be very embarrassed."

He got there just before Nadine, her arms full of shopping bags, pushed open the door.

"Hi," she said, dropping the bags onto the boot bench. "I've bought out the store."

Which turned out to be close to the truth. She told me the sales manager was so thrilled with the bill she ran up, she gave her a ten percent discount. For the next twenty minutes I was treated to a

fashion show, which I politely went along with despite my frustration level, which rose with the opening of every bag.

"I gather you're doing better in your practice than I am," I commented, thinking I really needed to find the time to work on my doctorate. I'd be able to double my fees.

I viewed the vast array of ski paraphernalia. Along with the horsehair boots there was an extremely chic, if not very warm-looking, one-piece black-and-white ski suit, a matching ski sweater, a Snowridge-logoed sweatshirt, a furry hat, two turtle-necked cotton shirts, and a pair of Grandoe down mittens. The boots alone would have used up half my monthly food budget.

"You have kids," she replied, when I mentioned that. She gathered up her loot. "I only have myself to worry about."

Just then my bedroom door opened and Ted, freshly showered, sporting a red-and-blue ski sweater over a navy turtleneck, and looking to my biased eyes, dashing as hell, strode into the living room.

"Here I am, all dressed for the Iditarod," he said to me. Then to Nadine, "Hi. I'm Ted, Carrie's friend. You must be Nadine." He grinned. "I'd offer to shake hands but this doesn't seem a good time."

When confronted with an attractive male Nadine goes into automatic come-hither mode. It's deeply ingrained. I don't think she's even aware of it. Dumping the packages onto the nearest chair she gave him the full hair-toss, Marilyn Monroe Happy-birthday-Mr.-President treatment, and held out her hand. "I never pass up a chance to hold hands with a handsome, sexy man," she said throatily.

I don't know what came over me. With the speed of a diving seabird, I grabbed Ted's hand before she was able to make contact. "You can pass up *this* chance," I said. "He's off-limits."

Ted's amused gaze flicked over to me. In my description of Nadine I'd neglected to mention that she was a predator, but I think he got the picture because he'd never seen me so obviously marking my territory. Granted, I'd refrained from peeing on him, but Nadine backed off as if afraid that was my next step. I'm fairly certain Ted was getting a huge kick out of the situation but he stepped in to ease

the tension. Gently extracting his hand from my death grip he put his arm around me and pulled me close.

"She's small but she's tough," he joked, winking at Nadine. "I keep my pistol under lock and key."

There's a reason I love this man.

Nadine laughed and gathered up her packages again. "You'd better keep *all* your valuables under lock and key."

Damn straight. I felt good. I may have been stupidly naïve where Rich was concerned, but I'm learning to claim what's mine. Having made my point I relaxed and offered to help her with the packages. She declined, and disappeared into her room closing the door behind her.

"Well," Ted said, his eyes twinkling. "I'm overwhelmed. I'm a handsome, sexy man and women fight over my bod."

"Get over yourself. Nadine will jump anything between thirty and sixty who's ringless and wearing pants. And I'm not a hundred percent sure about the ringless part."

"Well, just to be safe, you'd better get one on my finger."

I ignored that and sat on the couch, patting the seat indicating he should join me. "You think she's attractive?"

"Compared to?"

"No one in particular," I said breezily. "Just how would you rate her?"

"Well, I guess she's maybe a six or seven. 'Course, I haven't seen her stripped down to her thong. She could be an eight."

"Yeah?"

"Yeah, what?"

"What am I?"

"I thought we weren't comparing."

"Now we are," I said.

"Oh. Okay. Well, let's see." He turned to me, tilted my face toward him as if assessing my features, then ran his hands over my breasts and down my body. "Mmm, you I've seen stripped down," he said, as his tongue snaked from my collarbone downward. "A ten. Definitely a ten."

"You are a very smart man," I gasped, "but you'd better stop what you're doing before we have an audience."

"I don't care. I'm a handsome, sexy, smart man who's been celibate for four days. Let Nadine get her own."

"Ted!" I gave a whispered shriek, and grabbed the hand that was intent on unsnapping my bra. "Stop! That door's going to open any second."

Which it did. Ted dropped to his knees making a great show of searching under the couch for something. "I don't see it, honey," he said, his muffled voice choked with suppressed laughter.

My face felt hot. "Oh, here it is," I said, clutching my ear. "It was on my ear all the time."

Nadine's expression said, *Oh, f'chrissake, who do you think you're kidding?* but she went along with it, which was diplomatic considering that I wasn't wearing earrings. She directed her remarks to Ted's emerging rear end. "Sorry to bust in on you, but when you mentioned your pistol I remembered Carrie telling me you're a cop, and I heard something today I think you might be interested in."

Ted got to his feet. "I'm not a cop this week. I'm on vacation."

Nadine looked puzzled. "But Carrie told you about the murder and everything that's happened here, didn't she?"

"I think I'm pretty much up to date."

"Aren't you interested in solving it?"

Ted flashed me an exasperated look. "It's out of my jurisdiction," he said. "My only interest in this case is making sure Carrie stays out of it."

"But what I heard this afternoon could be important."

"Talk to the cops who caught the case."

"I don't want to talk to them. That female detective's obnoxious."

Ted's voice lost its bantering tone. "I don't have access to the information they have, Nadine," he said, sitting down beside me. "Telling me won't accomplish anything. Besides, if you told me something relevant to the murder I'd have to inform them and they'd want to talk to you anyway."

Nadine shrugged. "Okay, if you're not interested."

I sat up straight. "I'm interested."

"Carrie." Ted's voice held a warning note.

"Look, if Nadine doesn't want to tell Patrick and Mayer, I'll tell them it was me heard whatever it is."

Ted frowned. "That would constitute lying to the police. Not a great way to go if you don't want even more suspicion brought on your head."

"I'm not under suspicion."

"Your scarf may have been the murder weapon. Like it or not, you're under suspicion as a possible conspirator."

"That's ridiculous. I was nowhere near the lift."

"I'm telling you how Homicide will look at it. No one who's had any connection with the victim is ruled out at this stage of an investigation."

"Okay, forget it," Nadine said. "I don't want to be the cause of an argument between lovers." She got up and headed for the kitchen. "I could use a drink. Is that buttered rum I smell?"

"It's on the stove." I turned to Ted, my eyes pleading. "She's not going to tell them what she knows. What if it's something that could help Joe? He *is* under suspicion."

Ted threw up his hands. "Okay, I'll listen. But understand, I'm not taking any vows of silence."

"Nadine," I called. "Ted's agreed to listen."

Nadine peered out through the partition. "You swear my name won't come up?"

"I swear," I said.

Ted remained silent but I figured Nadine assumed my swearing took in us both, because she came back into the living room clutching her mug of buttered rum. She grabbed one of the dining table chairs, positioned it between us, and sat.

"When I was in the ski shop," she began, "the sales clerks were all talking about the murder, and one of them mentioned she has a friend who works in a ski shop in Burlington."

She paused for dramatic effect.

"Yeah," I said impatiently. "Go on."

"The friend thinks she sold the red jackets that the killer and Charlie wore!"

"The instructor's jackets?"

"They didn't have the Snowridge logo. But they were red, and from a distance nobody could tell the difference, especially because they were wearing black ski pants."

"She must sell lots of red jackets," Ted commented. "What made her think those were the ones the killer and Anders wore?"

"She didn't make the connection until her friend, this clerk in the ski shop here, told her what had happened. Then she started thinking about how most people want to try on the skiwear before they buy because different manufacturers size differently. So it struck her as odd."

"What did?"

"That a kid who looked like he didn't have two cents to rub together bought these without asking to try on either one. And he paid cash," Nadine added.

"Did she remember what the sizes of the jackets were?" Ted asked.

"Both men's large, and the kid wasn't more than a small."

"If those were the same jackets," I said to Ted, "that tells us that the murderer was a man about the same size as Charlie, right?"

"Not necessarily." He shifted his gaze to Nadine. "But it's also information that I'm sure the detectives on the case already have, so you don't have to worry about being dragged into it. Believe me, they'll have grilled that salesgirl's friend by now. They have Anders's jacket, so they'll have checked out where and when it was purchased. Assuming the jackets were bought at that Burlington shop, you can bet the cops are tracking down this kid, and they'll find him. Probably a local kid someone paid to buy the stuff."

"Oh," I said, disappointed. Nadine started to say something, but I caught the contemplative expression on Ted's face and motioned her to silence. It was an expression I've seen before—his I-wonder-if-this-piece-will-fit face. I waited.

"It brings up an interesting point, though," he said after a moment.

"What's that?"

"Why the perp chose to commit the murder in such a public way. Whoever it was took a huge gamble."

"Yeah, that's bothered me, too," I said. "Why not find a way to get Charlie alone and do it where there aren't any witnesses?"

"Maybe," Nadine said, "it was somebody Charlie wouldn't have gone with. Maybe the killer couldn't get him alone."

Ted raised his eyebrows. "He got Charlie to wear a jacket that wasn't his and convinced him to ski in the torchlight parade."

"Which is another funny thing," I put in. "Because Kate said Charlie hated the cold and he wasn't a good skier."

"And yet," Ted said, "the killer got him to go on the lift and strangled him at an event that almost everyone at the convention would see."

"That's crazy. Why would he do that?"

"I would guess," Ted said, "that he was sending a message."

"To whom?"

"To whoever else might know something about what Charlie knew."

Nadine's face went a shade paler. "Then—then that would mean there could be other people who're in danger."

"Unless they got the message."

"Which was what?" I asked.

"See no evil, hear no evil, and make goddamned sure you *speak* no evil. If, that is, you want to stay alive."

Ted's words sent a chill straight through me. Nadine must've felt the same because she took a huge gulp of her buttered rum, and her hand was shaking when she put the glass down on the coffee table.

"Did either of you see the instructors get on the lift?" Ted asked.

"I wasn't close enough to recognize anyone," I replied.

"I wasn't paying attention until the lift started moving," Nadine said.

"Would you have noticed if Anders wasn't sitting up straight when the lift started up?"

"I don't think so. Why?"

"It seems to me, unless Kate Donovan was lying about Anders's

skiing expertise, the only way the killer could have gotten him on that lift would have been to drug him."

"Or get him drunk," Nadine whispered. "Which he was. That's why he and Joe got into the fight."

"And that's how he got him to change jackets," I said, my excitement mounting.

"What do you mean?"

"He and Joe were rolling around in the snow. They got soaked. Joe told me he had to go back to his condo and change, and Charlie must've done the same. I'll bet whoever killed Charlie offered to lend him dry clothes. Which proves he knew his killer."

"You mean," Ted said slowly, "that both Anders and Joe Golden left some time before the parade started? And Anders was already crocked?"

"Yes."

"Not falling-down or anything," Nadine said. "But you could tell he'd had too much."

"But that's when the killer must've gotten him to change into the look-alike instructor's outfit," I said.

"The murder was premeditated," Ted said. "How could the killer have known Joe and Charlie would get into a fight and roll around in the snow and get their clothes wet?"

My balloon deflated. "He couldn't have," I said. "I guess that blows that theory."

"Not completely," Ted said. "But it does put a whole new complexion on it regarding your theory about motive."

"What do you mean?"

"There was one person who could've known for sure that Charlie Anders and Joe were going to get into a fight."

"Who was that?"

"The guy who threw the first punch."

Joe.

Chapter Eleven

I SPENT MOST of dinner trying to punch holes in that hypothesis. Joe wasn't a killer, he was a healer, and he had no motive to kill Charlie, I told Ted. And he hadn't known any of the Freundlich contingent before this week.

"The fight was one of those stupid male things, right Nadine? Charlie said something gross and Joe got upset."

"I didn't hear what Charlie said," Nadine replied, "but Joe sure went ballistic."

"Whatever it was it was hardly a motive for murder," I said. "And Joe feels awful about it."

Ted listened, but I could tell his cop mind was keeping all options open.

I'd called Joe before we left, hoping he'd join us because I was certain if Ted talked with him, he'd be as convinced as I was of his innocence. But there'd been no answer at Joe's condo unit. That

worried me. I figured he'd probably gone out for a bite to eat. He couldn't exist forever on vodka and Mallomars, but I didn't think it was a great idea for him to be wandering around talking to strangers in his present state of mind. Still, Joe was a smart guy. He'd have sense enough to keep his mouth shut about where he'd been when the murder took place.

We wanted to avoid the press who were camped outside the resort, so we had dinner at the only other restaurant on the premises besides The Cove, The Swiss Chalet. Not a terribly original name but it made a lot more sense than The Boat Shack, because all the servers were appropriately costumed, the strolling musicians wore lederhosen even though not all of them had the legs for it, and the menu offered plump sausages, schnitzels, and a variety of enticing fondues. The atmosphere was on the hokey side, but the food was good, and it was a big plus for me that it was a place I hadn't been with Charlie. I don't think I'd've been able to swallow even one bite of pizza at The Boat Shack. I didn't see many people from the conference either, so I figured most of them were eating at The Cove.

After we were seated and had ordered, Nadine got up and greeted a couple of fellow conferees, sisters whom she'd met, she later told us, at the party Friday night. They were psychologists, stern-looking, well up in their sixties, and neither woman struck me as anyone Nadine would connect with except on a professional level. I was right. She was back at our table in less than two minutes.

"They don't seem your type," I told her.

"What type is that?"

"You know. Party animals."

"They just came to the party because they wanted to rub elbows with The Man and ask him some questions. They left when things got jumping."

We shared three of the most popular fondues: cheese, beef, and a bubbling ambrosial chocolate for dessert. We were scooping the last vestiges of the warm fudgy sauce onto little rectangles of sponge cake when Dr. Freundlich walked in, followed by Gerta and Kate, with Scarborough bringing up the rear. There was a stir in the room as Freundlich was recognized and it wasn't only by the few biofeed-

back people who were there. His fame, or notoriety as a result of Charlie's murder, was spreading. As they approached our table I noticed that Kate wasn't limping. I suddenly realized that she hadn't been limping this morning either when she'd dashed out of the restaurant. Hadn't Nadine said that last night Kate had twisted her ankle? Either Kate was an extraordinarily fast healer or she'd been faking it.

The group passed us with barely a nod as they were led to a table by the roaring fire. I thought Scarborough's gaze slid our way for an instant, but he needed to take two steps to every one of Freundlich's so he hurried on without a word. I could understand how Freundlich might not remember *me*. But Nadine? Nadine with whom he'd had sex the night before last? Nadine who felt free to call him *Hubie*, for God's sake?

Nadine had half risen to her feet, a smile at the ready, but she sank back as the entourage passed.

"Well, for shit sake, how d'you like that?" she snapped.

"He's with his wife, Nadine," I said. I had to make an effort to keep my tone civil. Infidelity pisses me off. I take it personally. Much as I blame the cheating husbands, I can't help thinking that if the Nadine Claughtons of the world weren't so eager to jump into the sacks of married men, there'd be nobody for the assholes to cheat with. They'd be reduced to humping goats. Then again, I shouldn't be so hard on Nadine. Recalling Ted's words about Roofies, I thought she probably hadn't been a willing participant. At least on this occasion.

"What's the matter?" Ted inquired.

"That's Dr. Freundlich and his wife, Gerta, with Kate Donovan," I said.

"They mustn't've seen us," Nadine said. "They're probably still in shock."

"Maybe your amnesia was catching," I said to Nadine. "Maybe everyone at that party was on something." It seemed a good time to bring it up. I gave Ted's leg a gentle nudge under the table.

"You remember taking anything for your migraine at the party,

Nadine?" he asked, picking up his cue. "Did Dr. Freundlich give you a pain pill or a muscle relaxant?"

Her attention was focused on the group by the fireplace. "No," she said absently. "He did his thing with the magnets and the EEG and the headache disappeared like magic."

"How long did that take?"

"I don't remember. I was in a semihypnotic state. It's like doing alpha/theta. You lose all sense of time. Excuse me," she said, getting to her feet. "I have to tell them how sorry I am about Charlie."

She was already in Stage Two of denial, I thought. It won't be long before she convinces herself that nothing happened at that party. I twisted around in my chair and watched her cross the room to Freundlich's table. The two men half rose, then sat back down. Nadine pulled up a chair from a nearby empty table.

"Who's the ugly little guy with the boxer's face?"

"Paul Scarborough. Freundlich's right-hand man, the unsung hero who takes care of all the details."

I could see only Nadine's back but I saw her animated gesticulating. Freundlich nodded and patted her arm, and Gerta put an arm around Kate.

"God," I exclaimed in frustration. "I wish I were a fly on that fireplace."

Ted grinned. "You'd burn your wings. Stop staring."

Reluctantly, I did. "You've got a better view," I whispered. "Switch seats with me."

"You really want to be that obvious?"

"I'm worried about Nadine."

"Why? She looks to me like a lady who can take care of herself."

"Well, you're wrong."

"How's that?"

"Look what happened to her the other night. She's hung up on power. On powerful men, I mean."

"I thought you said she's hung up on men in general."

"That, too, but she prefers them rich and famous."

He gave an exaggerated sigh. "I guess that lets me out."

"I'm telling you, if it wasn't Freundlich, it'd be the CEO of some big company or some damned politician," I said. "She was raped at that party, and she's not dealing with it."

"Well, I don't think he's going to jump her right here in the restaurant with his wife sitting next to him, but if you want, we can go over and baby-sit her. You can express your condolences. You probably should anyway."

"I already have, to Kate, and I'm sure Nadine's expressed enough condolences for both of us."

"If you don't want to talk about Charlie Anders, why don't you suggest they try one of the fondues? Or, you could ruin Gerty's dinner by telling her that her husband was trying to make out with you in the hot tub."

I could see that still rankled. I changed the subject. "Did you notice Kate isn't limping?" I said. "She's walking just fine."

"Well, maybe he hasn't had his way with her today."

I rolled my eyes. "That's not the point I'm making. Nadine told me that before the parade, Dr. Geissing took Kate to the first-aid station to get an Ace bandage for her twisted ankle. And yet today she's perfectly okay. What do you make of that?"

"Not much. The Ace probably did the job. How long before the parade did they leave?"

"I'm not sure."

He tossed his napkin onto the table and signaled to the waiter. "What say we blow this place? I'd like to take a walk and scope out the lift area."

I glanced over at Nadine. "I'd better see if Nadine's ready to go."

I grabbed my jacket off the back of my chair and started for Freundlich's table. As I passed Nadine's psychologist acquaintances from Friday night's party, one of them reached out and touched my arm. Her thin face emphasized a longish nose and piercing gray-blue eyes that peered up at me from behind metal-rimmed bifocals.

"Excuse me," she said. "Could we speak to you for a minute?"

Surprised, I stopped. "Yes?"

"I'm Teresa Romano and this is my sister, Joanna. We haven't met, but we were just talking to Dr. Claughton, and she told us that you and she were rooming together."

"That's right."

"She mentioned that the gentleman at the table with you is a policeman."

I was going to tape Nadine's mouth shut when we got back to the condo.

"His jurisdiction is Bergen County, New Jersey," I replied. "He just came up here to ski."

"But if you told him something, if say, you'd learned someone had a—a theory that would help the police solve this crime, he could tell them and they'd listen to him, wouldn't they?"

Everybody's a detective. I almost groaned out loud.

"I don't know. I don't mean to be rude, Dr. Romano, but if you know something that would help the police you really should contact them yourselves." I started to move on.

She caught my hand. "Please wait. We've thought about telling the police, but they said we could leave tomorrow, and we both have practices to get back to. And we didn't think they'd pay attention to us anyway."

I glanced over at Ted. He was busy paying the bill, so I snagged a chair from the next table and straddled it. "What's this about?"

The women exchanged glances.

"We overheard something we weren't supposed to."

"When was this?

"Saturday morning."

Joanna Romano, a younger, plumper version of her sister, leaned forward and spoke in an excited whisper. "It was before the award ceremony. We got to the center early because we wanted to get seats up front. There wasn't anybody there yet, so we were wandering around looking at the displays when we overheard Dr. Zimmer talking to someone."

Teresa jumped in. "She was bragging about how she was going to annihilate Dr. Freundlich."

"Nothing new about that," I said. "She's been doing that since she got here."

"Yes, but then she said if all else failed she'd found out something, a way to finish him off for good. And then this other person got angry and said she was treading on quicksand, and she should think about how destroying Dr. Freundlich was becoming a dangerous obsession with her."

"So," chimed in Joanna, "we think the police should be informed that Dr. Zimmer was heard threatening—"

"Wait a minute," I interrupted, incredulous. "Your theory is that Flo Zimmer killed Charlie Anders?"

"She had a motive."

"To kill Charlie? Whatever for?"

"To hurt Dr. Freundlich."

"It was revenge," Teresa said. "Because Dr. Freundlich had made such a fool of her."

"And just look at the way she's built," added Joanna. "I'll bet she does mud-wrestling on the side."

"But then why not do Dr. Freundlich in?"

"Don't you see?" Teresa regarded me impatiently. "That would be too obvious. She would come under suspicion immediately. No, she figured out a way to stop him without killing him."

God give me strength. "And killing Charlie would stop Dr. Freundlich how?"

"By taking out the brains of the organization."

Charlie, the brains of the organization. A theory about as full of holes as the Swiss cheese in our fondue.

"Well," I said, "as obnoxious as Dr. Zimmer is, I don't see that as a real motive. Charlie was bright, and an important assistant to Dr. Freundlich, but I don't think he was essential to the research. As a matter of fact he was out of the loop for the past month or two, and according to Charlie himself, he'd already been replaced."

I rose, anxious to get away from these well-meaning pseudo–Jessica Fletchers. I could see the crestfallen expressions on their faces so I added, "But thank you. I'll ask my friend to pass on the

information." As I turned to leave, I said, "By the way, who was Dr. Zimmer arguing with?"

"We didn't see him," replied Joanna. "They were on stage behind the curtain. But his voice sounded familiar."

"Who do you think it was?"

"It was someone who was at that party Friday night," Teresa chimed in. "I think it may've been Dr. Geissing."

Chapter Twelve

"NOT AS FAR OUT as you might think," Ted remarked after I'd told him what the sisters had said. "Revenge is a powerful motive, and Zimmer was humiliated."

"What? If I came up with a half-baked theory like that you'd make me turn in my Dick Tracy badge."

"People have murdered for less."

"But they've murdered the humiliator, not his on-the-way-out assistant."

He grinned. "Usually."

We were standing at the foot of the lift, gazing up at the small wooden shack that marked the mid-station. The night was crystal clear, the storm having worn itself out or moved on to spend its fury on some other hapless skiers. But the frigid temperatures remained. Against the moonlit backdrop of shimmering pines, the motionless lift-chairs stood out like battery-dead robots, a reminder that like a

book, you should never judge a Currier & Ives greeting card by its peaceful facade.

Nadine had refused the invitation to join us, preferring to stay and bask in Freundlich's reflected glory, or whatever remained of it. Despite my desire to be alone with Ted, I did try to persuade her to come with us, because I thought she should stay as far away from him as possible. To no avail.

"How long does it take to get from the mid-station to the top of the mountain?" Ted asked me.

"About twenty minutes."

"Does the lift always go at the same speed?"

"Pretty much."

"And it doesn't stop in between?"

"Not unless somebody's falling off, which wouldn't've been the case that night, because the attendant thought only the instructors were riding."

"Was there only the one attendant at the base?"

"Yes, because everyone was supposed to get off at the mid-station. During the day, they have attendants at the mid-station and at the top as well."

"Would the lift attendant have increased the speed afterward, assuming that no one was on it?"

"I don't know," I said. "But we can find out who it was and ask him. Wouldn't you think Charlie would've put up a fight, though? He was a big guy."

"He was taken by surprise, and if he was half out of it as we've assumed, he was an easy mark. It'll be interesting to see what the autopsy produces."

"You don't think he died by strangulation then?"

"Maybe, maybe not. Maybe in addition to."

"What do you mean?"

"I've been thinking more and more about Nadine and the possibility that somebody slipped her a Roofie. Roofies and alcohol can be a devastating combination. If the killer did the same thing to Charlie, who was already intoxicated when he went back to change..."

"But how would he have gotten him on the lift? Wouldn't Charlie have passed out?"

"Whoever did this had a twenty- or thirty-minute window before that would've happened."

Oh, that Brodsky brain! I was jumping up and down with excitement. Also because my blood had quit flowing down to my feet. "Then what you're saying is Charlie could've died of—"

"Respiratory depression. Yeah. The scarf may've been tied around his neck and attached to the safety bar for dramatic effect. To scare the shit out of anyone else who might be thinking about shooting off his mouth."

"Which fits right in with your theory that the killer was sending a message," I said. "Which means other people know what Charlie knew."

"Or the killer suspects they might."

"Can you tell anything by studying the crime scene?"

"Only that whoever did it isn't stupid. There's no way to get DNA evidence in this environment. Both the perp and the victim were wearing gloves, their heads were covered with ski hats so the only hair to be examined would be Anders's. His ski outfit was new so there's no residual evidence. Only one person might've left DNA evidence."

"Who?"

"You. On your scarf."

The words were out before I thought. "Joe had the scarf in his jacket pocket."

"Oh, right. That makes two of you."

I was sorry I'd mentioned Joe. I decided to change the subject. "I'm freezing to death. Let's go back."

"I'd like to meet Dr. Zimmer."

"No you wouldn't. The woman's a horror. She looks like one of those plankton-eating whales that always have their mouths open."

"How can I resist that picture? Now I definitely have to meet her."

"I thought we'd just decided this murder was about covering something up. It wasn't about revenge."

"But," said Ted, "aren't you curious to find out what she knew that she thought could bring Freundlich down?"

"I would be if I thought we could believe her, but everything out of her mouth is spin. Anyway, I thought you didn't want to get involved."

"You were a witness to a murder and your scarf was possibly the murder weapon, which means you're involved, and your good friend Joe's involved. How can I avoid getting involved?"

He started back down the slope. I had to take huge steps to fit my footsteps into his larger prints.

"You have a handout that lists where everyone's staying, right?" he called over his shoulder.

"Yeah. Why?"

"So we can see which condo she's in and pay her a friendly visit."

"She'll throw us out. I can't believe you're buying into that crazy theory."

"I'm not buying into anything," he shouted into the wind. "I just can't resist the chance to meet a woman who looks like a whale."

By now I was panting and having difficulty keeping up. "Hey, slow down. I want to ask you something."

He stopped and waited till I'd caught up to him.

"I have a suggestion you won't be able to resist," I said. "*And* we can kill two birds with one stone because I happen to know which unit she's in."

"I'm listening."

"Let's pick up our bathing suits and take a dip in the hot tub. It's late enough so there probably won't be anybody there."

"Now that's tempting."

I stood on my toes and planted an icy kiss on his cheek. "We can fool around, then go see the wicked witch afterward because she's staying in a studio in Innsbruck."

"Whatever happened to your water phobia?"

"I guess I'm making progress," I said mischievously. "Ever since my encounter with Dr. Freundlich, I seem to associate hot tubs with sex."

He made a grab for me. I danced out of his reach, and he chased

me, slipping and sliding down the slope all the way back to the condo. We arrived minutes later covered with snow, giggling and shushing each other like a couple of college kids on spring break. Ted had my jacket unzipped and half off before I'd gotten the key in the lock.

"Wait," I gasped. "I thought we were going to have an orgy in the hot tub."

"Before, during, after," he said, pushing me inside and kicking the door shut. He pinned me against the wall, arms over my head, and pulled off my sweater. "You're going to need those massage jets when I get finished with you."

"Oh, yeah?" I said. Regaining possession of my arms, I unsnapped his pants, and yanked them down. "Well, let me tell you something, Buster. When I get finished with *you*, you'll be walking on your knees!"

We never made it to the hot tub. We were in the shower and Ted was drawing soap circles around my breasts sending electric shocks all through me, when my cell phone rang.

"Let it ring," he said.

"It might be the kids. I think I left my cell on the couch." Reluctantly I wriggled out of his grasp and dashed, naked and dripping wet, into the living room. He followed with a couple of towels, wrapped one around me and the other around his waist, while he licked the rivulets of water off my neck.

I picked up on the fifth ring. "Hello?" I giggled.

"Carrie?"

"Rich?" I sobered up fast. "What's the matter? Why're you calling?"

"You sound out of breath." His tone had that sarcastic edge he gets when he's decided to stick it to me.

"I was in the shower. Are the kids okay?"

"What do you think?"

"What?"

"They're disappointed as hell. I called the house to tell them

to have fun at Snowridge and Meg told me about your little adventure."

"I'm not having an adventure, Rich."

"I hear your boyfriend's joined you. Nice work, making it so you could get a few days away together without the kids."

Rich left *me* for his young marketing director but he hasn't quite made his peace with my having another man in my life. I could feel my blood pressure rising at the unfairness of the accusation.

"That would be something you might arrange, you hypocritical SOB," I snapped. "Don't attribute your devious motives to me."

"Yeah, well you sounded pretty happy when you answered the phone just now. Not like somebody who's being held as a material witness to a crime. 'Course, I suppose by now you're used to that."

I heard sniggering in the background. I gritted my teeth and dug what was left of my nails on my right hand into the palm of my left. Relax, I told myself, calming myself with biofeedback "self-talk." You can handle this. This is not a life-threatening situation. I took a deep breath. "What do you want, Rich?"

"Just wanted to let you know I'm saving your ass. Bree and I are gonna pick the kids up tomorrow and take them to Killington so their vacation won't be a total disaster."

Bree? *Bree?*

"Who the hell's Bree? I thought the current was Mandy."

He started to answer but I overrode him. "Oh, I'm sorry. Mandy was before Carol, who was after Suzanne, who was the one after Erica, right? I have a problem keeping them straight. Can Bree vote? Because I wouldn't want the kids to see their father get arrested for statutory rape."

"Funny. You're quite the comedienne, aren't you?"

"I try to keep a sense of humor."

I was furious that he'd set me up to look like the bad guy. But part of me was glad that the kids would have an opportunity to ski, even if they had to share their vacation and their father with a teeny-bopper named for a cheese. The other part wanted them to wait a

day or two in case things quieted down here and they could join us. The eternal internal tug of war that accompanies divorce.

"Hold on a minute." I put the phone down, rolled my head around a couple of times, forced my jaw to unclench and my muscles to let go. Ted raised his eyebrows and mouthed, "What's going on?" I shook my head and picked up the phone.

"I'm back," I said, having regained control of myself.

"So, that okay with you?"

Sweet of him to ask. "Have you already mentioned it to Allie and Matt?"

"Yeah. They're dying to go."

"Then that's it." I wanted to be mature about it but the child in me was sulking. "I'd made arrangements for the kids to fly up here if they open the resort in the next day or two, but if you've already invited them to Killington and they want to go, I won't stand in their way."

"Good." There was a pause. Then in a friendlier tone, "You okay?"

Rich isn't a total bastard. Every so often, I think he remembers that once upon a time we did love each other. Once upon a time, we were best friends and cared what happened to each other and had two wonderful children together and thought how very lucky we were. Every so often I remember it, too, and I soften toward him. Briefly. Because I don't think infidelity is something you ever completely get over. You get past it and go on with your life but you're left with all those hang-ups about trust. Tonight, though, I *was* grateful that the good father in Rich had surfaced and was trying to make up to his children, not just for this disappointment, which wasn't his fault, but for the big one, which was.

"I'm okay," I said.

"You're only a witness to this thing, right? Nobody's gunning for you this time."

I rolled my eyes at Ted. "No, nobody's gunning for me."

"Glad to hear it. I'd hate to have the mother of my children cut down in a hail of bullets."

It crossed my mind that maybe that wasn't quite true, in that the court had awarded me a few more years of alimony, but I shook off the thought as mean-spirited. Whatever else Rich was, he wasn't cheap and I don't think he'd ever wished me dead.

"Thanks a lot," I said, giving him the benefit of the doubt. "Let me know where you'll be staying."

"Will do. Bye."

"Bye."

As I hung up and turned to tell Ted what Rich had said, there was a loud crash, simultaneous with a *rat-tat-tat* sound, and something whizzed past my nose. Before I could react or utter a sound, I found myself knocked flat on the floor with my head pressed into the carpet and a hundred eighty pounds of Ted on top of me.

"Don't move," he hissed. "Stay right there."

He didn't have to tell me twice. I don't think my body would have obeyed a command to move. Unless shaking all over counted. Shaking came naturally. Breathing didn't.

I felt Ted's body ease off me, which helped a lot with the breathing, but the shaking got worse as it began to dawn on me what had happened. I raised my head an inch off the floor and saw Ted dive toward the picture window. The drape was still in place, but it was billowing out as a result of icy wind blowing through several holes in the center. He grabbed a corner and lifted it and I saw huge cracks in the glass radiating down from three holes.

"Oh God, oh God, are those bullet holes?" I gasped.

"What the fuck is this about?" he bellowed, getting to his knees and peering out the window. "Why the hell would someone be shooting at you?"

"At me?" I squeaked, scooting crab-style across the room to where he was and pressing up against him. "Nobody has a reason to shoot at me. I don't know anything. It's a mistake." My heart was whacking against my ribs, the towel was caught around my ankles, and I'd gone ice-cold despite the heat in the room. I reached down and dragged the towel up. "Can you see anything?" I whispered.

"Nothing. Not a soul out there." He dropped the curtain and pulled me closer. "Carrie, what's going on? What haven't you told me?"

"Ted, I swear, I—"

Just then the door opened and Nadine waltzed in. She stopped in the doorway as she caught a glimpse of us lying half-naked on the floor.

"Godalmighty," she drawled. "I thought I was bad. Can't you two wait till you get in the bedroom?"

Chapter Thirteen

I REALLY HATE getting shot at. It'd happened to me once before and I'd thought that was it. Kind of like lightning never striking the same place twice. It's not something you get over easily. I went back into therapy for a while after it happened, but I still have nightmares. Even more galling, tonight I was convinced I'd been shot at with bullets meant for somebody else. Not that my believing it helped much. Nadine and Ted had to practically carry me into the bedroom so I could put on my clothes because my knees didn't want to hold me, and I was having pains in my chest that felt like I was having a heart attack. Ted went back into the living room to call the police, leaving Nadine as my nursemaid/dresser, not a job for which she's well qualified. I managed to don underwear, jeans, and a sweater without her help, before I collapsed onto the bed.

"Want a tranquilizer?" Nadine asked solicitously.

I opened my eyes a slit. "What're you offering?"

"Valium or Prozac. Take your choice."

"What're you, for God's sake? A pusher?"

"Stuff I've taken at one time or another for my migraines. Always prepared, like the Boy Scouts."

"I'll take one of each."

She sat beside me on the bed. "Oh, I don't think you should—"

"I'm kidding. Just get me a couple of aspirin. My head feels like it's going to explode."

After Nadine left to get the aspirin, I pushed myself to a sitting position and held my hands up in front of me. They were still shaking. I thought about that other time I was shot at. I'd been driving a car chasing a fugitive. As the bullet smashed through my windshield, the fight part of my fight-or-flight response had kicked in with a major shot of adrenaline. I'd floored the accelerator and nailed the guy. This time, the only part of the response that seemed to be in working order was the flight part. I wanted to hide under the bed.

I'm getting too old for this, I thought.

Ted appeared in the doorway. He was still wearing the towel tucked around his waist. "Cops're on the way," he said. He walked over, sat next to me, and took my hand. "They're going to want to take our statements. You up to it?" he asked.

My eyes were drawn to the two bullet scars on his shoulders, which striated his skin like angry whiplashes, reminding me how insane I was to be involved with a homicide cop. On the other hand, he was even crazier to be involved with me.

"I will be." I averted my eyes from the scars and pretended that I was back in control. "You'd better cover your sexy bod. Nadine's bringing me aspirin and seeing you like this, she may not be able to control herself."

Less than an hour later I found myself again facing Detectives Patrick and Mayer. I felt at a disadvantage because I was sitting on a couch and they had parked themselves on barstools so that their heads were a lot higher than mine. I was also irritated by their insistence that Ted not be present during my questioning, and I was annoyed with him for not insisting on remaining. But all that was

nothing compared to how I felt as it became increasingly clear that, in Detective Mayer's eyes at least, I wasn't the victim in this scenario. By some convoluted logic, my status had evolved from eyewitness to possible conspirator.

The police had sealed off my unit and we'd been moved to a nearby suite in the same condominium complex. The detectives commandeered the living room to interview me. Ted gave a brief statement, then he and Nadine were banished to one of the bedrooms. I might have objected to that if Rich's words about my being cut down in a hail of bullets hadn't been rattling around in my head so that I couldn't think of much else except that somebody up there didn't like me, and somebody down here might want me dead. A hypothesis which I was hell-bent on denying.

"The shooting had to be a case of mistaken identity," I repeated for the umpteenth time. "I am not connected in any way with Dr. Freundlich or any of his people."

Mayer regarded me through narrowed eyes. "Maybe Dr. Anders's murder had nothing to do with his work," she said. "Maybe the motive for his killing and the attack on you was related to something entirely different. Something only you and he would know about."

"I didn't know Charlie Anders well enough to share a secret with him," I said, my temper flaring. "But I would think, whether or not I was the intended target of this psycho, you'd be out there looking for—"

I stopped in the middle of my sentence because Mayer had leapt off her stool and pushed her horsey face into mine. "Was something going on between you and Dr. Anders?" she barked.

"What?" I shrieked.

"Were you—"

"No! Jesus, I just met him." My hands were clammy, a sure sign that the old flight response was kicking in again. To keep myself rooted to the chair, I started silently doing diaphragmatic breathing and progressive muscle relaxation exercises. I'd barely gotten down to my neck when she continued the assault.

"What was your relationship with Dr. Freundlich?"

"Nonexistent." Thank heaven I'd kept my big mouth shut about

the hot tub "touch therapy." God knows what they'd have made of that. "We met at the opening reception, had a brief professional conversation Friday evening in the Innsbruck hot tub, and that was it."

"You and he were in the hot tub together? Chummy."

I wanted to punch her out. "There were eight or nine of us there, including Dr. Freundlich's wife. And," I added, in case she was thinking of charging me with indecent exposure, "we were all wearing bathing suits."

Sergeant Patrick spoke for the first time. "Have you located your scarf, Ms. Carlin?"

"No, I haven't."

"Well, maybe we can help you with that," smirked Mayer. She slipped on rubber gloves, reached into the brown paper bag she'd placed on the bar, and pulled out a long scarf. It was royal blue, fringed on the ends, and looked like it was made of a soft fabric like, say, cashmere. She shook it out, letting it dangle limply to the floor like a dead animal. It was crushed in places where knots had been tied. I had to force myself not to recoil.

"Is this it?"

It sure as hell looked familiar but I'm not stupid. I took my time. I reached out tentatively to feel the fabric but she jerked it out of my reach.

"Uh-uh, don't touch. Just look."

"Well, it's difficult to tell without holding it, but from a distance it does seem similar to the one my children gave me for my birthday."

Mayer's smile wasn't a pleasant thing to see. I could tell she thought she had it all figured out. I'd made the original 911 call, this was probably my scarf, it was the murder weapon, and just a day later, here I was, the target of a ski-by shooting. I had to know something. I knew better than to insist that it was all coincidence because I'm well aware cops don't believe in coincidence.

Not wanting to deal with her, I turned to the "good" cop. "Have you checked out the tracks? They had to lead somewhere. The shooter couldn't have disappeared into thin air."

"You don't have to tell us how to do our job," Mayer snapped before Patrick could reply. "Just tell us why the shooter was shooting at you."

I was tempted to take her mane of black hair and wrap it around her neck but I figured the comparison with the killer's MO would be too close.

Sergeant Patrick stepped in, his manner conciliatory. "Maybe you're right about your not being the target. Can you think of any reason why Dr. Claughton might be?"

Something maybe that went on at that damned party that she doesn't remember, I thought.

"She wasn't there when it happened," I said, "but maybe the shooter didn't know that. Still, I can't think why—"

"What was Dr. Claughton's relationship with Dr. Anders?" Mayer interrupted.

"So far as I know they had no relationship."

"Let me refresh your memory. Apparently, Dr. Anders and Dr. Golden got into a fight over her the night of the murder. You want to tell us about that?"

"I wasn't there. Why don't you ask Dr. Claughton?"

"We'd also like to talk to Dr. Golden. Maybe you can tell us where he is."

"I assume he's in his room."

"Well, you assume wrong. Dr. Golden is absent without leave."

I glanced at my watch and broke out in a cold sweat. It was ten thirty-five. Even if Joe had chosen to gorge himself on a five-course dinner he'd be finished by now. I was worried, but I was damned if I was going to let this obnoxious cop know it.

"He's probably gone back to one of the other condos to talk to some friends," I said. "I wasn't aware we had to keep you apprised of our whereabouts."

"What's your relationship with Dr. Golden?"

"He's a friend. He was my therapist during my divorce and he sends me patients."

"What was his relationship with Dr. Claughton?"

"They barely knew each other."

"And yet he felt compelled to defend her honor with his fists."

"I don't know that at all. What are you intimating?"

"Come on, Ms. Carlin. You're a savvy lady. You've never heard of jealousy as a motive for murder?" asked Mayer.

"That's the most ridiculous thing I've ever heard. There isn't a violent bone in Joe Golden's body. And as for his being crazed with jealousy, it makes no sense. He just met Nadine a couple of days ago. Hardly enough time to develop any relationship, much less one that would turn him into a homicidal maniac."

"Let's talk about your scarf again," said Patrick. "Try to remember where you left it."

I hesitated. They were already suspicious of Joe. They'd never believe his story about someone taking the scarf out of his jacket pocket in the demo room. Telling them he'd picked it up in the Innsbruck dressing room planning to give it to me would definitely put his head on the chopping block.

"I really can't remember," I said, which caused Mayer to utter a disbelieving bray which made her sound more like a mule than a horse. A more apt comparison anyway.

I started thinking about what the sisters had told me about Flo Zimmer, that she'd found out something that could ruin Dr. Freundlich. And that she'd been arguing with somebody—somebody they thought was Dr. Geissing. I remembered that I'd hinted to Dr. Geissing that Charlie had told me something that I planned to tell the police and it had upset him. I'd been lying, but if Dr. Geissing had something to hide, and he'd murdered Charlie to keep that secret, and he thought Charlie had told me the secret...

I needed to talk to Ted. I got to my feet. "I'm very tired. If you're finished with me I'd like to go to bed now."

"You're not planning to go home tomorrow, are you?" asked Sergeant Patrick.

"I guess that's your call."

"We'd prefer that you stay around for another day or two."

"Fine. If they run the lift maybe I'll get in some skiing."

It was a flippant remark but Sergeant Patrick caught my arm. "I wouldn't do that if I were you, Ms. Carlin. There's a killer running

around this resort. It wouldn't be smart to find yourself alone with him on top of a mountain."

His words rattled me but I shook off his hand and sailed past him. His voice followed me as I opened the door to the bedroom.

"We may want to talk with you again tomorrow. Please send Dr. Claughton in here."

The lights were out and my eyes had started to close when Ted's voice brought me out of my drowsy state.

"Tell me about Joe Golden."

I turned over and glanced at the glow-in-the-dark alarm clock on the table. It was after two. We'd talked till nearly one-thirty, going over everything that had happened, including my suspicions about Dr. Geissing. Ted had insisted I tell Patrick and Mayer about that conversation, and I'd promised I would. He was also adamant about my coming clean regarding the scarf. That, I didn't promise to do, although if Joe's DNA or fingerprints were found on that scarf, my keeping quiet could work against him. I was worried about Joe. I'd called his room up until midnight and had gotten no response.

"What do you want to know?" I mumbled.

"How come I've never met him?"

What was that about? I pushed myself up on one elbow. "Our relationship is professional. Mainly I just talk to him on the phone about patients he's sent me. Occasionally we have lunch."

"But you consider him a friend."

"Of course. A good friend."

"How well do you really know him? You know anything about his personal life? Who his other friends are, if there is or was a special woman in his life, that sort of thing."

"No, I don't." I scowled. "Why are you asking me this? There's no way Joe had anything to do with what's happened here."

"I'm not saying he did. I'm just considering all the possibilities."

"Well, stop considering that one!"

"Why're you getting angry?"

"Because you're acting like a cop."

"I am a cop."

"And I'm a biofeedback professional," I said hotly. "I don't practice it twenty-four hours a day."

"Yes, you do."

He had me there.

"I know Joe and he would never hurt me or anyone."

"You just told me you don't know anything about his personal life. You don't even know if he's ever been married."

"It never came up. He was my therapist. We talked about my messed-up life, not his."

"My point exactly."

How could I make Ted understand that there are some people, granted very few, whose honesty and goodness you feel certain about deep down in your gut?

"How much do you know about Dan Murphy's personal life?" I asked.

He took a few seconds to respond. "He's my partner. We've been to hell and back together and he's never let me down. That's all I need to know."

"I was drowning and Joe threw me a life raft," I said softly. "That's all *I* need to know."

There was a long silence followed by a deep sigh from the other side of the bed. "He started the fight, Carrie."

I had no answer for that so I grabbed my pillow, punched it a few times in frustration, turned over and closed my eyes. As I fell off to sleep I was vaguely aware of Ted's hand gently stroking my hair. It crossed my mind that this was not how I'd intended to spend the first night of our vacation.

My dreams this night were dark and disjointed, having to do with ghostly figures clutching daggerlike glass shards, flying over the trails, leaving no tracks in the snow. So when I heard a far-off voice calling, "Help! Someone, help me," I incorporated the voice into the dream. At some point, wanting out of the nightmare, I fought my way to the surface. But I could still hear the voice.

Teenagers, partying, fooling around on the slopes, I thought, my mind still foggy with sleep. Stupid to be sledding at this hour. Must

be twenty below out there. Then I remembered that some years back, after a young man's spinal cord was severed when his sled went out of control, the resort management had prohibited nighttime sledding. That chilling recollection brought me bolt upright. I crawled out of bed, careful not to wake Ted, wrapped a blanket around my shoulders, and fumbled my way to the window. There was no moon. Swirls of snowflakes made seeing beyond a few feet almost impossible. I recalled how we used to pray for snow. We'd displayed THINK SNOW emblems on our T-shirts, our hats, and even on the bumpers of our cars. Tonight I silently cursed the snow. Except for a lone spotlight illuminating the cascading flakes, the area was shrouded in darkness. I pressed my forehead against the ice-cold pane, straining to make out the lift. I listened. There were no shouts of young people sliding down the slope and no calls for help. Deciding the voice was residue from the dream, I tiptoed back to bed and slipped in next to Ted, taking comfort in his warmth. He moved, adjusting his body to allow me to spoon myself around him. Just as I was beginning to be lulled by the sound of Ted's even breathing, I heard it again—faintly now.

"He-elp me."

I threw back the covers, grabbed my ski pants off the chair, and pulled them on. "Ted, wake up! Somebody's calling for help."

Years of training had taught him to react quickly. He was wide awake in an instant and reaching for his gun.

"Where? In one of the other apartments?"

"Outside. By the lift, I think. Listen."

There was no sound for more than a minute and then we both heard it. Ted was dressed in two minutes.

"Call Security and follow me out with as many blankets as you can carry."

He shoved his gun in his waistband, grabbed his boots, and pulled them on as he dashed through the living room and out the front door.

"Be careful," I called after him. I don't know why I said it except that the word *ambush* suddenly flashed across my mind.

* * *

There was no ambush. By the time I got to the lift line, arms laden with blankets, lights had begun to dot the office complex and I could hear the keen of distant sirens shattering the stillness of the night. Ted was on his knees bending over someone, his jacket covering the still figure.

"Hurry," he yelled to me. "Toss me those blankets." I plowed my way through the thickening powder and threw the blankets at him, then got down on my knees and helped him pile them on. I took one and began folding it intending to pillow the head, but Ted stopped me.

"Don't move him," he said. "He has a head injury."

"Has he said anything?"

"In shock."

"Any idea who it is?" I asked.

He shook his head. "Take a look."

I lifted the blanket Ted had placed protectively over the man's head and saw the splotch of red in the snow. Glazed, swollen halfshut, brown eyes stared blankly up at me out of a mottled whitepatched face. It was seconds before I recognized this person I knew so well.

"Oh, my God. Oh, my God, Ted! It's Joe!"

Chapter Fourteen

JOE WAS unconscious when the paramedics arrived, so we had no way of finding out how he'd come to be at the foot of the mountain at four in the morning. The medics back-boarded him onto a gurney and Ted and I rode in the ambulance with him to the hospital.

Skiing is big business in Vermont, so the plows were already out clearing the roads, which made the trip to Burlington less hazardous than it would have been under these conditions almost anywhere else. Which is not to say it wasn't a mind-blowing experience. Sirens blaring, lights flashing, we tore down the treacherous mountain road taking the twists and turns at speeds I've seen only in adventure films. Hanging onto my seat, I watched in anxious amazement as the paramedics worked on Joe's head wound, unfazed by the swaying vehicle. Before we left Snowridge they'd fastened a cervical collar around his neck, inserted an IV tube in his arm, and covered him with a special warming blanket. In the ambulance they placed an

oxygen mask over his nose and mouth, and one of them began rhythmically squeezing a bag connected to the mask. He was a big guy with long hair, through which I could see one hoop earring, that hung almost to his shoulders. He looked like a member of Hell's Angels, but he ministered to Joe with the gentleness of Florence Nightingale. He talked to him, asking him his name, if he knew what day it was and where he was. He repeated the questions at intervals, getting no response that I could tell. When I couldn't stand it any longer, I tapped him on the arm.

"How badly is he hurt?"

"Aside from the hypothermia and frostbite, he's suffered a severe head trauma. We've stopped the bleeding but he's not responding."

"Can you tell if the wound's from the fall or a blunt object?" Ted asked.

"Where it is, my guess would be somebody bashed him good."

I must've made a sound because he looked at me and said, "Sorry. You his wife?"

"No. A friend."

"You wanna try talking to him? Sometimes a familiar voice will get through."

I nodded and he moved aside.

Up to now I'd kept my emotions in check, mostly by refusing to accept the possibility that Joe was in such bad shape that he might not make it. I knelt beside the gurney, reached under the blanket, and took his hand. It was dry and oh so cold, and lay limply in mine almost as if he were dead already. It shocked me and I could feel myself beginning to unravel.

"Joe," I murmured, struggling against the prickling starting at the back of my eyes. "Joe, it's Carrie. Can you hear me?"

His stillness terrified me.

"You're going to be okay. I'm right here with you. They're taking you to the hospital. If you can hear me, please answer me."

No response.

"Joe, can you tell us what happened? Can you tell us why you were out there in the freezing cold?"

Still nothing.

I thought of the hospital shows I'd seen on TV. "If it's hard to talk, just blink your eyes."

I stared at those closed lids willing them to move, to show some sign of life.

Not a flicker.

I leaned in closer and spoke into his ear. "Joe? Joe, it's Carrie. It's Carrie, Joe. Can you squeeze my hand? Please, if you hear me, squeeze my hand."

A long minute that stretched to infinity.

Was I wanting it so badly I thought I felt something, an infinitesimal movement, or was I imagining it? And then I saw his lips move.

"He hears me! He's trying to say something," I said to the medic. "Can you take off the mask?"

He complied, and I brought my ear close to Joe's lips.

A strangled whisper. "Carrie…"

"I'm here, Joe."

"Gotta…gotta…" His voice trailed off.

"What, Joe?"

"…leave," he whispered, his words barely audible. "…gotta…gotta get away…"

"You're safe now, Joe. You're going to be okay."

"No…no…you…understand…" He was becoming agitated, struggling for breath. The medic eased me away and replaced the mask.

"Better stop," he said. He lifted Joe's eyelid and shone a light into his eye, glanced over at the other medic, an older guy who'd been busy monitoring Joe's vital signs. The second medic looked up at me. "Sometimes, it's days till they come out of it," he said kindly. "I wouldn't give up hope."

I hadn't till he said that. The tears I'd been holding back seeped out of my eyes. I felt Ted's arms fold around me. I let go of Joe's hand and buried my head against the rough material of Ted's jacket.

"Joe's one of the special people in my life," I choked. "Aside from the kids and you and my dad and Meg, he's…" My voice broke. "I don't think I could stand it if…"

"I know," he said. "I know."

A few minutes later we pulled up to the emergency room at the University of Vermont Medical Center. The snow had stopped and the approaching dawn had backlit the sky a smoky purplish gray. Ted and I stood on the blacktop feeling helpless as the paramedics guided the gurney down the ambulance ramp. We followed them as far as the ER, where Joe was whisked inside and we were directed to an area reserved for families and friends of trauma victims. A young couple and an elderly woman were slumped in their seats, talking in low agitated tones. They glanced up as we entered. No one spoke, but something passed between us, a silent communication, an empathy that often happens between people caught in similar calamitous situations. Ted and I nodded at them and took seats on the other side of the room.

"What was it Joe said in the ambulance?" Ted asked me after we'd removed our jackets and settled in for the long wait. "Did he recognize his attacker?"

I shook my head. "All he said was that he had to get away. I'm telling you Ted, something happened at that party. Something he saw or heard, or someone thought he heard. And that person obviously thinks Nadine heard it, too. But whatever it was is a complete blank to Nadine."

A clerk appeared and beckoned us into a small cubicle. She sat behind a desk, indicated that we should sit, and handed me a form that required that I fill out Joe's health history and insurance information.

I glanced at it and handed it back. "His name is Joseph Golden," I told her. "He lives in Fort Lee, New Jersey. I can give you his office address and phone number. Beyond that, I haven't a clue."

Ted spoke up. "He's a psychiatrist so I'm sure he has adequate medical insurance."

"Are you family?"

"Friends," I said.

"I'll need the name of his next of kin. They'll have to be notified."

I stopped breathing. "Notified," I gasped. "Is he—"

"They're still working on him. But we'll need to inform his family."

It struck me then, more forcefully than it had when Ted had asked, how little I really knew about Joe. I didn't know if he had any family. I don't discuss my personal life with my patients, and Joe had never discussed his with me even after the therapy was finished and we'd become friends. I assumed he dated because I'd seen him at conferences having dinner with various women but I never saw him with the same one twice. That hadn't surprised me because there were often lapses of several months, or even a year, between conferences. Without consciously thinking it out, I'd taken it for granted that Joe was one of those dedicated doctors who, almost like a good priest, had devoted himself to his patients, and simply wasn't particularly interested in a social life.

"His wallet may be in one of his pockets," Ted told her. "If it is, his insurance card would probably be in it. If not, it's in his room and we can get it to you tomorrow."

"We can't admit someone without insurance information," she said in that flat, officious tone bureaucrats use to people over whom they fleetingly have power.

There was nothing remarkable about this woman who was sitting behind her desk fingering the stacks of forms piled neatly in front of her. She didn't look like a robot or a monster. She had a forgettable, round scrubbed face, neither pretty nor plain, brown hair pulled back, her expression exhibiting just the proper mix of professional concern and efficiency. But she represented everything I detest about our health care system, the callousness, the bottom-line mentality. I lost it.

"Well then," I barked, glaring at her. "Why don't we just toss him back out into the snow? Would you like some help carrying him? We'll have to do that because I don't think he can make it on his own."

Ted glanced at me, surprised. "Carrie," he said softly, "let's not—"

"If he requires surgery someone has to sign," the clerk said, her tone snippy. "Someone has to give permission."

"I'm sure we can work this out," Ted said pleasantly, bringing his foot firmly down on mine. He has this revolting habit of attempting to stop my mouth by tromping on my foot. Occasionally, if the pain

is excruciating enough, it works. This time I hardly felt it through my heavy boot, and I was on a roll.

"Maybe those nice paramedics are still around. We could ask them to help, although they'll probably have some objection, seeing as how they spent the last couple of hours trying to save him. Why don't—"

"Why don't you let me talk to your supervisor?" Ted interrupted. "There has to be provision for people who come in on an emergency basis."

The clerk gathered her papers and got to her feet. "I certainly don't need to sit here and be insulted when I'm only doing my job," she announced.

"I'm sure you understand that Ms. Carlin is upset," Ted said. And to me, he whispered. "Cool it, sweetheart. You're making a difficult situation worse. Go back to the waiting room."

I knew he was right and I wasn't getting anywhere with this automaton anyway, so I got up and flounced out of the cubicle.

When Ted rejoined me five minutes later, he wagged his finger at me. "What got into you? She was just following procedure."

"Dammit, this is a hospital. How about some compassion, a little do-unto-others? What do they want from people? Are we supposed to have our insurance information tattooed on our butts?"

"Not a bad idea. You could patent it."

"Don't make jokes. Did you find out anything?"

"Not much. He's listed as critical."

"Is he conscious yet?"

"I don't know." He took both my hands in his. "We're going to be here a while. You want me to get you anything from the cafeteria?"

There was a cavernous hole in my stomach, but food wasn't going to fill it. "Maybe just some coffee. Do you have your wallet? I didn't bring..."

"Thought you'd be here," said a grating voice that had become all too familiar. I fought an impulse to ignore the voice, overcame it, and looked up to see my nemesis, Detective Mayer, standing in the doorway.

"They tell me he's alive," she said.

Ted anchored me with his boot again. "Let it go," he said, sotto voce. And to Mayer, he said, "Dr. Golden's still in the ER. What's going on?"

"Looks like we've ID'd your shooter."

Images raced across my mind like pictures in a slide show. Geissing, Zimmer, Freundlich, Donovan.

"Who?"

She took her time pulling off her gloves and unzipping her jacket. I'll bet it was people like Mayer who inspired the Greeks to kill the messenger.

"We found the gun used in the shooting in the snow not far from where Dr. Golden was lying."

"Are you saying the shooter dropped it?" I asked.

"I don't think that's the way it went. Not in light of our latest information."

Ted was losing patience. "Give it to us straight, Mayer," he snapped in a cut-the-shit tone.

She recognized the authority in his voice and dropped the cat-and-mouse game. "As it turns out, Ms. Carlin was right. She wasn't the target. Nadine Claughton was."

"I told you," I began.

"Golden was out there looking to finish the job he'd started earlier when, unfortunately for him, he slipped and hit his head."

I couldn't help myself. "Oh, for God's sake, are you still hung up on that jealousy theory?"

"No, I was wrong about that being his motive. His motive was to stop Dr. Claughton from telling what she'd found out about him which would ruin his career."

This cop was from another planet. "And what's that?" I asked.

"Same thing Dr. Anders found out when he rejected him. That your Dr. Golden, who makes his living primarily treating heterosexuals with marital problems, is a freakin' fag."

Chapter Fifteen

FROM SOMEWHERE outside myself I was vaguely aware of the group on the other side of the room staring at us, bug-eyed. I was dumbstruck. Not because I had a problem with Joe being gay but because I hadn't known, and I'd been convinced he had a thing for Nadine. Why had he felt that he couldn't tell me? And how had Mayer found out? Who had told her he'd come on to Charlie Anders? And she was saying Nadine knew. Impossible. Nadine thought Joe wanted her.

And what difference did it make anyway? This is the twenty-first century. People don't ask their doctors about their sexual orientation. Maybe some patients, particularly those who come for couples counseling might be put off, but by-and-large... And as a motive for murder? It was ludicrous and I was furious because this moronic cop was trying to make it into a motive when Joe couldn't defend himself. I opened my mouth to tell her off but Ted beat me to it.

"What kind of bullshit thinking is that? Talk to his doctors, for chrissake. You'll find Golden's injury was caused by a blunt object, not from a fall. And it wasn't self-inflicted. He'd've had to be a contortionist to bash himself on the back of the head with that degree of force."

As if conjured up by the reference, a doctor wearing hospital greens appeared behind Mayer and edged her aside. The slump of his shoulders and the expression on his face as he wearily reached up and pulled off his mask, sent my heart plummeting into my boots.

"Which one of you is Detective Mayer?" he asked.

"I am," Mayer replied, swinging around to face him. "What's the story?"

He turned and took a couple of steps away from her before he spoke. "I'm sorry to tell you you won't be able to interview the patient."

"He didn't make it?"

My knees went weak and I grabbed onto Ted's arm.

"He's alive but we haven't been able to stabilize him yet. He's in no condition to answer questions."

"Is he conscious?" I asked, struggling to keep my voice steady.

"He drifts in and out," he said. "Who're you?"

"Carrie Carlin. A friend. Lieutenant Brodsky here and I came with him in the ambulance. Is he—"

"This man is under investigation for murder," Mayer interrupted. "How long before I'll be able to interrogate him?"

"I really couldn't say," the doctor replied, obviously annoyed at her insensitivity. "He's in bad shape. It could be days till he's recovered enough to tell us what happened to him. There's no point in any of you waiting around here tonight." He turned to me. "I'm Dr. Rosen. Leave information where you can be reached with Reception, and I'll contact you if and when he's able to receive visitors."

If?

"The head wound," Ted said. "Could it have resulted from a fall?"

"Unlikely," Rosen answered. "Caught him high on the parietal bone. If he fell backward he'd have injured the occipital area, forward he'd have hit the frontal or sphenoid bones."

Ted turned on Mayer. "There's obviously been an attempt on Dr. Golden's life," he snapped. "I'd suggest you post a guard outside his room."

Mayer opened her mouth to protest but Ted never gave her a chance.

"This case has been bungled from the beginning. If that isn't done immediately I'll lodge a complaint with the department and you can bet your sweet—pension, heads will roll."

I have to admit it gave me great pleasure to see Mayer speechless. Color suffused her face and her fingers curled into fists. She shot me a look that would've frozen lava, nodded curtly at Ted, and turned on her heel. If I hadn't been so worried about Joe I'd have laughed out loud.

Dr. Rosen couldn't suppress a smile. "Man, oh, man, that's not a lady I'd like to have out to get me. What's going on?"

Ted gave him a quick rundown. "We're sure Dr. Golden was attacked by whoever murdered Charlie Anders. We just don't know what he found out that made him a target."

"How bad is he?" I asked the doctor, my stomach knotting. "Is there a chance he might not—might not be all right?"

"I won't lie to you," he said. "It's touch and go. If he does pull out of this there could be permanent brain damage."

This wasn't something I'd considered, and his words left me numb. Something similar had happened to me once before, and strangely, Ted was with me then, too, although he wasn't my lover at the time. It was after Rich had left. Ted was investigating Rich's girlfriend Erica's murder, my children were getting into fights at school trying to defend me, and it seemed as though Meg, too, had betrayed me. When things pile up beyond my capacity to deal with them, some sort of protective mechanism kicks in and I stop feeling.

I have a dim recollection of Ted making some calls from the hospital and I remember someone from Social Services asking me questions about Joe, but I don't remember what they were or how I answered them. The only thing that stuck in my mind was that a nurse who'd been in the ER asked me if Joe was my father.

"My father," I'd cried. "My father! He's thirty-nine years old!"

* * *

I'm not sure how we got back to Snowridge. I think the cops took us, but Mayer wasn't driving and we weren't in a black-and-white. The sun was already up when we pulled into the resort. I saw TV trucks parked in the lot and reporters with cameramen in tow staking out the office and filming the mountain. But no one approached us as we drove up to Mountainside in the unmarked car.

Nadine wasn't in the apartment. I knew I should worry about that but I couldn't dredge up the energy. In a sort of daze I wandered into the bedroom, got out of my clothes, and crawled into bed. Ted came in and sat down next to me.

"Take this," he said, handing me a pill and a glass of water.

"What is it?"

"Xanax. Doctor Rosen gave it to me for you."

I didn't argue. I swallowed the little white pill and leaned back against the pillows. I was completely drained.

"I'm just tired," I said. "You don't have to sit with me. I'm okay."

"No, you're not," he replied, taking my hand.

I lost all sense of time so I'm not sure how long we sat like that but then the Xanax must've started working because I felt the knot in my chest loosen.

"Did you know," I said, "that some stupid nurse thought Joe was my father?"

"She probably didn't get a close look at him."

"No." I struggled to a sitting position. "That wasn't it, and she wasn't stupid. She saw him. I saw him in the ambulance. He looked old."

"He wasn't in pain, Carrie. They gave him something in the IV for the pain."

"He looked old because some monster hit him over the head and left him out in subzero temperatures to die. In a few hours he aged years. Can you imagine what he must've gone through, lying there hurt, freezing, thinking he was going to die?"

"No, I can't."

"He didn't deserve this. He's such a good person. You know for the first months of my therapy he wouldn't take money from me?

He wouldn't let me pay him till I got my settlement. And he's a really good therapist, too. He cares. He cares about all his patients. He—"

Ted reached over and pulled me into his arms.

And the dam burst. I cried an avalanche of tears for my friend Joe, who might not make it through the day. Ted held me close until the storm abated.

I fell asleep and was out of it for most of the rest of the day. When I woke it was dark and I was famished. The sleep had restored me. Things were clearer in my head. The murder of Charlie Anders had been frightening and horrifying but it hadn't hit me where I lived. The assault on Joe was gut-wrenchingly personal and I was no longer going to pussyfoot around intellectualizing about who might have done it. There was no question in my mind that both attacks were related to a secret that had something to do with Dr. Freundlich. I couldn't understand why the detectives on the case had gotten so sidetracked, unless it was that they were incompetent and so anxious to solve the case they didn't care if they arrested the wrong person.

I believed that at least three people, aside from Joe and the killer, knew something about that secret: Flo Zimmer, Nadine Claughton, and Hubert Freundlich. Freundlich would be a tough nut to crack if the secret were related to his work; Nadine apparently knew something that she didn't know she knew; and Flo Zimmer might be full of shit, but I had to get to all three of them. And something else puzzled me. When had Nadine learned about Joe's homosexuality and what had made Mayer think she would want to use it against him? Why wouldn't she have mentioned it to me? For that matter, if it were true, why hadn't Joe ever told me? Did he really believe it would make a difference to me? Lots of questions to be answered. I threw back the covers and scrambled out of bed.

I found my clothes still in the suitcase where I'd tossed them when we had to vacate my old unit in such a hurry last night. I dug out a clean ski sweater, long johns, and socks and headed for the bathroom. By the time I'd dressed, added lipstick, and run a brush

through my hair, I felt human again. I went into the living room, and was happy to see a pizza box on the coffee table. Opening it, I discovered several cold slices inside. There was no sign of either Ted or Nadine so I assumed what was left was all for me. I gobbled one soggy slice, then decided to heat the rest in the microwave. I carried the box into the kitchen and saw the note Ted had stuck on the refrigerator door.

Back by 9:00, it read. *Patrick's moved Nadine to a safe place. Don't unpack. I'm working on him to give the okay for us to leave in the A.M. Luvya. Ted*

Damn. Ted was trying to run my life again. With Joe still in the hospital hovering between life and death, and with Mayer, despite all the evidence to the contrary, still believing he might be the perp, there was no way I could leave. How could Ted think I'd abandon Joe at a time like this? Of course, it didn't take a psychiatrist to follow his thought process: Get Carrie away; get her home safe.

Don't get me wrong. I love having someone in my life who cares enough about me to worry about my safety. If I'd been with Rich instead of Ted when that window shattered, he'd probably have picked me up and used me as a shield. But I don't want Ted making decisions for me. He's used to running the show and he really hates giving up control. I admit I was pretty craven yesterday when those bullets came smashing through the window. Enough of my life flashed through my mind to convince me that I want to go on living it. In retrospect, I'm sure I gave the impression that I welcomed Ted's body thrown protectively over mine, and at the moment I had. And I appreciated the gesture, although I wouldn't have been thrilled if he'd taken a bullet for me. I saw him get shot once and it totally freaked me out. But it was obvious now that the bullets weren't meant for me, so I no longer had a reason to run for cover. I glanced at my watch. Not yet seven. If all went well I'd be back before Ted was aware I'd gone anywhere. Just in case, I added my own addendum to his note.

Gone fishing. Don't wait up. Love, Carrie

Chapter Sixteen

FLO ZIMMER slid the bolt and opened the door without so much as a squint through the peephole or a cautious "Who's there?" With a killer running around the place, the woman certainly had guts. Or more guts than brains. She stared at me blankly for a minute and then slowly recognition dawned. I doubted that she remembered my name, but she knew I was the little snot who'd made a feeble attempt at insulting her in the hot tub. Fully expecting her to slam the door in my face, I thrust my shoulder against the frame and stuck my hard rubber boot, which was beginning to develop a permanent dent over the instep, across the threshold.

"Hello, Dr. Zimmer," I said. "I'm Carrie—"

She flung the door wide open, throwing me off balance and nearly causing me to fall flat on my face.

"I know who you are," she said in a tone that, while testy, tilted more toward friendly than frosty. "Come on in."

Recovering quickly, I took a surreptitious glance behind me to see if she might be talking to someone else. Nope. Nobody here but this chickie. I took a couple of steps forward, crossing the threshold into the room. She reached behind me and pushed the door closed.

Up close, and not floating in a hot tub, she was bigger than I'd realized. Maybe five-foot-nine or -ten. Her orange-red hair was slicked back in a ducktail, and she wore dark sweat pants and a T-shirt that clearly outlined bulging pecs and biceps.

Man, I thought, starting to sweat under my layered clothing. The woman must lift two-hundred-pound weights on a daily basis. I was completely outclassed physically. If by some quirk of fate the sisters in the restaurant had been right, and she was the killer, I was the dumb fly who'd flown straight into her web. Casually I took off a mitten and allowed my hand to curl around the condo key in my pocket. Some weapon. You would've thought I'd've had the sense to bring my pepper spray, which, ever since I was nearly killed by an off-the-wall patient, I keep on a key ring along with my house and car keys.

"You shouldn't be opening your door without asking who's outside," I said. "It's not safe."

"I can take care of myself."

Uh-huh. I definitely believed that. I cleared my throat a few times and decided to come to the point and get out fast.

"Uh—I don't know if you're aware of it, Dr. Zimmer, but one of the other attendees, a friend of mine, was badly injured last night."

"Yeah," she replied. "I heard. And I heard someone took a pot-shot at you."

News travels fast when you're stuck in an enclosed environment with a bunch of people who make their living sticking their noses into other people's business.

"I don't think I was the intended target."

"Whatever. We have to find the sonofabitch who's behind this before something else happens."

My mouth fell open. *We* have to find the sonofabitch?

"Take a load off. Grab a chair." She indicated a Breuer much like the ones around the card table in Joe's studio room.

I sat, wiped the perspiration off my forehead with my sleeve, and unzipped my jacket. She sat on the chair opposite mine.

"How's he doing? Your friend."

"He's still critical."

"He conscious?"

Why was she asking me that? Was she afraid he'd talk? My fingers tightened around the key.

"He wasn't when I left the hospital."

"So." She stretched her lips into one of those disingenuous smiles that don't show any teeth. "Why're you here? Think I did it?"

"No, of course not," I replied with bravado. "I wouldn't be stupid enough to come here if I thought that."

"Well, you're in the minority. People have been looking at me funny ever since this happened. I'm not a monster, you know, despite what you and your colleagues think."

Because I wanted her cooperation I opened my mouth to lie outright and assure her that we didn't think any such thing, but she went on before I could.

"I may believe what you biofeedback people do borders on the criminal, but that doesn't mean I think you deserve the death penalty for doing it. I'd appreciate your making that clear to your associates."

Ah, that accounted for her letting me in. Her motives weren't altruistic. Plus, it was a good bet Mayer had been leaning on her as hard as she had on me. As if reading my mind, she said, "Would you believe, yesterday that bitch, Mayer, actually accused me?"

We had that in common anyway. "She tends to jump to conclusions."

"Believe me," she said fervently, "I want this maniac caught as much as you do."

My fingers loosened from around the key. "Good, because you may have information that could help catch him."

She stiffened. "I don't know anything. DAHM had absolutely nothing to do with this. We're a nonviolent organization. I told the police—"

I held up my hand to stop the barrage. "The police already have a suspect and it's not anybody from DAHM."

She noodled that for a minute. "You're not going to tell me who it is, right?"

"Right. Because they're wrong."

"So who do you think did it?"

"I don't know who, but I think I know why. I think Charlie Anders was killed because he knew something that someone wanted kept quiet. And I'm sure it has to do with Dr. Freundlich."

Leaning back, she folded her arms across her chest. "So you admit there's something wrong with the research."

"I didn't say that. I thought his results were impressive and hard to refute. I don't know what it has to do with, but I'm damned well going to find out."

"No kidding." She didn't laugh out loud but she looked me up and down and her expression made clear what she was thinking. "And just how're you planning on doing that?"

"By asking the right questions of the right people, which I don't think the police have been doing."

"Why come to me? I've told the cops everything I know."

"Maybe not everything." I leaned forward pinning her with my eyes. "The morning of the award ceremony you were overheard talking to someone about something you found out about Dr. Freundlich. You said it could finish him off. Did you tell the cops about that conversation?"

She got up so fast her chair fell over backwards. "That had nothing to do with what happened."

"You intimated it could ruin his career."

"I was angry. I exaggerated."

"About what?"

"Oh, f'chrissake," she muttered, setting the chair on its legs and sitting back down. "He was involved in a scandal. Got sued for sexual harassment by one of his students."

Why didn't that surprise me?

"The student was bought off and it was hushed up but the university let Freundlich go. They made him a deal that, if he'd leave quietly, no mention of it would appear on his record."

"So how did you find out?"

A cackle. "I knew somebody who knew somebody."

"When did this happen?"

"Maybe seven or eight years ago. That's when he got out of legitimate research and got involved in that shit you people do."

I bit my tongue and silently congratulated myself on keeping my cool.

"Truth is, I was hoping to embarrass him in front of his colleagues. But who would care in this day and age?"

"I imagine Gerta would, but I can't see Dr. Freundlich hiring a hit man to kill Charlie to prevent his wife from finding out something that happened years ago that she probably knew about anyway. It would've been pretty difficult to hide the reason he was fired from her."

"You think Freundlich hired a hit man?"

"If he did it was for another reason or you wouldn't be sitting here safe and sound." It was obvious Freundlich walked the edge of the infidelity precipice daily, taking chances with both his reputation and his marriage. It was also obvious Zimmer's plot wasn't the motive for Charlie's murder. It looked like Zimmer was a dead end.

Disappointed, I got to my feet and zipped up my jacket. "Thanks for the information. Sorry to have bothered you."

She followed me to the door and held out her hand. "You're pretty ballsy for somebody your size," she said.

Her grip made me wish I'd put on my mittens. "Well, you know what they say about good things coming in small packages."

"Is that like 'a narrow mind has a broad tongue'?"

I could feel the blood rushing to my face as I recalled our exchange in the hot tub. "Sorry about that. I was defending my turf."

"Well, like I said, you got balls. You like living dangerously." She released my hand and laughed, this time revealing a full set of large teeth.

My, what big teeth you have, Grandma.

"See you on the slopes," she said.

I shook off the sense of foreboding that suddenly swept over me and forced an answering smile. "Oh, by the way, Dr. Zimmer," I said

as I pulled open the door. "Who were you arguing with behind the curtain the morning of the award ceremony? Was it Dr. Geissing?"

"Geissing? That ass-kissing wuss? No, it was Scarborough. Imagine the little turd having the gall to threaten me. I could break him in two with one hand." Which she proceeded to demonstrate in pantomime.

My heartbeat quickened but I nodded and closed the door behind me.

Lots of people are big and strong, and able to break someone in two with one hand, I thought as I hurried down the stairs. Well, actually not lots of people. And more often men than women. But some women work out and develop their muscles. It's healthy. Nothing wrong with that. Probably doesn't mean a thing.

See you on the slopes, she'd said. Okay, so she skied. People who come to a ski resort, even for a convention, generally like to ski. Hadn't I myself pooh-poohed to Ted the idea of Zimmer being the killer? Besides, she had seemed concerned that something she had said could have motivated someone to commit murder. Sort of. Which brought me to Paul Scarborough. Would he commit murder to protect his boss's reputation? Zimmer hadn't told him what she'd found out. Maybe Scarborough knew something a lot worse about Freundlich than his having had a sordid affair and having been kicked off a university faculty. But Scarborough was probably not more than five-foot-five or -six, and he was skinny. I didn't think he'd have the strength to strangle a chicken if he were starving.

I pushed open the heavy outer door, welcoming the blast of cold air that hit my face. I needed something to clear the cobwebs out. I was suspecting everyone but had no proof that pointed definitively to anyone. But at least I was sure I was on the right track, which was more than I could say for the police.

Half sliding down the icy steps, I grabbed onto a tree trunk to stop myself from falling. I rested against it, taking a minute to catch my breath and decide on my next move. Nadine was hidden away somewhere so I couldn't talk to her, and the possibility of her

suddenly remembering what had happened at the party was remote anyway. At this point, Dr. Freundlich was my only hope. I decided to head for his villa, which I knew was in Copenhagen, one of the newer condominiums that had recently been built on the west mountain. I guessed that, like the DAHM people, many of the conferees had been given the okay to leave today. But I was certain most of the Freundlich group would still be here.

It was pitch dark now, but the resort was well lit and I saw several people walking down toward the restaurants. Suddenly I remembered my date with Julie. Clumsily I tugged at my jacket sleeve with my mittened hand and squinted at my watch. Just past eight. Plenty of time to catch Dr. Freundlich before Gerta got him "early to bed," if, indeed, she ever did. And I was anxious to talk more with Julie. She'd been close to the action that night and she'd had time to think about it. She might remember something that could be helpful.

When I arrived at the restaurant, I looked around but I didn't see her. Waiting for the hostess to seat me, my eyes were drawn to the dancing lights on the brightly decorated Christmas tree, and my mind flashed back to our first holiday at Snowridge. December 25, 1995.

It had been a perfect day and we'd decided to have dinner here at The Cove. The tree in the corner had been ablaze with lights and brightly colored decorations. After dinner the children, drowsy and sated, had sat cross-legged on the floor in front of it, mesmerized by the on-and-off flickering of the tree lights. Rich and I, exhausted after hours of hauling our tireless children on and off the lift, of getting them out of and back into their clothes and skis and boots every time a pit stop was required, sat in front of the fire drinking hot cider laced with rum and playing footsies under the table. Chanukah coincided with Christmas that year and we'd exchanged gifts in the morning, matching ski sweaters, so I was surprised when Rich reached into his pocket and handed me a small box. On the accompanying card he'd written, "To my lucky charm. May we always stay in the winner's circle. All my love forever, Rich." The box contained a gold ring in the shape of a horseshoe encrusted with tiny diamonds and emeralds.

As it turned out our life wasn't charmed, the ring wasn't lucky, and I no longer wear it. Six months after Rich left I threw the card away along with all the others promising everlasting love.

"Carrie?" Julie's voice brought me out of my reverie. "You okay?"

"Oh, I didn't see you. I'm fine. I was daydreaming."

She took me by the arm. "Come on. I have a table next to the fireplace."

We sat and ordered hot ciders, and I kept my impatience in check, waiting until the drinks came and we'd chitchatted about her wedding and my divorce, before I brought up the murder.

"Julie, the night of the parade, did you happen to notice the person who got on the lift with the guy who was killed?"

"The police asked us about that and I can't say I did. I mean, there was so much going on. I've racked my brains because I think Jim and I were the last ones on the lift before them and I did notice that blue scarf. It wasn't waving in the breeze or anything, but I remember being annoyed at the guy's wearing it. I was going to yell at him to take it off but then the lift started up."

"Didn't you wonder why you didn't recognize him? You run the ski school. You must know all the instructors."

She shifted uncomfortably and her gaze dropped to the table. "Occasionally an instructor brings one of the guests. It's good for business and we kind of look the other way. The only rule is that the person has to be a good skier. So he or she doesn't fall down and mess up the parade."

"Did you notice anything about the person with him? Height, weight, anything at all? Do you think you'd recognize him if you saw him again?"

"I doubt it. They were both sitting by the time I noticed them, and there was no reason to look closely, you know?"

With the image of Flo Zimmer's biceps in mind, I asked, "Could it have been a woman?"

"I don't think so." She hesitated. "Well, I guess I wouldn't swear to it. There's no way to tell with everyone wearing the same ski outfit. I suppose it could've been either."

Which gave me food for thought.

"You know," she added, "this has really affected Jim and me. Nothing like it's ever happened here before. I know I shouldn't compare it to something like the World Trade Center. That killed thousands of people. But when a person is strangled sitting two feet behind you, I mean, it gets to you. Who could imagine having a murder happen right in one's own backyard?"

I could, I thought morosely.

Chapter Seventeen

AS WE WERE leaving the restaurant, I caught sight of Dr. Freund-lich and Gerta. They were crossing the parking lot behind the office heading for the conference center. Freundlich was hatless, his imposing figure caught in the glare of the lights of a car just backing up, the silver-blond hair unmistakable.

"There's that guy from your convention," Julie whispered. "Everybody's saying he did it."

I looked at her in surprise. "Who's saying that?"

"It's just going around."

"He was watching the parade from the lift line. People saw him. He's hard to miss."

"Well, I don't know about that but somebody tonight said he and the guy who got killed were drinking in The Cove after the lifts closed Saturday and they had a huge argument. Something about the guy not being a team player, and Freundlich firing him."

153

I could barely contain my excitement. "Who heard it?"

"Gosh, I don't know. One of the waiters, I think."

My mind racing, I said a hasty good-bye to Julie, promising to call her before I left, and took off after the Freundlichs. A cop at the door of the center stopped me and asked for my conference ID, which he checked against a list before allowing me in. The place was practically deserted. The only room that was open was the demo room. I wandered in and glanced around as though searching for a particular display. The room had a disorderly feel to it, like an unmade bed, as exhibitors busily packed up their wares. A few of the computer setups hadn't yet been dismantled and a sprinkling of conferees were wandering around talking to the remaining exhibitors, who were making a last-ditch effort to sell their products.

I spotted the Freundlichs standing in the center of the room. People glanced at them but nobody approached, probably because they didn't know what to say. I shoved my mittens into my pockets, took off my hat, unzipped my jacket, and stopped at the book stall. I picked up a book on neurocybernetics and pretended to be absorbed in it as I kept one eye on my quarry. They were talking to a technician who I recognized as the person who'd been doing the brain mapping and who I assumed was one of Freundlich's lab people. After a brief exchange, the technician, a curly-haired, boyish-looking guy who appeared to be in his late twenties, pulled out a box from under the table and began stacking computer disks inside. I'd intended to buy copies of some of the disks for my own research so I took the opportunity to dash over and interrupt him.

"Are you still taking disk orders?" I asked the techie, pretending I hadn't noticed the Freundlichs. "I want to buy a sampling of brain maps for my—" I stopped. "Oh, Dr. and Mrs. Freundlich. Excuse me. I didn't realize it was you. Am I interrupting?"

"No, no, we're finished," Freundlich replied. "I was just telling Jeremy here, he may as well pack up. People are leaving. But he'll take your order, Dr.—ah…"

"*Ms.* Carlin. Carrie Carlin. Dr. Claughton's roommate." And don't tell me you don't remember who she is, you creep. "We met

Friday evening at Innsbruck in the hot tub—" when you ran your hand up my thigh "—before—before everything happened. I asked Kate to express my condolences to you."

Did Gerta's body stiffen at the mention of Kate's name, or was it the reference to the hot tub? Or to the murder?

"Yes, she told us. We're devastated, of course, as you can imagine. Charlie was our shining light."

So why'd you fire him? I pretended ignorance. "Kate was so distraught when I saw her yesterday. Have the police got any leads?"

"I hear there is a suspect, although they won't say who."

"Did you know there was another attack last night?" I looked directly into his eyes, daring them to waver. Could he hold my gaze if he knew something?

He met my gaze. "Yes, a Dr. Golden, I'm told. There seems to be no connection between the two men other than that both were involved with biofeedback, which makes me wonder if they were attacked by some psychotic individual who's opposed to our work. I've mentioned that possibility to the police, because that would mean any one of us could be next."

He was insinuating that the killer could be one of Dr. Zimmer's DAHM members and he may have been right, but that wasn't a tack I was interested in pursuing just now.

"Dr. Golden's a friend of mine. Do you remember him?"

"Yes, I believe we talked a bit at a party Friday night."

"Another friend and I were the ones who found him. Someone hit him over the head and left him out in the snow to die."

"How terrible. Is he a close friend?"

"Yes."

"I'm so sorry."

"Vill he all right be?" They were the first words Gerta had uttered.

I struggled to keep my voice steady. "I don't know. I hope so."

"I vill pray for him," she said.

"Thank you."

They turned to go and while I was racking my brain for some way to keep the conversation going, Jeremy saved the day.

"'Scuse me," he said to me, "but I've gotta get this stuff packed away. Which disks did you want?"

"Um, I don't know. I guess a set of the double-blind control studies." I tapped Freundlich on the shoulder. "Dr. Freundlich, what would you recommend?"

He turned back. "Why don't you give Ms. Carlin a set of the brain maps you took of the conferees?" he said to Jeremy. "No charge for those." He smiled down at me. "We mapped before-and-afters of several people who were experiencing varying degrees of pain. Your friend Dr. Claughton is a perfect example of how effective this therapy can be. You can order a set of the double-blinds but those will take several weeks to arrive."

"That's very nice of you. Thanks so much," I said, putting all the fawning adulation I could dredge up into my voice. "I can't wait to get back to my room and look them over." I turned to Jeremy. "I'll have a set of the double-blinds as well," I said to him. I pulled out my wallet and handed him my credit card.

"That'll be—" he began.

"Whatever," I said quickly. I had to think of some way to talk to Dr. Freundlich before they left. Gerta's back was to me, so throwing caution to the winds, I fluffed my hair and gave *Hubie* a good imitation of one of Nadine's come-on-a-my-house smiles.

"I hope you won't think me presumptuous even asking under these circumstances but well, we all have to eat. I was wondering if you'd care to join me for lunch tomorrow. It'd be such a thrill for me to be able to talk with you after I've had a chance to look these over."

Ted was not going to be happy with me.

Freundlich flashed me the full gleaming thirty-two. "What a pleasant idea. Some of my staff may be leaving tomorrow morning. Let me check and see what their plans are and let you know. What unit are you in?"

"Mountainside forty. It's the condo complex at the foot of Stonycreek."

As I signed the slip and gathered up the half dozen disks Jeremy handed me, Freundlich moved closer to me.

"If we can't make lunch," he said softly, "perhaps I'll be able to find a few moments to stop by your room and go over the results with you."

Ted *was* annoyed with me, but it was about my having "gone fishing" without him. It was nothing, however, compared to the hell I caught from Rich when, at about ten o'clock, the phone rang. The events of the previous day had made it to the front page of the Rutland papers. Under the bold headline, SLAUGHTER ON SNOWRIDGE SLOPES, one of the more tabloid types had graphically and luridly described the murder of Charlie Anders. My name was mentioned as a colleague of the victim who, along with a Dr. Joseph Golden, had also been the target of an attack. Rich was in an uproar.

"What is it with you?" he shouted. "Do you have a death wish? D'you walk around with your own personal black cloud hanging over your head? You should join Special Forces. You're a one-woman assassination squad. People drop like flies wherever you are!"

His assault caught me off guard and the palms of my hands went clammy. I was starting to believe that what he said had some validity. "Nobody's dropping like flies, Rich," I said, finally managing to get words around the lump that was forming in my throat. "And none of it had anything to do with me."

"Yeah? Well, why was somebody shooting at you? What the hell am I supposed to tell the kids? They saw the article. There were bullet holes in the picture window of Mountainside forty-one! That's the unit you were in, wasn't it—the one we used to stay in? They freaked out. They're worried sick about you."

"Unlike their father," I said, angry and unreasonably wounded at the same time. "Tell them it was a case of mistaken identity. I'm fine. And thanks a lot for your concern."

"Just get the hell away from that place. Go home. Not that your being home will necessarily make a difference," he added.

"I'll go home when I damned well feel like it!" I fought to stay calm. "When are you bringing the kids back?"

"Hell, I don't know. Maybe never. You're a jinx. Nobody's safe

around you. Maybe I need to do something about the custody arrangement."

I felt like I'd been kicked, and for one terrible moment I lost the power of speech. A throbbing pain started in my head and a red haze fogged my vision. I had to sit down. I was shaking all over. My fingers went limp and the phone dropped from my hand. Ted walked over and picked it up. I heard the fury in his voice.

"What the hell have you been saying to her, Burnham?"

There was a brief pause in which I presume Rich told him exactly what he'd said because Ted's next words were spoken in the chilling, measured tone I'd heard from him only once in our relationship, a time when I'd lost it and denigrated him and all cops and the work he'd spent his entire adult life doing.

"I'd be awfully careful what I did if I were you, pal," he said softly. "I think you'll find judges today aren't real sympathetic to Gary Condit types when it comes to placing minors. They might be inclined not only to leave custody as is, but to limit your visitation rights." His voice dropped lower and the menace was unmistakable. "And I'm just the guy who'll see to it that that's the fucking way it goes down."

There was long pause and then Ted said pleasantly, "Good. I'm glad we understand each other. Now, why don't you have the kids call Carrie when they get back to the room so she can tell them herself that she's okay?"

Did I mention there's a reason I love this man? Not that the encounter with Rich deterred him from letting me know his feelings on the subject. He gave me a few minutes to compose myself, which wasn't enough time for the pain to completely subside. I was still holding my head and blubbering when he sat down on the couch beside me.

"He's a sonofabitch," he began. "But you can see how reading about you in the paper could—"

"He called me a jinx." I dug around in my pocket for a tissue, found one, and blew my nose. "I used to be his lucky charm."

He sighed. "You still don't get it, do you?"

"What?"

"You still let what he says throw you. You keep expecting him to behave toward you the way he did when you were together. He isn't going to. He was a different man then."

"I know that," I said. "But he was never vindictive. It's like he's turned into somebody else, a total stranger."

"Things happen. People change."

"Oh, God, he said that to me the day he left. I told him you're supposed to grow, not become a scumbag."

Ted smiled. "Maybe he always had a bit of the scumbag in him. You just never saw it because it was to his advantage to have his cake and eat it, too."

"He's never threatened to go for custody before. What will I do if he actually tries it?"

"I think he's changed his mind about that."

I'm not the hand-wringing type but I was wringing my hands. "But if he decides to and he tells a judge everything that's happened to me over the past couple of years he could convince him I'm a jinx. Because I am. Even Meg said—"

He reached over and put his arms around me. "You're not a jinx. You're—well, you're more of a—"

"Yeah? What?"

"A lightning rod."

"Oh, great. Thanks a lot."

"It's not an insult. Things happen to you. But that's a good thing, too."

"Really? How's that?"

"You care about people. You get involved. Rich doesn't care about anyone but Rich. He may not always have been so self-centered, but that's who he's become. No judge is going to give him custody and when he cools off he'll realize he doesn't even want it. Too much responsibility. He prefers being the knight who rides in to save the day when you—after you—"

"Screw up," I said, coming up with the word he'd been searching for. "I don't know why I didn't tell him off, though."

"You did okay."

"He scared me so much when he threatened to take the kids, I

just fell apart." I relaxed and leaned my head against his shoulder. "Thanks for doing it for me."

After a few minutes he gently dislodged me, swiveled around, and cupped my face in his hands. "Which doesn't mean you don't ask for it some of the time. Like now. We should go home as soon as Patrick gives the okay."

I pulled away. "How can you talk about leaving when Joe is—"

"You can't do anything about Joe's recovery. He'll either come out of it or he won't. There's a twenty-four-hour guard on his room. He's safe for the moment. You, on the other hand, may still be in someone's crosshairs."

"What?" I was stunned. "I thought we agreed Nadine was the target."

He shook his head. "Think about what Joe said to you in the ambulance."

"He said he had to get away."

"He may have said that. Or he may have been trying to tell *you* to get away. It was you and Joe who were sitting with Charlie at lunch Saturday. Nadine wasn't there. Right?"

"Yes."

"You told me Charlie was upset and drinking heavily and you were doing your usual Curious Georgette thing asking questions, pushing him to tell you what was bothering him. According to you he was just about to do that when Dr. Freundlich came in and took him to the celebration at The Cove. Right again?"

"Yes, but—"

"Let me finish. There were other people from the conference in the restaurant at the time. What if the killer overheard part of that conversation? Or what if Charlie and he got into an argument, and for spite Charlie told him he'd spilled the beans to you and Joe?"

I was impressed. Even without knowing what I'd just found out about the shouting match in The Cove, Ted was fitting the puzzle pieces together.

"Okay," I replied. "I admit what you say makes sense because I heard there was a nasty row between Charlie and Freundlich Saturday after the lifts closed, and Freundlich fired him."

"Who told you that?"

"An old friend, Julie Aston, who runs the ski school here. She said somebody heard them going at it, one of the waiters, she thought."

"Good. I'll let Patrick know about that in case he hasn't already been told."

"Oh, come on. Mayer still thinks Joe came up behind himself and bashed himself over the head."

"She's off the case."

"Really? How did that happen?"

He grinned. "You can thank Dr. Rosen. He made a lot of noise when she dragged her feet arranging for the guard outside Joe's door."

"Remind me to pin a gold star on Dr. Rosen next time we see him."

"Which I hope will be tomorrow on our way home."

I was determined to stay so I could meet with Dr. Freundlich. If he wasn't guilty himself (and despite the altercation with Charlie I didn't believe he was) I was sure, knowingly or unknowingly, he held the key to Charlie's murder and the attacks on Joe and me. And without flattering myself, I was equally certain he wasn't going to pass up the opportunity to put one more notch in his belt if he thought he could pull it off.

"Let's take it one step further," I said. "If the perp thinks I know something, why wouldn't I have told the cops already? He must realize by now that Charlie didn't tell me whatever it was, so I'm no longer a threat to him. It'd be stupid for him to do something that might get him caught when there's no reason for it."

"I've thought of that. It's the only reason I haven't insisted on protection for you," Ted replied.

"How long can they hold me as a material witness?"

"Unless the shit hits the fan again, we can leave tomorrow."

"But I want to stop by the hospital and see how Joe's doing..."

"We go through Burlington on our way home. We can talk to Dr. Rosen and if Joe's conscious we can see him."

How could I explain to Ted that I couldn't leave if Joe were still

in a coma? How do you explain to the man you love that you have feelings for another man? Not sexual feelings, but feelings nonetheless. I wasn't worried about Ted being jealous. How could he be now that we knew Joe was gay? But I couldn't leave till I was sure Joe was going to be okay.

I needed at least one more day. Despite what Ted had said I didn't have much faith in Patrick's finding the killer. Soon he'd have to let everyone leave, and the bastard who'd killed Charlie and half killed Joe would get away with it unless Ted and I stopped him. And if Freundlich could supply a couple more pieces to the puzzle...

"Wouldn't you love to get in just one day of skiing?" I cajoled. "Julie told me they're going to start running the lift again. You haven't been out on the slopes at all and I haven't skied since Thursday. It's cleared up and they said tomorrow will be warmer." I nuzzled his neck. "I'd be safe with you."

He sat back, folded his arms, and regarded me through narrowed eyes. "You're up to something."

"No, honestly," I said, assiduously studying my bitten-to-the-knuckle fingernails, "I just think we deserve some fun. These past few days haven't exactly been the best vacation we've ever had."

"It hasn't been a vacation at all. I'll owe you one."

I could tell there was no moving him. No way was he going to put Joe's well-being above mine. I, on the other hand, had no intention of giving in. But I didn't want to start a fight, particularly tonight. Rich had sapped my energy. I'd think of something by morning.

"I'm starving," I said, jumping up. "I wonder if that pizza's still edible." I trotted to the table, opened the box and picked up a piece. It flopped over like an overcooked celery stick. "Yuck."

Ted came up behind me and looked over my shoulder. "Go take a nice hot bath. I'll crisp it up in the oven and bring it in to you."

Which ten minutes later he did, along with a hot toddy and his naked body.

I managed to down the whole cup and two slices of pizza before I lost all interest in food.

<p style="text-align:center">* * *</p>

Ted was asleep the minute his head hit the pillow. Normally, a hot bath followed by the sort of sexual calisthenics in which we'd just indulged would ensure me seven or eight hours of uninterrupted dreamless slumber. Not tonight. Exhausted as I was, sleep wouldn't come. I tossed and turned, rolled from one side of the bed to the other. Despite my bold words to Ted, I was a little scared. Just a few short days ago I'd arrived here looking forward to this conference, to meeting a man whose work I'd admired and to learning techniques from him that would enhance my ability to help my patients. My lover and my children were going to join me and we were going to spend the rest of the week skiing, eating, and making merry. Now one man lay dead, another for whom I cared deeply lay in a coma fighting for his life, and there was a possibility that someone was gunning for me.

I began to ask myself some discomforting questions. *Was* I a lightning rod? Did I set myself up for these things? Contrary to Rich's assessment of me, I don't have a death wish. But was there something in me, as Flo Zimmer had suggested, that liked living dangerously? Was I being foolhardy and irresponsible to my children? Could I be allowing my anger at the attack on Joe to cloud my judgment? Or was my motive in wanting to stay here and bring this killer to justice about more than my feelings for Joe? Was it ego, my belief that Ted and I could ferret him out whereas the detectives up here weren't as smart as we, and were allowing it to end up as one more cold case? Maybe yes to all.

Grisly images from the past couple of days played over in my mind like trailers from a horror film: Charlie's body dangling from the lift for that one brief terrible moment, then tumbling head over heels down the mountain; a gray-faced Joe as he lay on the gurney in the ambulance, desperately trying to get words out to warn me, if Ted was right, to get the hell away from here. Maybe I should follow that advice before my luck ran out.

I curled around Ted in the hope that his somnolence would be catching. No such luck. I pulled away, lay on my back and went through an entire Schultz progressive muscle relaxation exercise. I deep-breathed, imagining the tension in my body flowing out

through the ends of my fingers and my toes. I put myself in my safe place, a tranquil white-sand beach in Maui. When I was finished my body was completely relaxed, but my mind refused to banish the ghosts. I gave up, eased myself out of bed, threw a blanket over my shoulders, and tiptoed into the living room. My eyes fell on my laptop and the complimentary set of disks Dr. Freundlich had given me. Something to do, I thought, that would focus my mind.

I didn't turn on the overhead. The light from a lamp on the end table and my computer screen were sufficient illumination. I inserted the disk and waited impatiently for my computer to boot up.

Chapter Eighteen

TED FOUND ME in the morning fast asleep with my head resting on my laptop keyboard. The blanket had slipped from my shoulders and I woke at the sound of his voice, shaking with chills and fever.

"What in God's name are you doing out here?" he asked, throwing the blanket over me. "The heat's gone off. You'll catch pneumonia."

I was thinking the future tense was off the mark. Right now, this minute, pneumonia felt like a distinct possibility. "I couldn't sleep," I croaked. "I thought I'd—"

"Christ, listen to you. Go back to bed. You sound like a bullfrog."

"What time is it?"

"Eight-thirty. Go on. I'll make you something hot."

Meekly I complied. I didn't have the energy to argue. I struggled to my feet and dragged myself into the bedroom, trailing the blanket

after me. My head throbbed, my throat felt as though I'd swallowed a cactus, and my muscles screamed for mercy. I crawled under the covers and lay on my back fighting to control the shivering, wondering how I'd gotten so sick so fast. I tried to remember what it was I'd seen on the disks last night, something I'd wanted to tell Ted about. But my head was muddled and I couldn't remember. Gingerly I touched my forehead. It practically sizzled.

Ted came in carrying a steaming cup of something. He placed it on the bedside table, sat down beside me, and helped me to a sitting position.

"Ow, ouch, don't touch me!" I shrieked.

He pulled back as though I'd jabbed him with the cactus. "Why? What's the matter?"

"I must have fever," I moaned, struggling to a half-sitting position. "My skin gets sensitive when I have fever. I can't stand to be touched. And I get cranky."

"No kidding. Your nose is running, too," he said, placing a box of tissues next to me and handing me the mug. "Drink this. It's hot cider. It'll warm your innards. I'll get dressed and go get tea bags and aspirin."

"Thank you," I mumbled, taking a tentative sip. The scalding liquid slid down my throat, minimally blunting the cactus thorns.

"Guess we're not going anywhere today," Ted called from the bathroom. "Seems like you'll do just about anything to keep us here."

He didn't sound as though he were joking, and I didn't find the remark funny. I lay on my bed of misery sipping cider, listening to the drumming of water beating on tile, wondering if there could possibly be some truth to his accusation. Had I deliberately made myself sick to avoid having to go home today? From a psychological point of view, it was an interesting theory. Intellectually, it would've been plain stupid. Thinking about it made my head pound. What could I hope to accomplish lying here, unable to tolerate being touched, when I had to keep my assignation with Dr. Freundlich this afternoon? Assignation. What was I thinking? Raving delirium must be just around the corner.

I polished off the cider, blew my nose, lay back, and considered how my years of training as a biofeedback practitioner might work for me now. On the off chance that I had subconsciously done something to make myself sick, it followed that I could consciously work at making myself better. I'm not saying I believe I could cure myself in an hour or even a day, but I could speed up the process. The mind is a powerful tool. I teach self-healing: mind/body connection. Sometimes just shifting a person's perception of her or his condition from helplessness to active control is empowering and brings about positive changes. I'm a whiz at employing the techniques of self-talk, guided imagery, and self-hypnosis to help my clients participate in their own healing process.

"I have control over my body." I spoke aloud to pump myself up. "I have the ability to condition my mind with my own self-directions, to keep myself fit and healthy. Good health comes naturally to me. I have the power to heal myself."

The shower stopped. "Who're you talking to?" Ted called.

"Nobody," I tried to shout but my voice cracked and almost disappeared.

"Can't hear you. Be right out."

No point in trying to respond. "I have the power and the will," I mouthed. "My lungs are clear and strong. I can breathe deeply and fully." The diaphragmatic breath I took to prove the point set off a fit of coughing that left me gasping on my pillow, limp and exhausted.

Okay, maybe this was early in the progress of whatever bug I'd caught to self-talk my way out of it. But I had a Plan B. Guided imagery. I've had a few patients who've mastered this technique and have significantly altered the course of their illnesses. Martin Groves, a twenty-nine-year-old teacher, came to me last year suffering from severe back and neck pain. He'd been seen by several medical specialists, also a chiropractor and a physical therapist, and had been told, essentially, *get thee to a psychiatrist.* He'd decided to try biofeedback instead. We worked on a visualization in which he imagined the pain as a red-hot piece of coal lodged at the base of his neck. Daily, and at each session, he imagined himself pouring jets of ice-cold water over it. Over time in his mind, the coal turned darker in

color, became smaller, and eventually turned to ash and disintegrated. When the coal dissolved so did the pain. To be absolutely honest, that was just about the time he dumped his pain-in-the-neck girlfriend, so I was never quite sure if it was getting rid of her or the visualization that cured him. Probably a combination of both.

I'm a good visualizer. I practice alpha/theta training, a technique that, like NASA's astronauts, we biofeedback aficionados use to exercise the brain and bring about peak performance. I'd never tried using guided imagery to cure the common cold. But who knows, I might be on to something.

I closed my eyes and did a body sweep starting at the top of my head and working my way down, relaxing each muscle separately, which was a real challenge considering that every part of me felt like I'd been run over by a herd of buffalo. I forced myself to breathe slowly, mumbling my mantra over and over, "I am calm, ca-alm, ca-aalm," until finally I felt myself drifting off into a dreamy meditative state.

And an image popped into my mind.

A porcupine. The porcupine is wedged in my throat and the quills are sticking straight up. I see myself as a tiny figure moving inside my body, approaching the animal, talking to it softly as if it were one of my cats. As I talk it allows me to get closer and closer until I am standing next to it. I sit down and the quills start to flatten out and the porcupine puts its head on my lap and I begin petting it, and finally the quills become as smooth as a kitten's fur and the pain in my throat eases. And the scene changes.

I'm immersed up to my neck in steaming, bubbling water, sitting on an underwater bench in a hot tub. The heat penetrates all through my body; bath oil coats and soothes my skin. Around me I can see tendrils of steam rising. I can feel the force of the jets against my back and my shoulders, massaging away the aches. I begin to feel very comfortable, almost languid. I hear voices and I'm aware that I'm not alone but I can't see anyone through the mist. My eyes close as I concentrate on the beating jets. Then a hand comes from behind me and touches my forehead and miraculously the headache disappears. The hand moves down my body to my neck, my shoulders, my back. Each place it touches I feel a tingling, warm sensation, and the skin becomes

less tender. I try to see who the magician is but my head won't turn. Then someone splashes water in my face and I'm momentarily blinded, but I hear Flo Zimmer squawking, "Bawk, bawk, chicken," and Freundlich responding, "A revolution, right, Scarborough, Scarborough, Scarborough?" And then I hear Charlie Anders shout, "Lips sealed, lips sealed," and through the churning spray I make out the hands that were on me pushing Charlie down, down beneath the water. And a voice I don't recognize hisses, "Sealed."

I forced my eyes to open. My heart was beating like a metronome set at double time.

"Want anything besides the tea and aspirin?" asked a distant voice. "Could you eat an egg?"

I was disoriented and not a little shook up by the visualization. Occasionally, one will carry you somewhere you don't want to go, what we call having an abreaction.

"Scarborough?" I whispered.

"So that's who you dream about when you're delirious." Ted's amused voice drew me back from the depths. "Sorry to disappoint."

I came out of my fog and pulled myself up on my elbows. I was sweating so I guess you could say the visualization had accomplished something. "Scarborough," I said again, my voice coming out unrecognizably gravelly. "I remember now. That's what I wanted to tell you. There was something peculiar about his EEG."

"His what?"

"His brain waves. His high beta was off the charts."

"I don't know about his high beta but there's something definitely peculiar about your voice. Maybe you should give it a rest."

I pulled Ted down next to me. "Listen to me," I croaked. "I'm talking about specific waves on his brain map. All the other people Jeremy brain-mapped who were complaining of pain showed positive changes on their EEGs after Freundlich's new protocol was applied. Scarborough's was the other way around. It showed negative results and his amplitudes were—"

"Maybe the protocol doesn't work on everyone."

"That's probably true," I said, "but there should be some changes in his pain profile. His showed a significantly higher stress level but no pain reduction at all."

"So what? What difference does it make?"

"I think something's eating at Scarborough. I don't think anything goes on at Freundlich's lab that he wouldn't know about. What the brain map is showing is that his high beta, his anxiety level, is so elevated he might be at the breaking point. If we can just get him to talk to us..."

Shaking his head, Ted got up. "Damn, and I forgot my thumbscrews."

"Will you be serious? The research that's being done today indicates—"

"Patrick interrogated him and came up empty."

"He didn't know the right questions to ask."

I saw the muscle at the corner of his mouth twitch. I didn't want to challenge Ted regarding the competence of any of his compadres. The last time I'd done that the scene that had followed wasn't pleasant.

"Ted, I know what I'm talking about. This is my field. I'm sure I'm onto something here."

"I don't know how to get through to you," he said, impatience sharpening his tone. "I don't want to talk to Paul Scarborough. And I don't want you talking to him or Freundlich or to any of those people."

Sick as I was, I could feel my hackles rising. "What?"

"What I want is for us to get the hell away from this place." He picked up his jacket from the chair. "You want me to get anything for breakfast? Eggs and English muffins, maybe?"

"Get whatever you want." I flopped over on my side, turning my back on him. He didn't answer and I heard him close the front door and turn the key in the lock.

"Control freak!" I croaked at the closed door. I rolled onto my back and stared at the ceiling, feeling angry and frustrated. How dare Ted tell me who I could or couldn't talk to? And he hadn't even given me a chance to explain about the research.

I'd suddenly remembered the Pinocchio effect—the research employing EEG for lie detecting. When Jeremy had done my brain map he'd asked some basic questions to get a baseline for the pain research. I'd never gone back for an "after" because I wasn't a pain subject, but Paul Scarborough had. I tried to remember which question had caused his high beta amplitudes to spike, and went over them in my mind. Name, address, marital status, level of education, where the pain was and the degree of its intensity on a scale of one to ten. Wait a minute, level of education—that was the one. Something was screwy. I sat up and picked up the handout I'd left on the bedside table; ran my finger down the list of names and found him. Dr. Paul Scarborough, Oslo 31. On impulse—or maybe to defy Ted—I picked up the phone and dialed Scarborough's room.

It rang four times before he answered.

"Scarborough here."

"Dr. Scarborough," I said. "This is Carrie Carlin."

"Who?"

"I'm one of the conferees. I'm sorry to disturb you, but I'm doing bio sketches on all the panelists for my local chapter's newsletter, and I wondered if I could interview—"

"I wasn't on a panel."

Damn, I hadn't realized that. "Oh. Well, um, perhaps you'd be able to give me some background on—"

"Sorry. I don't give interviews," he said curtly, and clicked off.

Well, Ted didn't have to worry about my talking to Paul Scarborough.

I thought about Joe. He'd understand about the changes in Scarborough's EEG, and that it could mean something. To Ted, fair-minded as he was, changes in brain wave activity or high beta levels on a brain map were on a par with psychic predictions. In his mind neither had a significant place in crime solving.

It was more than twenty-four hours since we'd taken Joe to the hospital. I prayed that his condition had improved and that he was conscious. I reached over to the bedside table and picked up the phone again.

Chapter Nineteen

JOE'S VOICE sounded weak but he was lucid. I was so relieved and happy to hear that he was out of Intensive Care and that Dr. Rosen felt he'd fully recover, I blubbered all over the phone, completely forgetting the reason for my call. There was a problem with frostbite on a couple of his toes, Joe said, but the doctors were optimistic about being able to save at least one of them. He thanked me for getting him to the hospital in time.

After I'd calmed down, I asked him what he remembered about what had happened that night. His recollection was hazy. He remembered going to The Swiss Chalet for dinner—eating too little, and afterwards at the bar, drinking too much with a bunch of fellow conferees. The entire conversation had centered on what had happened to Charlie Anders and he figured that in his inebriated state he must have mentioned having had a couple of meals with Charlie. Like Ted, he suspected the assault on him had something to do with

the perp thinking Charlie had told us *the secret*. He had a vague recollection of leaving the bar quite late, and after that coming to and being so cold he couldn't move. He remembered thinking he would freeze to death, and calling for help. And he recalled having a moment of clarity on seeing me in the ambulance.

"All I can think is that whoever did this heard me spilling my guts, and thought I knew more than I do," he finished. "Maybe he thought Charlie had slipped one of us something at that lunch."

"Slipped us something?" I asked. "What do you mean? A note?"

"I was thinking a tape, maybe. Because of what Charlie said about needing to cover his ass."

"When did he say that?"

"I thought he—didn't you ask him what he meant by CMA?"

"CMA means cover my ass?"

"Far as I know. So I was thinking maybe he made a tape."

A tape or a disk! My heart started beating wildly. "The police searched his room. I don't think they found anything."

"Well, I don't know then," he said. "Maybe that wasn't what he meant."

He sounded exhausted and I didn't want to be the cause of a relapse so I didn't ask who or what had precipitated the fight at the lift line, but I did bring up Scarborough's elevated high beta. "I think Scarborough knows what this is about and he might be ready to cave. But Ted wants out of here by tomorrow so I don't know if I'll have a chance to—"

"He's right. You ought to leave, Carrie."

"Is that what you were trying to say in the ambulance? That *I* should leave?"

"Yeah. Because if I talked too much, whoever came after me might think you know something, too."

I thought it best for his recovery and peace of mind not to mention the ski-by shooting so I repeated what I'd said to Ted. "I doubt it. He'd've figured out that if I knew something I'd've told the cops by now."

"Even so," he said. "Don't stay around for me. I feel guilty enough as it is. If they don't have to operate on my toes, they'll

probably throw me out of here soon. And if the cops will spring me, you can bet I'll be on the first flight out."

I decided not to pursue what he'd said about a tape because if Charlie had recorded something I had an idea where to look and I didn't want Joe to try and stop me. I promised to leave in the morning, told him I'd pack up his things and leave them in the office, and said good-bye.

When Ted came back I pretended to be over my snit. But I wasn't, so I didn't tell him that I'd spoken to the hospital. I didn't tell him that Joe had regained consciousness and that his condition had improved enough for them to move him out of Intensive Care. And I didn't tell him that they'd put me through to his room.

I felt guilty about deceiving Ted but he'd been obnoxious, giving me orders as though I were one of his underling detectives. And he didn't ask me about Joe so I hadn't outright lied. Sins of omission. Wasn't that a Catholic thing? But Jews are good at guilt trips, too, and I especially, having lived with a liar, believe in absolute honesty in a relationship. I was torn but it didn't stop me from compounding the felony. Because, I rationalized, my motive was pure and it was in a good cause.

"As long as we're stuck here for another day why don't you take advantage of the great conditions and get some skiing in," I remarked to Ted after I'd thanked him for the tea and scrambled eggs and swallowed two aspirin, a giant cold capsule, and a godawful tasting cough drop that had completely numbed my throat. "You don't have to pamper me."

"How's your skin?"

"Better. You can touch me."

"Is that an invitation?"

"Consider it an IOU." I was being so flirty-cutesy I was making myself nauseous on top of everything else. "I'm still achy, but the fever's broken. I think, if I can grab a few hours' sleep, I'll be okay to travel tomorrow," I added.

Seeing through me, he regarded me suspiciously. "Why the sudden change of heart?"

"Excuse me?"

"Why are you so willing to leave tomorrow with Joe still in the hospital?"

"Like you said, I can't really help him by staying and I should be home in case Rich brings the kids back early."

I was going to hell for this even though I don't believe in hell.

Ted dropped a kiss on my forehead and took my hand. "Sorry about before."

Avoiding his eyes, I gave him a Flo Zimmer-insincere no-teeth smile. "It's okay."

"I think I might take you up on the skiing."

"It'll do you good." When he continued to hold my hand without moving I yawned and said, "You should get going. You have to buy a ski pass and it's good to get to the lift while the morning skiers are at lunch. The lift lines are much shorter then."

"Okay." He gave my hand a squeeze and heaved himself out of his chair. "Get some sleep."

"I will." I yawned again and watched him buckling on his ski boots through eyes half-shut.

"I'm taking my cell phone with me," he said, looking up from his boots, "so call if you need anything. And I'm double-locking the door. Don't open it for anyone but me."

"'Kay." I squeezed my eyes shut to keep him from looking into them, sure my uncooperative conscience would betray me. "Julie said the snow on Rolly's Peak is much better than on Stonycreek," I said, thinking that would keep him out of my hair for at least three hours. "Hasn't been skied off yet."

"How do I get there?"

"You can take the car up the mountain road to the other lift but you'll have to take your ski boots off to drive. Or you can take the Stonycreek lift to the top and ski across."

"Like your killer may have done."

"Yeah. Like that."

"Interesting. I think I'll go over the top," he said.

So you're not as uninterested as you'd like me to believe, I thought, satisfied.

"Have fun," I said, rolling over.

"Feel better," he replied.

You're going to pay for this, you conniving bitch, hissed my conscience.

I stayed in bed for a while in case he'd forgotten something and came back. I was feeling better. Not perfect, but at least I wasn't falling down. My first steps were wobbly, but I steadied myself on the wall as I made my way to the bathroom. Keeping an ear open for the phone in case *Hubie* called about lunch, I rejected my usual bath in favor of a hot shower. The heavy spray pounded away the aches. I washed and blew-dry my hair, brushed my teeth, and donned my standard Vermont garb. Normally this takes less than half an hour but I was dragging, and by the time I got to my hat and mittens, I'd used up almost a full hour of my precious time. I was out the door when I remembered my key chain with my pepper spray canister. Not that I expected to need it, but Ted's lightning rod comment stuck in my head. I dug the key chain out of my purse and put it in my pocket, along with the condo key and a handful of Kleenex.

Fifteen minutes later I was standing outside the convention center. Instead of crossing the mall, which would've taken me too close to the lift, I chose the long way around, following the road down past the bubble-covered swimming pool and tennis courts, and circling up behind the office. I didn't want to take a chance on running into Ted. I made it to one of the ski racks near the convention center, and pretended to be searching for my skis while I checked out the lift line. Ted's jacket was dark-colored, unlike mine, which is a bright metallic magenta (purchased deliberately so that the ski patrol can find me if I'm ever lost in an avalanche). It would've been difficult to pick him out from the other skiers snaking their way through the line. But even if he were there I didn't think he'd be looking my way, although Ted does have a cop's habit of observing everything around him. With that in mind, I ducked my head and scooted as fast as I could to the center's entrance.

There was no uniform at the door to check my ID and for a minute I thought the building might be locked up. I tugged at the

handle and the door gave easily. Once inside I stopped to catch my breath. A tickle started in my throat and a spasm of coughing gripped me. It hurt my ribs and tore at my mangled throat, and lasted for a couple of minutes. When it was over I was totally wrung out and my nose was dripping like a leaky garden hose. I stopped the leak with a bunch of tissues, and forced myself to move on to the demo room.

Passing the hospitality suite I heard voices. I'd thought that most of my fellow conferees would be leaving today, so I was surprised to see groups of them sitting at tables drinking coffee. Dr. Geissing, dressed from head to toe in mourning black, was standing at the front of the room next to the bulletin board, shifting his weight from foot to foot, and looking as though he'd rather be any place but here. I shifted my gaze to the table just inside the entrance that held the large coffee urn. Coffee. That's what I needed.

I turned my collar up, sidled up to the table and poured myself a cup of the hot brew, letting it slide down my throat, pacifying the porcupine.

"...a notice under your doors about this meeting," Geissing was saying, "so I'm happy to see such a good turn-out. Last but certainly not least, Dr. Freundlich has asked me to let you know that he'll make himself available from seven to ten this evening in his villa at Copenhagen twenty-six, to speak with anyone who has questions regarding the pain protocol. If you're interested, he's asking that you sign up now or call Ms. Donovan at Copenhagen twenty-two, so that she can space appointments."

Briefly, I wondered why I hadn't received a notice about this meeting, but decided that could've been because I'd changed units.

"You can also place disk and magnet orders in case you neglected to do so up till now," Geissing added. He paused to mop his brow with his handkerchief. It wasn't hot in the room but he looked ready to pass out.

"I'd just like to add," he went on, "on behalf of the committee how sorry, how appalled we all are about the, uh—horrific incident that has cut short our conference. We realize that many of you were looking forward to being on and attending panels that never took

place so we'll be refunding half your conference fee." He paused. "Thank you for your patience through this unpleasantness. Have a safe trip home."

There was an appreciative murmur among the conferees as people got up and began congregating around the bulletin board. I noticed that Dr. Geissing left immediately without stopping to speak to anyone. I quickly followed suit.

The demo room was deserted as I'd hoped it would be. The computers and software had all been boxed up and removed. Chairs were stacked in a corner and the long rows of tables were bare except for one table that still had some flyers and brochures piled on it. Sunlight filtering through the windows illuminated the room so I didn't switch on the overhead lights. Several of the tables had taped cartons lined up underneath them and I tried to recall which table had been the techie's. Somewhere in the middle of the room, I thought. Half-bent over, I crept up the aisle peering at the writing scribbled on the various cartons. It didn't take me long to find what I was searching for. Under the fifth table was one small box marked MAGNETS and four medium-sized cartons clearly marked HF—DEMO DISKS. With one eye on the door, I gave myself thirty seconds to change my mind. For what I was planning to do, the charge was first-degree burglary. That's if I found what I was looking for. If I didn't I'd probably get away with a simple breaking and entering. And Ted would be so pissed he'd probably leave me to rot in a Vermont jail.

Thirty-one seconds later I was on my knees ripping the tape from the first carton. I flipped through the disks. They were alphabetized, making my search easier. Except that this carton contained the S's through Z's. I needed the A's. I'd started at the wrong end. If the techie, Jeremy, was as organized as I hoped he was, it would be the fourth carton and Charlie's disk would be toward the front. I scooted to the other end of the table, tore the tape off the carton, and flipped through the A disks—ABBOTT FRANCES, ABRAMS LYLE, ACKERMAN JAMES, ALSTON BARBARA, ANDERSON CHARLENE, APPLE-BAUM DANIEL, ARDSLEY—I flipped back, thinking I must have missed it. But there was no disk for Charlie. Maybe it had gotten misfiled. Or maybe there wasn't a disk at all. Maybe I'd guessed

wrong and Charlie wasn't going to point a finger at his killer from the grave. I went through the rest of the A's and was starting to look through the B's when suddenly the door was pushed open, someone hit the switch, and light flooded the room. I was trapped. I scrunched down behind the boxes, curled into as small a ball as I could manage in my bulky ski clothes, and prayed for a miracle. Like they say, there are no atheists in foxholes.

"...can't remember," a female voice whispered.

"Forget it. Come 'ere," came another voice, definitely male.

"But you were there—" whispered the female.

"Shh. Man, you are one hot babe."

"I am?"

"Totally."

There was silence and some rustling of clothes and a couple of moans. Then the woman giggled and it sounded familiar.

"Now? Right here?" she whispered.

"Nobody's coming. I'm supposed to lock up."

Another giggle. "It's too dangerous."

"Come on. Where's your sense of adventure?"

Peering around the boxes, I could see two pairs of after-ski boots, one horsehair and one black, intertwined.

Oh, God, I thought. I'd better cough or something.

"Lock it first," said the female.

Help, I don't want to hear this. I clapped my hands over my ears, then the door opened again and the boots jumped apart.

"Hey, you. Can you help me?"

It was a voice I would recognize anywhere. Flo Zimmer's jumbo Nor'easters came toward the black after-skis.

"I want a set of those double-blind study disks."

Horsehairs retreated to the doorway. Black boots moved to intercept the Nor'easters.

Man: (pissed off) "I'm not—they're taking orders in the hospitality suite. You'll have to ask in there."

Zimmer: "Nah, I'll just wait here till somebody comes."

Man: "The conference is over. I'm supposed to lock this room up."

Zimmer: "Not with me here, you're not."

Man: (annoyed, black boots toe-to-toe with the Nor'easters) "Look, you're going to have to leave."

Zimmer: (strident, Nor'easters not budging) "You look. I don't like the atmosphere in the hospitality suite. It's not hospitable. So why don't you go fetch whoever takes disk orders, and get 'em in here. Because I'm not leaving till I get what I came for."

Man: (angry) "Fine! Stay here till hell freezes over!" The black boots joined the horsehairs and the door slammed shut.

I never thought I'd be grateful to Flo Zimmer, but I could've hugged her. I remained frozen as the seconds ticked by, figuring that when no one came she'd finally give up and leave. But she didn't. I peeked around the table leg. She was thumbing through the flyers; then she took a bunch and shoved them into her pockets. Feeling as she did about biofeedback therapy, I wondered why she wanted them.

And then it happened: another tickle in my throat. I swallowed hard. I tried to imagine myself sucking on that awful throat-numbing cough drop. I envisioned myself petting the porcupine, but the beast wasn't to be placated. The tickle got worse. There was no stopping it. I gulped saliva, but I knew it was hopeless. I was going to cough. I got up on my knees, pulled my hood over my head and buried my face in my collar hoping to mute the sound. But it was like trying to push lava back down into an erupting volcano. I started coughing. And I coughed and coughed until tears poured out of my eyes soaking the collar of my jacket, till my stomach cramped and my throat felt like sandpaper, and I collapsed like a rag doll flat onto the floor. When the spasm finally let up, I gasped a few times trying to catch my breath; then held it waiting for the inevitable. Silence. Maybe Zimmer hadn't heard me. Maybe she'd gone suddenly deaf. Maybe God had heard my prayers and miraculously made her disappear.

I opened my eyes and raised my head. No miracle. There she was, down on one knee, staring me full in the face, wolfish grin spreading from ear to ear.

"Well, well," she said. "If it isn't Little Red Riding Hood, the lady who gets her kicks outta livin' dangerously."

Chapter Twenty

"CAUGHTCHA with your hand in the cookie jar, didn't I?"

My mind went blank. All I could think of was a remark that Ted had once made about my hand frequently being in the cookie jar. I crawled out from behind the boxes, struggled to my feet, and slumped against the table debating whether I should bolt or try to talk my way out of it. Zimmer was on her feet now, towering over me. Bolting began to look like a terrific idea, but I wasn't sure I could make it past her to the door.

"I'm curious," she said. "What were you looking for back there?"

"Uh…" A flash of brilliance. "My credit card."

"Your *credit card*?"

"Yeah," I croaked in my new sexy voice. "I was in here last night ordering disks and either they never gave my card back to me or I dropped it."

She glanced down at the ripped-off tape. "In the box with the disks?"

"Well, it isn't anywhere on the floor. I thought maybe it'd gotten packed up with the disks by mistake." I looked her straight in the eye, pleased that my lying skills had improved since this morning. "I was too nervous to wait. I don't have lost-card protection and if someone finds it and starts using it, I'll be in terrible trouble." My eyes lit on the brochures. "Oh, I haven't looked underneath those flyers." I moved toward the corner table, but Zimmer grabbed my arm and spun me around before I'd taken two steps.

"Cut the crap. What were you looking for in those boxes? And what's with your voice?"

"I have laryngitis. I'm sick."

"I'll buy that. I don't buy that you were looking for your credit card. You were hiding."

She had me. I was too bushed to continue with the charade. I pulled a chair off the stack, sank into it, leaned my head back, and considered my options. What would happen if I brazened it out? What if I simply told her to take a hike—what I'd been doing was none of her business? What would she do? Possibility one, she might take a hike. Remote, though. Possibility two, she might call Security and they in turn would call the cops. And given that I was already not in their good graces, I'd rather not find out how that scenario would turn out.

What if I told her exactly what I'd been doing? If she were in any way involved with Charlie's murder that would be a bad idea when one considered her ability to break someone in two with one hand. I felt around in my pocket again for the pepper spray canister, allowing my fingers to tighten around the cold plastic case. Did I really believe she had anything to do with the murder, though? She wasn't at the top of my suspect list, but even if she were innocent, it would be stupid to trust her. Aside from her not being a particularly nice person, we were on opposite sides of a long-standing battle for the hearts and minds of the scientific world. If I discovered something that reflected badly on the biofeedback community, she'd use it against us. On the other hand, she was a suspect in the investigation, and she had seemed as anxious as I to nail the "maniac," as she'd put it, who'd killed Charlie. She hadn't even wanted to walk into the

hospitality suite because people were giving her the evil eye. So there were pros and cons.

"You got sixty seconds to come clean." She crossed her arms across her chest, reminding me of one of those old toy wooden soldiers my son used to play with. "Or maybe you'd like to explain yourself to a security guard."

"Okay, I admit I was looking for something else," I said.

"Yeah?"

"Joe Golden has regained consciousness." I watched her closely. If the news threw her, she hid it well.

"So?"

"I spoke to him, and something he said made me think Charlie Anders might have made a disk."

"A training disk? How would that tell you anything?"

"Not a training disk. A disk with information, saying if anything happens to him, this or that person did it."

"That's movie stuff. Who does that in real life?"

"Well, Charlie obviously didn't," I said, "because I didn't find it."

She regarded me suspiciously. "Why should I believe you?"

I was out of patience. "You just said people don't do that in real life," I snapped, unzipping my jacket. "Wanna search me? Be my guest."

She stayed put, her brow furrowing.

"You know," she said, "you might be onto something. Working with an egomaniac like Freundlich, Anders was bound to be paranoid as hell. I wonder if there's a reward. Where'd you look?"

"What do you mean, a reward?"

"If Freundlich didn't do it himself, he might offer a reward for information leading to the arrest of the killer." The wolf grin again. "Wouldn't it be a hoot if I won it?"

"It'd be a travesty."

She got down on her knees and pulled one of the boxes from under the table. "Which box did you look in?"

"The disks are alphabetized. I looked in the box with the A's. Where would you look?"

"I would look in a less obvious place."

"Such as?"

"Any box but the *A* box." She shoved a carton toward me. "Here, you take this one. I'll start on one of the others."

I glanced at the door. "What if somebody comes?"

She grinned. "We'll tell 'em we're lookin' for your credit card."

Much like politics, murder makes strange bedfellows. I joined my new partner in crime on the floor, and ripped the tape off the carton she'd shoved my way. It was the *F*'s through *K*'s and the third disk in it was marked FREUNDLICH, GERTA. I flipped through the rest of the box. There was no disk marked ANDERS, CHARLES. I flipped back and removed Gerta's disk.

"You find it?"

"No, this is Gerta Freundlich's disk."

"Lemme see."

I handed the disk over. Zimmer glanced at the name and handed it back. I put it in my pocket.

"Why're you taking it?" she asked, eyeing me suspiciously.

"I've been thinking if Charlie didn't want to be obvious, he'd leave the message on a disk that belonged to someone else."

"Be stupid to leave it on Freundlich's wife's disk."

Probably true. Charlie would have come up with a better hiding place. "You're right," I said, replacing the disk in the box. "We're not going to find it unless we crack his code."

"Ah, spy stuff," she said. "A code. Like the Enigma machine?"

"I meant we need to get into his head. I think he'd use a different name. Something not too obvious, but clear enough that someone good at puzzles could figure it out."

"Someone like you?"

"Or the cops. But I'm good at puzzles."

"Okay, Sherlock, where do we start?"

"What's Anders spelled backwards?"

"S-r-e-d-n-a." She rolled her eyes heavenward. "Sredna. It's not a name."

"Let's try anyway. Look in the *S*'s."

"Exercise in futility." But she riffled the disks. "Sabine, Sagerman,

Saltsman, Sever, Sobel, Tallman. Sorry, no Sredna. Any other brilliant ideas?"

"Charles could be a last name." I pulled the A through E box back to me and ran through the C's from Carlyle to Culver. No Charles. "All right," I said. "Let's approach this from a different angle. Charlie had to have made this disk in a big hurry."

"If he made one at all."

I nodded. "But assuming he did, he wouldn't've had much time to stash it. If I wanted to hide a disk from people who work with disks every day, I'd use a fictitious name, but I'd put some identifying mark on the disk so that, after the fact, someone could find it. Maybe we've missed it because we don't know what mark to look for."

"Too risky," Zimmer said. "Might never be found. I'd put it in a safety deposit box or give it to someone I trusted."

"Except Charlie didn't have access to his safety deposit box. And he wasn't sure who he could trust."

I wasn't about to clue her in, but she'd come up with an idea that I hadn't thought of. Charlie may not have had access to his own safety deposit box, but he did have access to the resort's. Would the police have thought to check that out?

"Face it," Zimmer said. "You don't have evidence that would lead you to believe Anders put anything on a disk. That's just something you and Golden pulled out of a hat, right?"

Actually, it had more to do with a scarf than a hat, but I decided not to bring up the events of last Saturday, including Charlie's remark about having something important to do after lunch. It could've been anything, like calling his mother or buying gifts in the ski shop.

"It was worth checking out," I said, getting up. "I give up. I'm beat. I'm going back to bed."

"Yeah, you look dead on your feet."

Unfortunate analogy.

"Coupla days' rest and you'll be good as new." She smacked me on the shoulder, and added with a snicker, "Hey, maybe you could deep-breathe your way to wellness."

I suppressed the impulse to smack her back.

"I'll be fine," I said. "I'm probably going to leave tomorrow."

"The cops letting you go?"

"I think they'll have to."

"I'll be taking off, too." She shoved the boxes back under the table and got to her feet. "Guess I'll go order those disks. Good thing that jerk didn't send anybody in here, huh? Coulda been embarrassing."

I'd forgotten about the couple whose sex act Zimmer had rescued me from witnessing. "Was that Jeremy?" I asked, casually.

"Jeremy who?"

"The technician who does the brain maps."

"I don't know him. Didn't you get a look at him?"

"No. I heard him talking to someone but I didn't recognize the voice."

"I recognized the woman," Zimmer said.

"Really? Who was it?"

"That loudmouth who was falling all over Freundlich in the hot tub."

"Kate Donovan?"

"Nah. The other one."

Nadine? Of course. Horsehair boots. That giggle.

I headed for the door. "Have a good trip back."

"Yeah, you, too. Keep out of trouble."

"You, too," I said, pointedly. I opened the door and allowed her to precede me out.

The cops must've sprung Nadine this morning. One thing about Nadine. No grass grows under her feet. Or under any part of her anatomy, for that matter. Well, I thought, like Ted said, she's a big girl, and who she gets it on with isn't any of my business.

I zipped up my jacket and headed for the office. Once there, I realized that I was on a fool's errand. I had no key, no ID that would permit someone working here to turn over the contents of Charlie's box to me. But by a stroke of luck, the young woman behind the desk was the same one who had let me use the phone the night of Charlie's murder. I was counting on a shared traumatic experience to give me the opening I needed.

There were three people ahead of me waiting to check out. I took my place at the end of the line, figuring I'd come up with a plan by the time my turn came. I was still working on it when, ten minutes later, I came face to face with—I glanced at her name tag—CORY ELLEN. I smiled my friendliest smile. "Hi, Cory Ellen," I said. "Remember me?"

She studied my face. "No, I don't think so."

"My name's Carrie. I remember you because your name's so similar to mine. Carrie, Cory, practically the same."

She continued to look at me with a blank expression.

"Don't you remember? The police brought me here Saturday night, after the—ah, accident. You and I talked and you let me use the phone to call my kids."

"Oh, yeah. You sound different."

"I have laryngitis."

"Bummer," she said. "You checkin' out?"

"I'm not leaving till tomorrow, but I thought I'd beat the crowds and settle up now. Carrie Carlin, three nights in Mountainside forty-one and three in forty. I think the last three nights are supposed to be on the house."

She nodded. "Right. Management's havin' a hairy. Costin' them a bundle."

I indicated the stack of computer-generated bills in front of her. "Looks like you've had a busy morning."

"Yeah," she said. "The cops're letting most of the convention people leave, so it's been a madhouse. This is the first chance I've had to breathe in two hours." She pulled up my bill and handed it to me. "I'll need a credit card."

I pulled my card out of my pocket, and handed it to her.

She ran it through the machine. When she handed it back, she leaned across the desk and whispered, "It's terrible to say but I'm glad it didn't turn out to be one of the instructors."

"It hits you harder when it's someone you know," I said.

"Did you know the guy?"

"I'd met him a couple of times. But the doctor who was attacked near the lift is a good friend of mine."

"No kidding." Her dark eyes warmed with sympathy. "Jeez, you must feel awful. He gonna be okay?"

"I think so. He was lucky."

Cory Ellen shuddered. "This used to be a safe place. Now I'm afraid to walk alone at night."

"I don't think you have anything to worry about. I think the person who did this is somebody connected to the convention. He's probably already gone."

"Maybe it's a freaky patient of one of the doctors," she said. "Your friend who got attacked's a psychiatrist, isn't he? Half his patients're probably whacko."

I didn't mention that I was one of them—I hoped from the non-whacko half.

"But Mr. Anders was in research," I said. "The only patients he saw were the ones on the studies he was doing."

"I read about him in the paper. It said he worked with that doctor, the one doing pain management."

"That's right."

"What if one of the people on their studies got pissed 'cause they didn't cure him like he thought they would?"

"Anything's possible, I suppose," I said. "You're a smart girl to think of that."

She grinned. "I read detective stories. A lot of 'em are based on real life, you know, so you learn stuff."

I saw my opportunity and took it. "Maybe you'll be the one to solve this crime and collect the reward."

Her eyes opened wide. "There's a reward?"

Behind my back I crossed my fingers. "Don't quote me, but I heard there might be."

"How much?"

"I don't know. But whoever gets it would have to come up with something that leads to the arrest of the killer. That's how those things work."

The credit slip kicked back out of the machine and Cory Ellen slid it across to me. "Yeah, well, fat chance, my doing that."

"You know," I said, scribbling my signature, "I'll bet the cops

didn't even check to see if Charlie Anders had left a letter or something in the safe here."

"Why would he do that?"

"Sometimes people who are afraid someone's after them try to protect themselves that way."

Her eyes sparkled with excitement. "Yeah, one of the stories I read was about a guy who thought his wife was gonna kill him, and he sent a letter to his lawyer that said if anything happened to him, she did it. Turned out it was all a ruse so he could claim self-defense when he killed her."

"Did he get away with it?"

"Yeah. I don't know if it was a true story. It's creepy to think about somebody killing a person and getting away with it, isn't it?"

I lowered my voice. "Maybe you and I can see that whoever committed this one won't. Do you know if Charlie Anders rented one of your boxes?"

"I could look," she whispered. "Hey, wouldn't it be cool if he did and there was a letter in it?"

"Cool."

"You think we'd win the reward money if we found it?"

"If it helped catch the killer." I decided I'd pay her myself if there was a disk in Charlie's box, and she helped me get my hands on it.

I held my breath as I watched her pull open a file drawer and extract a folder. She opened it and ran her finger down the list of names.

"Here it is," she almost shrieked.

"Shh," I admonished her, glancing nervously behind me. "What's it say?"

But the excitement had drained from her face. "Bummer," she said. "Double bummer. He rented it at three forty-five on Friday afternoon but his wife canceled it at seven-forty on Saturday."

"His wife," I said, stunned. "I don't think he had a wife."

"Well," Cory Ellen said, "she signed for it." She slapped the folder down in front of me. "Look. Right here."

And under Charlie's loopy scrawl, was a cramped, almost illegible signature. *Mrs. Charles Anders.*

Chapter Twenty-one

"YOU FINISHED YET?"

I turned around. A swarthy bearded man, who, if he'd been wearing a turban instead of a ski hat, I would've sworn was a Taliban, was standing behind me, scowling.

"How long does it take to check out, f'chrissake," he growled in a recognizable accent.

Definitely American. Brooklyn-born. And too well-fed to be Taliban.

"Just one more minute," I said and smiled, but he was oblivious to my charms.

"Well, hurry it up, willya? I gotta get on the road."

I asked Cory Ellen to Xerox the page, which she quickly did. I folded the copy and stuffed it into my pocket along with the crumpled wad of Kleenex. I wasn't sure what I planned to do with it. The sensible thing would have been to go back to my condo, call the

190

number on Sergeant Patrick's card, and tell him what I'd discovered. But Sergeant Patrick should've had the smarts to check out the safety deposit boxes in the first place. Of course it was conceivable that at a time when Cory Ellen wasn't on duty, he had.

I mouthed, "Sorry" to her, waved good-bye, and took off. I pushed up my sleeve and consulted my watch. Twelve-fifteen. Plenty of time till Ted got back. I was determined to talk with Dr. Freundlich. I'd have preferred to meet him in some crowded place like The Cove, but right now my only option was to beard the lion in his villa.

I couldn't imagine that Freundlich himself was the killer, but he was the pivotal figure in this drama. He was connected to Charlie's death; he may even have been responsible for it by the work atmosphere that he'd created. He'd fired Charlie and I wanted to know why. Was it because of Kate? Scarborough's assistant had said Kate had "buried" Charlie. For sure Charlie hadn't known that or he wouldn't've been coming on to Kate the way he had at The Boat Shack. Was Kate the woman who had pretended to be Charlie's wife and stolen the contents of his safety deposit box? She seemed the only logical possibility. But why? What was she afraid of?

Trudging up the west mountain toward Freundlich's condo, I considered how Kate would have accomplished the theft. She would've had to steal the box key from Charlie, probably not a difficult feat, considering his often inebriated state. Or maybe Charlie had told her he'd done something to protect himself, maybe even trusted her enough to give her the key. People do stupid things when they're in love. At 7:40 P.M., more than an hour before the parade had started, and well before Charlie had been murdered, she or someone had removed whatever evidence had been there. Nadine told me that Kate had twisted her ankle and had left with Dr. Geissing to get an Ace bandage. After going to the first-aid station, she could have slipped away to the office. And by the next morning she was walking perfectly well. Because she hadn't twisted her ankle.

The pieces began to fall into place.

I stopped to wipe my nose. The sky threatened again and the cold air had turned on the spigot. I used up the last of my tissues trying to stem the tide. With my running Rudolph nose, my watering eyes,

and my hair squished flat as a matzo under my hat, no wonder the Taliban look-alike hadn't been captivated. I wasn't exactly what GenXers would call a totally hot babe. I didn't think I'd have to worry about fielding Dr. Freundlich's passes today.

I found the Copenhagen condo complex, pulled open the heavy outside door, dragged my aching body up two flights of stairs to number 26 , and rang the bell.

"Who iss it?"

God, it was Gerta. I hadn't planned on her answering the door. I couldn't very well tell her I'd come to take her husband to lunch, could I? It would look as though we'd had a prearranged rendezvous. Which we had. But not in the way she would think. Or that I'd had in mind. *Hubie*'s intentions were another matter.

"It's Carrie Carlin, Mrs. Freundlich," I said, finally finding my tongue. "I—"

"Yess. I know you." The door opened. Gerta, attired in a long velvet robe, royal blue with gold tassels on the zipper and the ends of the belt, stood framed in the doorway. Tiny diamond-studded gold earrings complemented her hair, which was pulled off her face and caught in a knot at the nape of her neck. The blue of the robe matched eyes that regarded me with a gaze more appraising than hostile.

"I'm sorry to bother you," I said, "but Dr. Freundlich said last night that—"

"The doctor iss not here."

"Oh. Will he be back soon?"

"I think—maybe in half or one hour."

"Would you mind if I wait for him? I was supposed to see him around noon today. I'm not sure he remembered."

She didn't budge from the doorway. "You must call Kate," she said. "She iss making for people appointments for this evening."

"Yes, I know, but I have a previous engagement. I won't be here tonight." The lies were tripping off my tongue. I stood on my toes and peered behind her into the living area. "I've never seen one of the Copenhagen villas. I used to come here every Christmas with my family, but the Copenhagens weren't built then."

"Kate vill—" she began.

"Oh, you have a tree. It's beautiful. I love Christmas trees. May I see it up close?"

Either she'd decided I was no threat, or she was taken aback by my chutzpah, because after a few seconds she nodded and allowed me to step past her. I slipped off my boots and left them in the hallway, so as not to deposit snow clumps on the plush carpet. Then I walked over to the Christmas tree and stood in front of it making admiring noises. Which wasn't a problem because the tree was charming, its boughs laden with red-and-gold-striped balls, little gingerbread men cookies wrapped in yellow cellophane, and bright multicolored bows.

"It's one of the prettiest trees I've ever seen," I said. "Did you decorate it yourself?"

"It iss like this when the doctor and I arrive," Gerta replied. "All vas done by the owners of the villa."

"Well, you must be enjoying it."

"Yes. Sit, please."

I pulled off my hat, unzipped my jacket, and gratefully sank into the club chair she'd indicated. It was one of those deep-cushioned chairs that are meant for people five-foot-ten and over. By the time I'd wiggled my butt to the back, my feet were hanging two inches off the floor. Which made me feel like an awkward child. Gerta sat in the chair across from me, her long legs crossed, one foot flat on the floor, looking regal. In her fifties, she was still a stunning woman. I wondered if she was aware of her husband's extramarital activities, and if so, why she put up with it. How, over the years, had she resisted the temptation to take a carving knife to his jewels? Maybe it was a cultural thing. She was European. In certain upper-class circles, it's apparently considered acceptable for men to have mistresses and for their wives to take lovers. President Mitterand of France had a mistress and no one had blinked an eye. I don't know about his wife. I hoped Gerta had a lover.

She smiled politely at me.

I made a passing attempt at fluffing my squashed-down hair, scooted forward so that my feet could touch carpet, and returned her smile. Then I sneezed. Four times in a row.

"Excuse me," I said, when I could speak. "I have a bad cold." I dug around in my pocket for a tissue, came up with the folded Xerox, and quickly slid it back.

Gerta produced a fresh pack of Kleenex from her pocket and handed it to me.

"Thank you," I said.

"You should not in cold weather be outside," she admonished me. "You make yourself more sick."

"I'm fine, really."

The silence stretched. I glanced around at my elegantly appointed surroundings. Looking up, I saw dazzling sunlight spilling through a skylight in the high cathedral ceiling. Light shone on the sofa that faced a marble fireplace, brightening the earth tones in the nubby fabric. The picture window overlooking the upper half of Stonycreek Mountain was twice the size of the one in my condo. Against the backdrop of snowcapped pine trees, skiers skimmed the sides of the moguls and came skidding to a stop at the mid-station. I was about to comment on the advantage of being able to determine the ski conditions without even having to leave your condo, when Gerta broke the silence.

"You haf children?"

A safe topic.

"Yes, two. A girl and a boy. Fourteen and twelve. They're skiing Killington this week with their father."

"Your husband, what kind of profession he has?"

"My ex is in the cosmetics business. I'm divorced."

"Oh. That is sad. For a long time?"

"About two years." She seemed to be waiting for an explanation, so I said, "He had a girlfriend."

For a moment she looked puzzled. Then she said, "Ah, yes. Americans are so—" she searched for the word "—puritan. Girlfriends, they come and go. A clever wife iss for the whole life."

I guess I'd been right about the European attitude. I felt a need to defend myself.

"It changed our relationship. It killed the love."

"*Ach*, love." She waved one ringed hand dismissively. "For *kinder*,

for the young. Family. Family iss what iss important for a woman. Family iss the only thing worth fighting for." She paused, then added with a little laugh, "And, of course, security."

Which told me why she hadn't employed the carving knife. I thought it politic to change the subject so I looked out the window and said, "My children learned to ski on this mountain."

"You like skiing, too?"

"Yes, very much. This week, of course, with everything that's happened, I've only skied once."

"The lifts are open now. Maybe you go tomorrow," she said.

"I'm leaving tomorrow, but I might take a quick run in the morning if I'm feeling up to it."

"The doctor and I teach all our children to ski in Switzerland."

"How many children do you have?"

"Four. All sons," she said, her face softening. "Two in university, two in graduate school."

I did a quick calculation in my head and hoped Dr. Freundlich was being well paid for this seminar.

"Were any of them here to see their father receive his award?"

"Sadly, no. It iss difficult to take time off. They are most proud of the doctor, though."

It was the fourth time she'd referred to her husband as "the doctor." Not Hubert, or their father. The doctor. I found it peculiar, but maybe it was just another cultural difference. Or maybe she couldn't get over the fact that her husband was a Ph.D.

"As you must be, I'm sure," I said, feeding into it.

Her chest visibly swelled. "Yes. He help many people. I see many letters of thanks. Sometimes jealous people scorn his work. Like that Dr. Zimmer."

I nodded my head. "She can be very unpleasant."

The blue eyes flashed. "She iss evil."

Her reaction surprised me. I wouldn't have expected her to like Flo Zimmer, but calling her evil seemed a little over the top.

"Well," I said, "Dr. Freundlich made mincemeat of her at the ceremony."

"Yes. I vas sorry to miss it. I vas very sick that morning."

"Dr. Zimmer was very sick that afternoon."

She laughed and seemed to relax. "How iss your friend?" she asked.

For a minute I thought she was referring to Ted and I wondered how she knew about him. "My friend?"

"The gay young man who iss hurt."

Had everybody but me known Joe was gay? "Oh. Much better, thanks. I talked to him this morning."

"Yes? His head, it iss—how you say—clear?"

"Yes."

She was silent for a few seconds. Then she said, "I prayed for him."

I smiled. "Yes, you said you would. When he's better I'll tell him."

"He remember the attack?"

"Very little of it right now," I said. "But we're hoping something will come back to him."

She looked down at her lap and with a graceful gesture flicked a piece of lint from her robe. "Sometimes," she said, "it iss better not to remember a bad experience."

"I guess it would depend," I said. "Joe's remembering the attack on him might help find Charlie's killer."

"Yes, but it iss a risk. Ve haf a saying—let me think how to say in English—he who iss digging a hole for another may fall in himself."

I caught my breath. Was she intimating that Joe could still be in danger? "What do you mean?"

"Your friend should go home soon as possible. You, too, after your experience."

A chill ran through me. Did she know more than she was saying? But her eyes were sympathetic and she said softly, "Already too much death."

"But neither Joe nor I had any connection to Charlie Anders," I protested. "Except that we're all in the same field."

"Maybe that iss the reason, then."

A reference to DAHM and Zimmer?

"What did you think of Charlie, Mrs. Freundlich? Did you know him well?"

"Charlie vas a fine man. Very smart. But he vas a drunk."

"Was his drinking the reason Dr. Freundlich replaced him with Kate?"

I waited for a response but she only shrugged.

"Kate and he seemed to have an odd relationship," I went on. "When I first met them I thought they were romantically involved, but the way they bickered..." I let it hang.

"Alcohol iss a problem for any relationship." She paused. "Your friend," she added, "drinks, too. It iss a bad thing."

I was nonplussed. "Joe? He's not a drinker. Who told you he drinks?"

"I hear it."

"Well, it's not true. And Charlie seemed to me to be drinking because he was angry. And I think someone was afraid—"

There was the sound of a key in the lock. The expression on Gerta's face altered. She leaned toward me, and I caught the sweet scent of expensive perfume.

"That iss the doctor now," she whispered. "Please do not mention the death of Charlie. It is most important he iss not getting more upset."

Which put a huge crimp in my plans for having a heart-to-heart with Dr. Freundlich about his firing Charlie, about Kate and Dr. Geissing and Paul Scarborough, and who among them might possibly have had a motive for wanting Charlie Anders out of the way.

If *Hubie* was startled to find me sitting in his living room chatting with his wife, he covered it well.

"Ms. Carlin," he said, surprising me by remembering my name. "How nice to see you."

I pushed myself up out of the club chair and took his extended hand. "I hope I'm not intruding, Dr. Freundlich," I said. "I had a couple of questions about the results on one or two of the disks you gave me. I won't be here this evening, and I remembered you'd said you might be free around lunchtime."

He raised his eyebrows and shot me a quizzical look. "Ask away," he said, removing his jacket and handing it to Gerta.

She rose. "I vill hang up your jacket, too," she said to me. "You vould like something to drink?"

"Water would be fine," I replied. I slipped off my jacket, gave it to her, and sat down on the sofa so as not to have to deal with the club chair cushions.

"Wine for me, my love," Freundlich said, dropping a kiss on Gerta's cheek as she passed. "And why don't you put out some cheese and crackers for our guest? She looks pale. I think she needs nourishment." Behind Gerta's back, he winked at me.

"I have a very bad cold," I said quickly. "I hope I'm not communicable. Please don't bother with anything for me," I called to Gerta's retreating figure. "I can't stay long."

When Gerta was out of earshot, Freundlich sat down next to me. "I stopped by your unit and you weren't there," he said softly. "Didn't you invite me to do—lunch today?"

"Yes, I did," I replied, ignoring the innuendo. "But when I woke up this morning, I was feeling really ill, so—"

"So you got dressed and went out in the cold."

"I went to the store to get aspirin and cold medicine. And then, as long as I was out, I decided to stop by and see if you were here."

"Ah."

Looking and sounding the way I did, he bought the explanation. He leaned closer and ran a finger lightly over the back of my hand.

"So we shall have to put off dining together until next time I come east and you are well," he murmured. "You're in New Jersey, right? Bergen County?"

"Yes."

"In the book?"

I nodded.

His smile conveyed his meaning as clearly as his words. "I'll call you."

I broke out in a sweat and withdrew my hand on the pretext of needing to cover a cough. I'm not good at playing seduction games unless I intend to follow through. I glanced nervously toward the kitchen. "Fine," I mumbled from behind my hand.

He looked amused. "My wife and I have an understanding," he said.

His words made my skin crawl. Gerta may have made her peace with his philandering, but this was right in her face; in addition to which his "shining light" was barely cold! I felt like puking all over him but pulled out a Kleenex and blew my nose instead. Which at least caused him to move an inch or two away.

I decided that despite Gerta's admonition, I wasn't going to worry about the sensibilities of a man who obviously had none. "I need to ask you some questions," I said, crumpling the tissue and shoving it in my pants pocket.

"So you said. About the disks, right?"

"No. About who would've taken a shot at me Sunday night."

He looked startled. "The police told me there'd been a shooting in your condo unit, but they said that Dr. Claughton was the target. Something about a jealous lover."

"That was Detective Mayer's theory before Dr. Golden was eliminated as a suspect."

"I see." He steepled his hands and peered at me over the tops of his fingers, his amazing eyes crinkling at the corners. "And you want to know if I was the shooter because that would affect your decision to have dinner with me?"

Could the man stop thinking about his dick for one minute? His response made me angry and I forgot that I'd set myself up for it. "I'm talking about someone trying to kill me. The same person who killed Charlie Anders and attacked Joe Golden."

He dropped his hands into his lap and his expression turned serious. "I'm sorry. I'm just trying to get my mind off the loss of Charlie."

An odd response to a vicious murder, but I gave him the benefit of the doubt. "You must have some idea who's behind it, Dr. Freundlich."

"I wish I did."

I looked at him, astonished. "You have to. It's got to be someone you're associated with. And you have to have some idea what it's about."

"Originally I thought it was one of Dr. Zimmer's fanatics," he said, "but then I learned about your friend being attacked. And now you tell me that you were shot at. I think we're dealing with a disturbed patient. All of us have had patients we haven't been able to help. Some sick mind is taking revenge on the entire biofeedback community." He nodded emphatically. "That's it, I'm certain. I'm more convinced about it now than ever." His voice dropped, took on an intimacy as he shifted closer to me. "But I'm so sorry, my dear, that you had to go through such an ordeal. It must have been terrifying."

Did he really believe what he was telling me, or was he covering up? If he did, he was more into denial than Nadine had been about what had happened to her at the party. I opened my mouth to ask him about that party when, in a flash, all thoughts of Nadine vanished. Because before I realized what was happening, he recaptured my hand and placed it directly on the bulge in his pants.

Shock waves engulfed my entire body. I jerked my hand free, and in a reflex response to the *Kill him!* message my brain was sending, I hauled off and socked him as hard as I could right in the gut. He grunted and doubled over, his mouth falling open in surprise.

Just then Gerta came in with a tray and set it down on the coffee table in front of us.

"I make you special tea," she said, smiling at me. "Chamomile. To cure your cold."

"I'm sorry," I gasped, jumping to my feet. "I have to go. I'm not well." I glanced wildly around. "My jacket—"

"Hanging in the hall. My dear, you look—what is wrong with the doctor?"

I turned and fled as though the hounds from hell were pursuing me.

Chapter Twenty-two

JACKET TRAILING in my wake, I pounded down the stairs and ran blindly, not certain where I was heading. That pig! How dare he! The hot tub incident paled by comparison. Tears coursed down my cheeks and froze there. I didn't know why I was crying. And then I did. I was mad as hell, but a portion of my fury was aimed at myself. It had been partly my own fault. I'd been sending out vibes, leading him on, and he'd called my bluff. I felt cheap and ashamed and violated, all at the same time. I thought about telling Ted, some vestigial part of me wanting him to confront the pervert and defend my honor, but as soon as the thought surfaced, I deep-sixed it.

Out of breath and freezing, I came to a halt. I struggled into my jacket, barely able to work the zipper with fingers gone stiff from the cold. I managed to extract my hat and mittens from my pockets, put them on and leaned up against a tree, allowing the icy air to blow across my face and cleanse me. Could a man like this, to whom right

meant taking whatever he wanted whenever he wanted it, and wrong was what someone like Charlie might do to thwart him, be capable of murder? The answer was a resounding maybe. He couldn't personally have committed the murder. He was watching from the base when the parade started. Unless he kept a hit man on his payroll, it would've been a difficult thing to arrange on such short notice.

I started to think about who was or wasn't at the lift line when the parade started. Joe wasn't there, of course. And Gerta wasn't. But if I were Gerta, I'd've cheerfully killed *Hubie*, not Charlie. Where had Flo Zimmer been? Where was Paul Scarborough that night? Geissing had gone off with Kate. And it was probably Kate who had emptied the safety deposit box. Had they come back in time to watch the parade? I was sure the police had checked out everyone's alibis, but the more I mulled things over, the more I wondered about Dr. Geissing and Kate. Strange bedfellows. I needed to talk to someone who knew the players. Someone teetering on the brink, ready to spill his guts.

I reversed course and a few minutes later, I was banging on the door of Oslo 31, the room the handout had said was assigned to Paul Scarborough. I was convinced that if I could make him believe I knew more than I actually did, I might break him. I knocked several times; then repeatedly rang the bell. But no one came to the door. Disappointed, I gave up and headed back to my condo. On the way, I saw Kate standing at the back of the lift line talking to Sergeant Patrick. She kept shaking her head and finally turned away from him and moved on through the line. Hands in his pockets, he stood watching her until she reached the chair lift. In no mood to be waylaid by him, I hurried on my way.

I opened the outer door to the hall and nearly tripped over Nadine looking sportily sexy in black stretch ski pants and her newly acquired black-and-white ski sweater and horsehair boots. She was on her knees, packing a pair of shiny blue-and-gold K2 T:nine reflex skis with matching poles into a ski bag.

"Well, hullo," I said. "I guessed you were back." I waited for her to ask me how I'd known. She didn't.

"Yeah," she replied, "Sergeant Patrick drove me here." She started to zip up the bag. "Hold the other end out straight, will you?"

I took off my hat and jacket, hung them on a peg, and grabbed the opposite end of the bag. I pulled while she zipped. "Nice skis," I said. "Look new."

"Bought 'em here."

"You leaving today?"

"Uh-huh. I've already paid my bill and said good-bye to people."

And a warm farewell it was, too.

Shut up, Carrie, said my conscience. Not your business.

"Tell me everything that's happened since the cops spirited you away," I said. "Where'd they stash you?"

"In some hell-and-gone bed-and-breakfast. It was so far off the beaten track, a Saint Bernard couldn't've found it."

"That was the point, wasn't it?"

"At least if a Saint Bernard had shown up, he'd've had a keg of brandy around his neck," she grumbled. "No alcohol, food was disgusting, and there was nobody interesting to talk to. Just these two old Margaret Rutherford–type English ladies who run the place. I swear they must sit by the window with their tongues hanging out, just praying they'll get to see the garbageman once a week."

"Did you get to see the garbageman?" I asked.

That earned me a dirty look so I said more seriously, "The cops aren't concerned about your safety anymore, I assume."

She straightened up and gave me a Cheshire Cat grin. "Nope."

"There a particular reason?"

"Yes."

"You gonna tell me or you just going to stand there with that smug smile on your face?"

"You have to promise not to tell anybody else."

"Okay."

"Well, I s'pose you can tell Ted." Her eyes shone with excitement. "They picked up Paul Scarborough this morning."

"What?"

"Yeah, they found the kid who bought the red jackets, and he ID'd Scarborough as the guy who paid him to buy them."

"No kidding." I hadn't seen this coming. No wonder he hadn't answered when I'd pounded on his door.

"Repulsive creep. I didn't like him from the minute I saw him," Nadine said.

"But what was his motive? Why'd he do it?"

She shrugged. "Dunno. According to Patrick, he's not talking. Jealousy, maybe. Charlie was everything he wasn't. Smart, good-looking, hot. Even if he was a boozer."

Was it possible Freundlich had known, and had still given me that bullshit theory about a disturbed patient? "I've just come from Freundlich's villa," I said. "He didn't say a word."

"Probably hasn't heard. Cops are keeping it on the q.t. for now."

Between us, we hefted the heavy bag and propped it against the wall. Short of breath, and still reeling from her news, I leaned up against the doorframe. "I'm not well. I've gotta sit down," I gasped. "Let's go inside."

She followed me into the living room and we dropped onto the couch.

"You sound awful," she said.

"Caught a bug. Don't get too close."

"Ted still in bed?" She leered at me. "You got a bug, he must have a bug."

"Give it a rest, Nadine. He's skiing. So tell me what else Patrick said."

She tucked her feet up under her, enjoying her moment in the sun. "They haven't charged Scarborough yet. That's why they don't want it spread around."

"I knew he was stressed out big-time," I said. "I read his disk and you could see it. His high beta amplitudes were through the roof."

"Patrick said he's called a lawyer."

"The jackets were both size large," I mused aloud. "And everybody said the person on the lift was fairly tall. How could Scarborough have made himself look bigger?"

"Elevator boots?" Nadine asked, giggling.

"He'd've needed stilts. I just don't see how he could've pulled it off."

"Well, if he didn't, he knows who did."

"Damn, I wish I'd gotten to him before Patrick did," I said.

"You think you could've made him talk when the cops couldn't?" Nadine hooted. "You flatter yourself."

"You're probably right." I kicked off my boots while I thought about Paul Scarborough, and what could have motivated him to commit murder. Nadine was right about one thing. Charlie was everything Scarborough wasn't. Tall, bright, handsome, personable. But Charlie had fallen from grace; he'd been fired. So what was there to be jealous of? I came back to my original theory. This murder was about a cover-up. And if it wasn't about hanky-panky related to the research, maybe it was about hanky-panky of a different kind.

"Was Scarborough at the party Friday night?" I asked.

"The party?"

Hoping to jog her memory, I stepped over the line. Way over. "You remember the party, don't you? The night you had sex with someone and you can't remember who it was."

Her face registered horror. "You're not suggesting I had sex with him?"

"I wasn't there. But you don't seem to be terribly picky."

She bridled. "That's a lousy thing to say."

"Sorry." I wasn't.

"Why would you say something like that to me?"

I hesitated, then thought, what the hell. "I saw you in the demo room this morning."

"What? How— You sneak. Were you spying on me?"

"I have better things to do with my time than spy on you," I snapped. "I didn't even know you were back. I just happened to be there when you came in."

"Where? I didn't see you."

"You were occupied."

Thank heaven, she didn't pursue it. I didn't want to explain why I'd been hiding behind the disk boxes.

She shifted uncomfortably. "All right," she said finally. "So I was fooling around with Jeremy."

"That Don Juan was *Jeremy*?" Where had I gotten the impression the guy never thought about anything but his computers?

"He's cute and I'd been locked up for days."

"*Two* days."

"I like sex," she said. "I don't look at it the way you do. I'm like a guy in that respect. I don't have to be madly in love."

"I'm not judging you."

"Sure you are."

She was right. I backed off. "I just think you need to be more discriminating. You could get a disease. Granted, you weren't responsible for what happened at the party because you were probably drugged, but—"

She shot off the couch. "Who says I was drugged?"

"Don't freak. Ted thinks somebody dropped a Roofie in your drink. That's why you can't remember doing it."

"That's crazy. Why would anybody at that party do something like that? They're intelligent adults, not a bunch of wild college kids."

"Even intelligent adults take drugs and have sexual hang-ups," I replied, repeating what Ted had said. "What I'm saying is you could've been with anyone," I said. "Even Scarborough."

"But—he's sexless. I don't think he likes women. Or men either, for that matter."

"You can't always tell about a person's sexual preference from the way he or she appears on the surface. You were wrong about Joe."

She took the bait. "Boy, was I ever. And when I asked you," she said, pointing a finger at me, "you lied."

"I didn't lie. I didn't know he was gay. And now that I do, it makes absolutely no difference to me. I love him." I waited a few seconds and added casually, "How'd you find out?"

"He came into The Swiss Chalet Sunday night after you left. He was drinking at the bar with some guys you could tell are gay. Everybody joked about how I was wasting my time trying to get something going there. It was embarrassing."

Was it possible Joe had made a pass at Charlie as Mayer had hinted, and that's what had caused the fight?

"Did you say something to Joe or anybody hinting that you were going to spread it around?"

She had the grace to look ashamed. "I was humiliated. He'd been coming on to me. He made me look foolish."

I was angry. "I think you did that yourself," I said. "Joe has women friends. He thought you were smart and nice, his mistake, and he may've been thinking about sending you patients. That's probably all there was to it."

She sank into the chair opposite me and covered her face with her hands. "I feel sick to my stomach. The thought of Scarborough fucking me when I didn't know it, makes me want to throw up."

"Well, let's not jump to conclusions. He wasn't the only guy at that party. Would you feel better if it was the great god, Freundlich, who took advantage?"

She managed a smile. "Yes."

Yuck. I shook my head and got to my feet. "You're hopeless. I'm going back to bed."

She got up and followed me into the bedroom. "Promise you won't tell anyone about it."

I sat on the edge of the bed and stripped down to my thermals. "Nadine, if you can live with never finding out what happened to you at that party, I guess I can. I give you my word, my lips are sealed." Then I remembered who had last said that, and I shivered. I crawled into bed and pulled the covers up to my neck. "It was nice meeting you," I said. "Have a good trip home." I closed my eyes.

Silence for about sixty seconds.

"Carrie?"

"What?"

"I didn't wash the panties I wore Friday."

My eyes flew open and I sat bolt upright. "You serious?"

"Uh-huh. In case I needed evidence. Lesson learned from Monica Lewinsky."

"Scarborough's being held as a murder suspect. They can get his DNA."

"Yeah. God help me if it's a match."

By the time Ted came back around four just after the sun had

dipped and the lifts had closed, Nadine and I had convinced ourselves that she'd been drugged and raped by Paul Scarborough, and that the evidence on her panties would prove it. Ted sat on the edge of the bed pulling off his ski boots, while we filled him in on the latest developments.

When we'd finished, he turned to Nadine. "Even if it is a match," he said, "how would you prove it was rape? It'd be your word against his. The Rohypnol, if that was what was given to you, is out of your system by now. It'd get ugly and you'd be dragged through the mud in court. Your entire sexual history would be an open book."

Nadine blanched.

"You sure you want to open yourself up to that?" Ted asked.

She didn't hesitate. "No," she said. "I certainly don't."

"Maybe there was a witness," I suggested hopefully. "Someone who wouldn't be afraid to speak up now that Scarborough's been arrested."

"He hasn't been arrested," Nadine said. "He's only being questioned. And I just finished telling you I'm not Mary Poppins. The last thing I need is for my patients to read about my—liaisons in the newspapers."

I couldn't resist. "How many liaisons have there been?"

"Would you ask that question of a man?" she demanded.

"Probably not."

"Neither would the courts. And if they did, he'd be called a stud, whereas I'd be labeled a whore."

"Tell me anyway."

"More than fifty, fewer than a hundred."

Yikes. I'd been raised too strictly, and I'd married too young. I'd missed the whole sexual revolution experience. Maybe that was why I'd been so thrown by Freundlich's behavior.

Ted caught my expression. "Don't get any ideas," he said, poking me in the ribs. "It's not all it's cracked up to be."

"You're not a woman. How would you know?"

He laughed. "Bottom line is, it's not worth it to Nadine to pursue this."

"I just can't stand for anyone to get away with rape," I said.

"You don't know that it was Scarborough who raped Nadine," Ted said. "And you don't really believe he strangled Charlie Anders, do you?"

"Obviously, he was complicit," I said. "He paid that kid to buy the jackets."

"But he couldn't've been the person on the lift. Not according to the description given by anyone who saw them."

"Then he's protecting someone," I said.

Ted picked up his boots and took them into the bathroom. "Whoever it is, we'll find out soon enough."

"How?" Nadine asked. "Cops gonna beat it out of him?"

Ted came back in the room. "Nobody'll ever know," he said, deadpan. "We're extremely careful about leaving bruises, nowadays."

"He's joking," I said to Nadine, ninety-nine percent sure he was. Ted's smile was enigmatic. I smacked him. "Be serious," I said.

"If Scarborough's lawyer is even halfway competent," he continued, "he's going to convince his client that if he takes a murder rap, he won't be going to a white-collar resort. And the inmates at those places aren't nice people."

Nadine got to her feet. "He's an accessory. He should go to jail, anyway."

"Oh, he'll do time," Ted said, "but you may have to live with the fact that you'll never find out what happened to you at that party."

She noodled that for a minute.

"You want to know what really bugs me about it?" she said.

This time, I took the bait. "What's that?"

She grinned. "That maybe it was Dr. F I had sex with, and I never got to enjoy it." She picked up her purse. "No reason for me to hang around then. I'm outta here."

"I'll help you load your car," Ted offered.

"I can manage. I only have my skis to carry. Everything else is already packed. Carrie, I left my room key on the dining room table. Drop it off at the office for me, will you? And let me know how all this turns out."

She blew us kisses and was gone.

I was silent for a couple of minutes after she left. Then I flopped back onto my pillow and let out a long sigh.

"You know," I said. "Compared to Nadine, I'm practically a virgin."

Ted dropped down beside me. "You know," he said, "if you're up to it, I'm prepared to do something about that."

"Well, I'm certainly not one to welsh on an IOU," I murmured in my new sexy voice.

Fifteen minutes later we were in the midst of making sure I could never again consider myself even remotely virginal, when there was loud pounding on the door.

"Fuck," Ted groaned, rolling off me. "This isn't happening."

I pulled him back. "Maybe they'll go away."

But the bell started ringing and the pounding got more insistent. Ted reached for his jeans. "Don't lose the mood. I'll be right back."

I heard the front door open and Nadine's excited voice babbling something I couldn't quite catch. I grabbed my robe and threw it on, tying it as I dashed into the living room. Nadine was clutching at Ted as though he were all that stood between her and the devil himself. Over her head, he glanced at me helplessly. I moved to the rescue.

"My God, Carrie," Nadine cried, on seeing me. "This place is jinxed!"

"Get a grip, Nadine," I said, gently loosening her stranglehold on Ted. "What happened? Why're you back?"

"You're not gonna believe it. I was driving to the gate, and when I got to that jog in the road where you can see the mountain, I saw a couple of ski patrol guys come whizzing down, and they had somebody on that litter they use to carry injured people off the mountain. And they must've radioed ahead 'cause there was an ambulance already waiting."

I could feel my body tensing. "Please don't tell me it was anybody we know."

"I don't know who the hell it was, and I wasn't going to hang

around to find out. But when I got to the gate there were two patrol cars blocking it, and they wouldn't let me leave. So I asked one of the cops why, and he said they'd been ordered to close the place down again. I was so freaked out driving back here I missed the turn by the tennis courts, and nearly took out an entire family!"

"Did he tell you the reason for the lock-down?" Ted asked.

"He said there'd been another suspicious death."

Chapter Twenty-three

NADINE COLLAPSED on the couch and began talking herself through a relaxation exercise. Ted and I went in the bedroom and threw on our clothes. Ted suggested I stay with Nadine to keep her from coming totally unglued, but I told him I'd come unglued myself if I had to sit here wondering what had happened. I stayed behind long enough to slip her one of the Xanax pills Dr. Rosen had given Ted for me, along with a glass of water. Then I grabbed my jacket off the peg and took off after Ted.

It was déjà vu, like the night of Charlie's murder. Except that it was still partially light, the scene was eerily similar—skiers milling around at the foot of the mountain talking in hushed tones, uniforms rounding up possible witnesses, patrol car and ambulance lights flashing. Over the loudspeaker, a disembodied voice asked everyone who'd been skiing on Rolly's Peak during the last hour to please remain in the area. Ted noticed Patrick and another

plainclothes detective talking to some uniforms behind the ambulance.

"Stay here," he told me. "I'm going to see what I can find out." He strode over to them and I scanned the crowd searching for a familiar face. I caught sight of Jeremy, and worked my way to where he was huddled under the ski shop awning.

"What happened, Jeremy?" I asked. "I just got here. What's going on?"

"I'm not sure," he said. "I heard somebody hit a tree on Alligator Alley."

I knew Alligator Alley. It was an expert slope on Rolly's Peak, steep and extremely narrow with randomly scattered trees that loom in your path when you least expect them. My kids and Rich had skied it on the rare occasion when there was a really good base and the snow was thick. The one time I'd joined them, I'd ended up taking off my skis and walking down the mountain.

"I heard somebody may've been killed," I said. "You know who it was?"

"No."

"It had to be an accident. Why're the police stopping people from leaving the resort?"

"I think because nobody was supposed to be skiing Alligator Alley. The ski patrol had closed it because of dangerous conditions. Bare spots and roots sticking up and lots of blue ice. But somebody took the warning sign down."

"Maybe it was knocked down by mistake," I said.

"No. It was there when I took my last run. There was a rope across it, too, and the ski patrol said that was gone."

"Anybody else from the convention still here?" I asked, my eyes sweeping the area. "Were you skiing with anybody?"

"I came earlier with Kate," he said. "But Detective Patrick pulled her aside when we were waiting on line, and I went on ahead. I didn't see her after that."

I saw Ted separate himself from the group by the ambulance and come toward me. Siren silent, the ambulance took off, in no rush to get its occupant to the hospital.

"Excuse me," I said to Jeremy and hurried to meet Ted. He took my arm and steered me back toward Mountainside.

"Wait a minute," I said, pulling my arm free and stopping. "What'd you find out?"

"Keep walking," he said. "You don't want to get in the middle of this."

"Why should I be in the middle of it?"

"Because the vic was one of yours."

"What do you mean, one of mine?" I asked, horrified.

"One of your biofeedback people. One of Freundlich's people." My breath began coming in short gasps.

"Who?"

"Kate Donovan. She hit a tree head-on. Broke her neck."

Which took what was left of my breath totally away. My knees felt as though they were going to buckle under me and a throbbing began in my temples. I'm not sure how I made it back to the condo. We were in the hall, taking off our jackets before I was able to form words.

"You said victim," I breathed. "It wasn't an accident?"

"The trail had been closed all day, but when the ski patrol checked it out, the sign and the rope had been removed and there were two sets of tracks in the snow. From the position of the tracks, it looked like someone had cut Kate off, she went out of control, hit a rock and slammed into a tree. The other tracks continued on down the mountain."

Nausea rose and I was glad there was nothing in my stomach. Head down, head down, I told myself. I doubled over, trying desperately to fight it. All I could think was that another young life had been snuffed out and nobody had been able to prevent it. The killer was getting desperate, had gone over the edge. I wished I'd listened to Ted and gotten away from here.

"Take deep breaths," Ted said, bending over me.

"I wish we'd left when you wanted to," I gasped.

"Too late now. We're in a lock-down situation again. Keep breathing."

The nausea passed and I straightened up, leaned against him.

Ted brushed wisps of my hair off my face. "You okay?"

"Better. I don't know how you stand what you do every day."

"I try to keep in mind that I'm one of the good guys."

"I know. You are good."

He kissed my forehead. "I'll remind you that you said that."

It flashed through my mind that now Charlie's disk, if indeed there was one, would probably never be found. I pulled away and reached into my jacket pocket for the Xerox. It wasn't there. I tried the other pocket. Empty. Maybe I'd dropped it. I got down on my knees and looked on the floor and behind the boot rack.

"What're you looking for?" Ted asked.

"I had a piece of paper. It was a Xerox of the names of the people who'd put valuables in the safety deposit box here. Charlie had rented one, but before the parade, someone, who I think may've been Kate, signed as his wife, and took out whatever was there."

He looked at me, puzzled. "When did you find that out?"

Serendipitously, just then the door swung open to reveal Nadine in stocking feet, holding a drink that clearly wasn't the water I'd left with her. "Don't keep me in suspense," she said. "For God's sake, tell me what happened."

We went inside, and I let Ted recount what we knew, while I tried to bring my nerves under control, and figure out a way to explain why I, who constantly made speeches about honesty in relationships, had lied to him.

"It still could've been a horrible accident," Nadine protested. "Even if somebody deliberately removed the warning sign, it doesn't mean the person intended for Kate to hit the tree. Maybe they were both just being daredevils."

"Sorry to burst your bubble," Ted said, his tone brusque, "but this was a homicide. It's too coincidental that two of Dr. Freundlich's closest associates have suddenly ended up dead."

"Besides which," I put in, hoping to keep Ted's focus on the puzzle, "how could anyone see a friend hit a tree and then just take off?"

"But nobody could've made Kate ski a trail she didn't want to go down," insisted Nadine.

"No," Ted replied. "But if there was no warning sign up, some-

body could've challenged her to do it. Someone for whom the trail wouldn't have been as much of a challenge."

"Dr. Freundlich taught all his children to ski in Switzerland," I said.

"How do you know that?"Ted asked.

"Gerta mentioned it this morn—"

"This morning. You mean you saw her after I left?"

Oh, shit.

"Well, yes, but—"

"How did that happen? I thought you were feeling lousy. I thought you were going to stay in bed."

He was making me feel like a disobedient child and I didn't like it. I narrowed my eyes. "I was feeling better and I decided to go out."

His face was a thundercloud. "I see."

"Oh, who cares how she found out," said Nadine impatiently. "You think Freundlich wasted them both?"

Suddenly, I couldn't stand the term. Because it trivialized their deaths, even though, in a bizarre and hideous way, it was appropriate. Two young and promising lives wasted. "Stop drinking, Nadine," I snapped. "Xanax and liquor don't mix."

I turned to Ted. "I remembered that I'd asked Dr. Freundlich to have lunch today, so I—"

"Really. When was that?"

Deeper and deeper.

"Last night when I went to the demo room to order disks," I said. "I ran into him and Gerta there. I forgot to tell you."

"So you never had any intention of leaving today."

I gritted my teeth. "After lunch. I'd planned to leave after lunch."

"Could you two go at each other another time?" Nadine said. "I asked you if you thought Freundlich is behind this. Because I don't think so. Because the attacks on Joe Golden and me wouldn't've made any sense, and tons of people saw him at the lift line. And it couldn't be Scarborough because he's in jail, so he couldn't have killed Kate. And it couldn't be Kate because," she shuddered, "because she's dead. So who's left?"

Who indeed? Geissing or Zimmer or a crazy person.

* * *

I had another coughing fit and went back to bed. It didn't help my pounding headache to know that Ted was furious with me, and that I'd only made things worse by getting angry myself. I love Ted. There's not the slightest doubt in my mind anymore about that, but when he tries to control me, when he tells me what I can and can't do, he brings out the worst in me. I don't see it as concern for my well-being. I see it as male domination, infantilizing me, diminishing both me and my hard-won independence. And I snap.

After I was in bed, Ted came in the room with aspirin and cold medication. Then, without saying another word to me, he left to go to The Cove for take-out soup and burgers. Nadine, half-zonked by the combination of Xanax and Southern Comfort, went into her room to take a nap. So I was alone when my cell phone rang.

"Hello?" I croaked.

"Mom?"

"Allie? Hi, sweetheart. How're you doing? You having fun?"

"Yeah, snow's terrific, and they have really good trails here. You okay? You sound funny."

"I'm fine. I have a little cold, is all."

A pause. "I miss you. I wish you were here."

I caught something in her voice.

"Everything all right?"

"Uh-huh." Very slight hesitation. "You gonna be going home soon?"

"We were supposed to leave today but the police want everyone to stay for another couple of days." No reason to elaborate. "Why're you asking? Aren't you staying for the week?"

"Um, we were, but um, Bree isn't a very good skier and she fell and hurt her leg and now she wants to go home."

The mean little elves banging away inside my head traded in their hammers for clubs.

"So, let her go home. Why can't Daddy put her on a plane? There's no reason to spoil your vacation."

"Daddy doesn't want to stay without Bree. And it's okay. It wouldn't be any fun for him with just us."

Why couldn't that sonofabitch ever put his children first?

"Of course it would. It'd be a treat for him. He probably doesn't know how to get rid of her without hurting her feelings." Yeah, sure. "Is Dad there now?"

"He's in their room."

"Could you go get him?"

A beat. "I don't think I should bother him."

"Why not?"

"Um—he gave me and Matt dinner money and said he and Bree were tired and wanted to rest."

Rest, my ass!

"Honey, go knock on his door and tell him I'm on the phone, and I want to speak to him."

"Okay," she said, her voice tight with reluctance. "But please don't tell him I called you, okay?"

"I promise."

I waited impatiently, while my cell phone clock racked up minutes. By the time Rich picked up, my temper had risen to the boiling point but I held myself in check, thinking I'd try the soft approach first.

"Hi," I said. "Just wanted to let you know, I can't leave here for another couple of days so—"

"Oh, f'chrissake, I thought you'd be home by now. What's your excuse this time?"

Initial reaction: mind-numbing rage, followed by the icy calm that heralds a storm.

"Stop it."

"What?"

"I said, stop it! Don't you ever dare talk to me that way again."

"What way? I just asked—"

"Don't even think about asking. I don't have to explain myself to you. Ever. Nor you to me anymore. But you'd goddamned well better think about explaining yourself to your children if you want their love and respect. Because they're not babies anymore and you're not fooling them."

"I don't know what you're talking—"

"Yes, you do," I snapped. "But I won't go into that. You took the kids on a vacation and you promised them a week. Be a mensch and stick to it. For once in your I-me-self-centered life, put them first. You might find the rewards even greater than a good fuck."

There was a pause, and it wasn't the pause that refreshes.

"You know," he retorted, "you never used to talk like that. It's not becoming. Must come from hanging around that cop."

Keep cool, Carrie.

"Actually," I said, "the credit is yours. It came from finding out my husband was a liar and a cheat. Now are you going to send your cheeseburger home and stay up there with the kids or not?"

Another pause. "I'll stay," he grumbled sullenly.

"Good. I'll see you all next Sunday." I cut him off.

I felt wonderful. And all the elves departed.

By the time Ted came back with dinner, I was sitting up in bed. I'd washed my face and combed my hair and put on a touch of rouge and lip gloss. I'd set one man in my life straight, and I needed to clear the air with the one who mattered.

"Can we talk?" I asked, after I'd polished off my burger, and he'd come back in the bedroom to take away the dishes.

"Now?"

I patted the bed. "Yes. Please. Would you sit here?"

He hesitated, then put the dishes down on the dresser, and sat a little distance from me at the foot of the bed. No physical contact allowed. He wasn't going to make it easy.

"First," I said, "I'm really sorry about this morning. I know you were angry—that I didn't tell you about it. Sneaking around is the last thing either of us wants in this relationship."

"I would've thought so."

"So I need you to understand what made me do it."

His body language told me he wasn't giving an inch. "Should be interesting."

"Okay." I took a deep breath. "You can't make decisions for me, Ted. It brings out the worst in me. I know I don't always—"

"You don't think about consequences. Like running off by yourself, for chrissake, when there's a psycho—"

"I agree, on occasion I've blown it, done some stupid things. But I've been deciding things for myself and the kids on my own for quite some time now, and most of the time, I do okay."

"If I didn't care so goddamned much—"

"I know, and I appreciate it. But much as I love you, I can't let you put me back where I was when I was married, because that's a place I don't want or deserve to be ever again. I have to make my own decisions and you need to respect that even if sometimes you don't agree." I searched his face for a sign that I was getting through, but he'd put on that impassive cop's face that doesn't let me in, doesn't give a clue as to what he's thinking. I fidgeted with the edge of the blanket. "So that's it," I said. "I love you, but that's how it has to be or it won't work." I was letting it all hang out and taking a terrible chance, but it was a chance I had to take. "Can you live with it?"

He didn't answer right away. Then he said, "That's quite a speech," and got up and walked to the door. I thought he was going to leave and my heart dropped. But instead he flicked the lock.

"What're you doing?"

When he turned around, he had a lopsided smile on his face. "You said you loved me twice and I didn't have to drag it out of you."

"Did you hear the rest of what I said?"

"I heard. Can I live with it? Shit, I don't know." He came back to the bed and took me in his arms. "It's a helluva challenge," he whispered, his lips roaming over my face. "But I must think you're worth the trouble."

"You'll catch my cold," I murmured.

"Take my chances."

I wrapped my arms around him. "We okay, then?"

"Guess so, 'cause I'm planning to screw your brains out."

Which he did with a passion and tenderness that left me shaken and breathless.

Chapter Twenty-four

I WOKE UP Wednesday morning feeling amazingly good, both mentally and physically. I rolled over and reached for Ted, but he was gone. My hand touched paper on his pillow. Pushing myself up on one elbow, I picked it up.

> *Am off to find Patrick to convince him to let us leave today. He has to know we're not on his short list.*
> *Love you, Ted*
> *P.S. This is a helluva time to ask, but will you marry me?*

I fell back on my pillow. This wasn't the first time Ted had hinted about marriage, but it was the first time he'd put it in writing. I re-read the note and noticed a small "over" written at the bottom. I flipped it to the other side.

If you want to know why this came to mind, I don't think either of us thought about using protection last night. Just doing the gentlemanly thing. T

Holy shit, he was right. I'd gone off the pill last month because my doctor had advised me to take a few months' break, so we'd been using the old-fashioned methods. Or not using them, as the case happened to be last night.

I got up and dashed for the bathroom, my mind seesawing between shock at the possibility of my getting pregnant at my age, and the shock of yesterday's trauma, which suddenly came back to me. Kate's murder won out. I could deal with marriage and unborn babies tomorrow.

Poor Kate, I thought as I soaked away my aches in my ten-inch bath. I hadn't really liked her because of the way she'd used Charlie. I couldn't get out of my head what the assistant had said, that she'd "buried" him. Also because I was pretty sure she'd been fooling around with Dr. Freundlich. But why was she killed? It had to be because she'd suddenly become a threat. She'd taken over Charlie's job, so maybe she knew whatever Charlie knew. As long as Kate was enamored of Dr. Freundlich, she probably wouldn't have done anything to harm him. But when the police picked up Scarborough, things began unraveling. And Kate, who was capable of "burying" a fellow employee, would not have allowed herself to go down with the sinking ship.

As I was blow-drying my hair, I heard the front door open and close, followed by a knock at the bedroom door.

"Honey, you dressed?"

"Since when does the father of my hopefully nonexistent child have to knock?" As I said the words, I felt a rush of excitement deep in my gut. What was that about? Did I want Ted to father a child of mine? I shook my head. Ridiculous. I already had two children.

He opened the door and shut it behind him, grinning. "Threw you, didn't I?"

"In more ways than one. You got me thinking I need to go back on the pill."

He pulled me to him. "Would it be so terrible?"

My heart skipped a couple of beats. This was a whole new scenario that I hadn't anticipated. "Not if we were both a few years younger, but as it is—"

"Hell, we're not in our dotage, but we'll discuss it another time. Patrick's out there with Nadine. He wants to talk to you."

We'll discuss it another time?

I pulled away. "What does he want? Is it about my scarf?"

"Dunno. Come and find out."

I slapped on some lipstick, ran a brush through my still damp hair, and followed Ted into the living room.

Patrick got to his feet, and held out his hand, a much friendlier gesture than any he'd made to me the last time we'd met. I took it. He smiled. He had a pleasant smile that showed slightly crooked white teeth and a dimple on his left cheek. He wasn't a man whom I would've called drop-dead gorgeous, but his features were strong and his brown eyes hinted at intelligence. Funny, the things you notice when you're not on the hot seat. He was wearing jeans, a brown corduroy sport jacket with suede elbow patches over a rust turtleneck, and suede Timberlake boots. I caught Nadine eyeing his left hand, which conspicuously lacked a wedding band.

"Ms. Carlin," he said. "Lieutenant Brodsky tells me you haven't been well. I hope you're feeling better."

"Much better, thanks, Sergeant."

I glanced at Ted, knowing he was thinking what I was thinking. Patrick was smiling at me and inquiring about my health. He wanted something.

He sat, and we followed suit, him in the recliner, Ted in a chair opposite him, and me on the couch. At least this time we were all on the same eye level. Patrick's gaze flicked over to Nadine who was perched on the arm of the couch, long legs crossed, posing. She was wearing a low-cut red silk robe with a high slit up the side, and fluffy backless red slippers, one of which hung suggestively half-off the crossed-leg foot. A chain around her neck held a gold pendant that peeked out from between her breasts.

"I assume Dr. Claughton told you that we'd picked up Paul Scarborough," he said.

"Yes."

"We released him this morning."

"Why?" Ted asked.

"Not enough evidence to hold him. His lawyer flew in last night. Hired by Dr. Freundlich. Partner in a high-priced firm. Scarborough denied ever having seen the kid who ID'd him. No other witnesses, so unless we could prove otherwise, we had to let him go."

"Are you saying you think there's a conspiracy involving Dr. Freundlich himself?" I asked.

"His people are the ones getting killed. The other possibility is that we've got a psycho with a beef against your entire profession running loose, in which case the kid fingered the wrong person. But my money's on the first scenario."

"Carrie's only just met most of these people," Ted said. "What is it you want from her?"

"Information. Her take on them."

Which meant, notwithstanding my scarf as the probable murder weapon, I must be off the suspect list.

"Dr. Claughton has already given me her thoughts." He smiled at Nadine, then tore his eyes away from her and focused on me. "You're on relatively good terms with Dr. and Mrs. Freundlich, aren't you, Ms. Carlin?"

Actually not so much, after I threw that punch. I looked over at Nadine. She was certainly on good terms with *Hubie*, but I took a wild guess she hadn't mentioned that to Patrick.

"Well," I replied carefully. "I wouldn't exactly say that. We've had a couple of conversations since the night in the hot tub. That's about it."

"When was that?"

"Yesterday and the day before."

I saw a frown crease Ted's brow but he kept silent.

"I'd asked Dr. Freundlich to have lunch to go over some material on a couple of disks he'd given me," I added.

Nadine poked me with a long red nail. "Aren't you the sly fox," she murmured.

I wanted to shove her off her perch. "I went to his villa and ended up mostly talking to Gerta because he didn't come back till later."

Patrick took a small notebook and pen out of his inside pocket, and I caught a glimpse of the shoulder holster under his jacket. So did Nadine. Her slipper fell off her foot. Leaning over to retrieve it, she managed to display a significant amount of cleavage. Patrick picked up the slipper and handed it to her.

She smiled a kittenish smile. "Thank you," she said.

He smiled back and replied, "You're very welcome," before turning back to me. "What's your impression of Mrs. Freundlich?"

If he just wanted character assessments, I could do that. "Very European. Formal. Family oriented. Her whole life revolves around her husband and her children."

"If she thought they were threatened?"

"She's a lioness. She'd defend her lair."

"Would she kill?"

"Oh, hey. That's a big jump. I don't know her well enough to even hazard a guess. But she doesn't strike me as the type who'd enjoy breaking a fingernail."

"How about him?"

"Brilliant. Charming, charismatic, but…"

"Sexy," Nadine added.

"So was Bundy," Ted added, dryly.

"You said *but*. But what?" Patrick asked.

I studiously avoided looking at Ted. "He can't keep his hands off women. I think he has an ego problem. He has to keep proving himself."

"Oh, come on," Nadine said. "Women can't keep their hands off him."

Speak for yourself.

"What would he kill to defend?" Patrick asked.

"I don't know. His place in the scientific firmament, maybe?"

He made a note.

"Don't quote me," I said anxiously. "These are off-the-top-of-my-head first impressions. I don't know these people."

He kept writing. "How about Dr. Geissing?" he asked, without looking up.

"Um…" I chewed on my lower lip. "I'd say he's a typical academician who got to where he is by being careful not to make waves or step on toes."

"What would push him over the edge?"

I hesitated.

He looked up. "Take a stab. You're doing great."

Was I? It seemed to me that I was giving everyone he mentioned a motive for murder. "Maybe if he saw everything he'd worked for over the last thirty years going down the tubes."

More note-jotting. "Mr. Scarborough?"

"Dr. Scarborough," I corrected him, arching an eyebrow at Nadine, whose face flushed the color of her robe. "I haven't had an opportunity to talk to him much, but—"

Patrick flipped back through his notes. "He's not a doctor."

"He's a Ph.D.," I said.

"No. He doesn't even have a bachelor's. We've checked him out."

The reason for the high beta spike on his disk!

"That's interesting," I said. "Because I looked at his brain wave disk. When asked about his educational background he lied, and his brain wave pattern indicates he's under terrific stress."

"Explain what that means," Patrick said. "About the brain waves."

"Research is being done that seems to indicate certain changes take place in a person's brain waves when he or she lies. It's very similar to the lie detectors you guys use, only I think, when read by someone qualified, it may be even a more precise barometer. Also the brain wave pattern alters when a person is highly stressed." I turned to Ted. "Remember what I was trying to tell you yesterday morning? I know you don't think what I saw was significant, but I think Scarborough's the key. I think he's at the breaking point."

Ted glanced at Patrick. "She could have something."

Maybe a brain?

"If she's right," Ted went on, "he could be next on the hit list. Too bad you had to let him go before you had a crack at him."

"We have him under surveillance." He turned back to me. "Tell me about the loudmouthed woman. Zimmer."

There was definitely more respect in his tone, and I smiled smugly at Ted. I was beginning to get into this.

"You think she could be involved?" Patrick asked.

"I tend to doubt it."

"Why?"

"Because killing people wouldn't further her cause," I said. "And I think her bark is worse than her bite. But that doesn't mean there couldn't be some nut tagging along with her who's determined to win her war against biofeedback therapy. Someone with a mentality like those pro-life killers. But if that were the case, I'd think Dr. Freundlich would've been the target."

He put his notebook down, and gave me his full attention. "Let's cut to the chase. Take a guess as to why someone would've wanted to kill Kate Donovan."

I rubbed my forehead hoping that would stimulate my brain, and somehow it did, because the answer came to me. "For the disk."

"What disk?"

I told him what Joe and I had come up with, and mentioned that I'd been able to get a look at the safety deposit box list. He didn't ask me how and I didn't elaborate. I left out the part about the demo room break-in.

"But you don't know for certain that there even was a disk, or that it was Kate Donovan who removed it from the safety deposit box."

"No, but something important was in that box, and it strikes me that if there were a disk or a tape or a letter, and Kate did take it, after Charlie was killed she might've decided to use it to blackmail the murderer."

"Pretty stupid," said Nadine.

Ted spoke up. "Avarice, one of the seven deadly sins. Or overwhelming ambition, which ought to be. People kill or are killed for

those reasons all the time." He shifted his gaze to Patrick. "I guess we've covered all the usual suspects. About wraps it up, Sergeant, right? We have your okay to push off today?"

Patrick jotted some final notes before he answered. "I'm afraid not," he said. "This disk, if it exists, or even if it doesn't, could be just the bait we need to set up a sting operation."

I saw Ted stiffen. "What's that got to do with Carrie?"

"I'm going to need Ms. Carlin's cooperation," Patrick said, "If she'd agree to—"

"To be bait?" Ted finished for him. "No way. Over my dead body."

I thought about that bullet whizzing by my head and shivered. "I'm sorry, Sergeant," I said. "I'd like to help but—"

"At least let me tell you what I have in mind," Patrick said.

"No," Ted responded angrily. "I'm familiar with sting operations, and I know what can go wrong. I won't permit it."

Permit. Damn, I hate that word.

Patrick closed his notebook and got to his feet. "Of course, I can't force her to do anything she doesn't want to do. But I would like her to keep herself available until we sort out how her scarf came to be in the possession of the perpetrator."

Ted exploded out of his chair. "That's bullshit. You know damned well she's not a suspect. Her scarf was stolen. You don't have anything on her, and she's been nothing but cooperative. You can't keep her here and you can't force her to be your bait."

"She'd be completely safe. I'd have my people all around her."

They were confronting each other like a couple of bantam roosters, and talking about me as though I weren't here.

"Hello," I said sweetly. "Remember me? The bait? Do I have anything to say about this?"

"Carrie, it's a cop trick," Ted said. "Trying to scare you into doing what he wants. But it won't work. You're free to leave."

Patrick picked up his jacket. "You're a homicide cop, Lieutenant. Wouldn't you like to see this sonofabitch caught? He's killed two people already, nearly killed another, and almost got to your lady friend here. What's to stop him from trying again?"

Won't permit it was ringing in my ears. "It can't hurt to let Sergeant Patrick tell us what he has in mind," I said.

"Goddammit, Carrie—"Ted began.

"I thought we had an agreement," I said, cutting him off, "about my making my own decisions. I'm not a fool. I just want to hear the plan."

Patrick dropped his jacket and sat down again. Scowling, Ted remained standing, his arms folded across his chest.

"I haven't worked out all the details in my mind yet," Patrick said. "This is just the basics of the plan. We'll refine it and make sure the meeting place is one that we can have well covered."

"What meeting place?" Ted asked.

"I don't know yet. The way I see it," Patrick said, turning his attention to me, "you'll write a note to Paul Scarborough telling him you have a copy of a disk that Anders made before he was murdered, identifying the person Anders was afraid of, and the reason behind his fear. You'll say you want him to set up a meeting, that you're willing to turn over the disk for a price."

"Jesus Christ," Ted groaned. "That's probably what Kate Donovan did, and why she was murdered. Carrie, you can't do this."

"Donovan was skiing alone," Patrick said. "We'll secure the area, put sharpshooters behind trees, and cops dressed as ordinary skiers all around her."

I looked at Ted. "That doesn't sound too dangerous, does it?"

"Are you out of your mind?" Ted roared. "Do you have any idea what could go wrong with an operation like that?"

"She could get whacked," Nadine said, giggling nervously.

Ted wasn't laughing. "One bullet," he said. "That's all it would take. You could have fifty cops around you. One bullet, and Allie and Matt are motherless."

Chapter Twenty-five

HE'D KNOWN which buttons to push. There was no way I could go along with the scheme. I opened my mouth to tell Patrick I was sorry but I'd have to refuse, when suddenly Nadine piped up, "I'll do it."

"What?" I gasped.

She leaned in to Patrick, letting the robe fall slightly open. The pendant swung loose. "I don't have kids," she said. "I'm unattached, and I could just as easily have found the disk as Carrie."

It took Patrick a few seconds to recover from the shock of her offer. Or maybe it was the hypnotic effect of the swinging pendant. "Well," he said finally, "I guess that'd work." And then he added solicitously, "There is some element of danger. You want to take some time to think it over?"

Wonderful. Her he's worried about, I thought, annoyed.

Nadine moistened her lips with the tip of her tongue. "As long as

you're there, I'll feel safe," she murmured. "You will be there, won't you?"

"Sure, of course. Not visibly, not where anyone can see me, but I'll definitely be there."

She smiled, a cat-who-swallowed-the-canary smile. "Well, then," she said, "it's settled. We'll get together this evening, and you'll explain the whole thing to me."

I could tell Ted was flabbergasted. So, I'm sure, was Patrick, but that's because neither of them had any idea the lengths to which Nadine would go, in order to get a man she wanted into her bed.

"Nadine," Ted said, glaring at Patrick. "Think this through. There's more than a little element of danger here. You're making yourself a target for a killer, and there's only so much protection the police can provide."

"Why can't you use a female detective?" I asked Patrick. "Put her in a ski outfit with a ski mask and goggles, and nobody'll know the difference."

"Why is it any safer for a cop than it would be for me?" demanded Nadine.

"They're trained and armed, f'chrissake," Ted snapped. "They know what they're doing."

"I can't use a detective," Patrick said. "Even if we arrange for the meeting to take place outdoors so that ski clothes would make sense, there'll be a couple of minutes of face-to-face before we can close in. These people know what Ms. Carlin and Dr. Claughton look like."

"Oh, please, Sergeant," Nadine cooed. "Stop this Doctor business. If we're going to be working together, call me Nadine. And you are—?"

"Brian. My name's Brian." He grasped Nadine's hand warmly with both of his, and smiled down at her. "You're doing a good thing, Nadine. You're probably saving someone's life."

And putting her own on the line for a fuck, I thought. Like Faust. And look where he ended up. The woman is a stark raving mad nymphomaniac.

* * *

Later, over breakfast at The Cove, Ted and I did our best to talk her out of it, but she was unshakable.

"I don't get you, Nadine," I said. "You're not doing this for any altruistic reason. You've suddenly got the hots for Patrick. That's what it's about."

She feigned hurt. "That's not true. I mean, I'm not saying I don't find him attractive, but this killer has to be stopped. And you wouldn't step up to the plate. Someone had to do it."

"Right," said Ted. "Cops, not civilians."

"I'm sure Brian will see to it that I'm all right," Nadine said coyly. "After tonight, he's not going to want anything to happen to me." She took a bite of her cheese omelette. "This is very good. I wonder what kind of cheese they use."

I threw up my hands. "Vermont cheddar, and you need help."

"You're getting yours," she said, her voice sharp. "Why shouldn't I have some?"

I was about to remind her that, like it or not, she hadn't exactly been celibate this week, but I decided it'd be cruel to rub her nose in it.

Ted pushed back his chair and got up. "Be right back. I'm going to the men's room."

I watched him go, wondering why he headed in the wrong direction. Nadine pulled out her lipstick and a mirror from her jacket pocket and replaced the color she'd eaten off. I was concentrating on sopping up a puddle of maple syrup with the last chunks of pancake on my plate, so I didn't notice anyone at my elbow until I saw Nadine's face light up. Expecting to see Patrick, I swiveled around. But it was Steve, the hunky waiter from Sunday.

"I know you," he said to me. "You were here Sunday morning with the lady who had the skiing accident." His tone was reproving, as though he thought that somehow I was responsible for her death. "You told me neither of you were with the convention."

I heaved a sigh. "I'm sorry, Steve. I didn't want to talk about what happened. I still don't."

"And who is this attractive young man?" Nadine asked.

"Steve works here," I said shortly.

"Well, young man, you can refill my coffee any time you want," Nadine said.

Was it me, or did everything out of Nadine's mouth sound like a proposition?

"Yes, ma'am," Steve said. And having totally missed the double entendre I'd heard, he picked up a coffeepot from a nearby station, and proceeded to do just that.

"I'm sorry about your friend," he said, as he topped off my coffee. "She was so—she was totally—I mean—she was so young." His face colored as it dawned on him that it might be inappropriate to refer to a dead woman as hot.

"Yeah. Thanks." I wished he'd go away.

"I can't think why anybody would've taken the sign down," he went on. "People're saying it was deliberate 'cause she knew something about what happened to the other guy. I served him, too, ya know."

"So," Nadine said, smiling brightly. "How long have you—"

I grabbed Steve's sleeve. "You waited on Charlie Anders? When?"

"Saturday. I started to tell you that the other morning, but you said you were UVM faculty, and weren't interested."

"I'm interested now. Tell me what they said."

"He got in a fight with his boss. You know, that big doctor all the girls're wiggin' out over. Now everybody's saying he's the one did it."

"Sit down, Steve." Trying to cover my excitement, I pushed him down in Ted's chair. "Did you hear what they were arguing about?"

"Yeah. Uh—I'm not supposed to sit with the guests when I'm working."

"Don't worry about it. I'll square it with whoever makes the rules." I was practically bouncing up and down. "Did you tell the police about the argument?"

"Yeah. That lady cop."

"What was the argument about?"

"Well, the young guy, Anders, he was clobbered, and he said this other guy, his boss, had shit for brains and that if he, Anders, didn't

get what he wanted, he was gonna make some kind of announcement so everybody'd know it. And he said he'd made sure he'd covered his ass so the boss'd better not try to get rid of him like he did the other assistant. Jeez, imagine telling your boss he has shit for brains. Even if he does. I mean, *my* boss's got shit for brains but I got more sense than to tell him."

"What assistant?"

"Janet Something, I think. I guess she got fired."

Janet Wiley? "Did he say what the announcement was about?"

"Uh-uh, but the boss knew, and he got all red in the face and started yelling that Anders had never been a team player and he was history just like this girl. And then they got up and started to leave and I had to stop 'em at the door to get the check signed." He grinned. "I got a big tip out of it. Probably didn't realize what he gave me. The boss, I mean. He was so freaked out. Ten bucks on a thirty-buck tab."

I repeated the conversation to Ted when we were back in our bedroom, packing up.

"It sure sounds like Freundlich's up to his neck in this, doesn't it?" I said, sweeping my jumble of makeup off the dresser and into my cosmetic bag. "Charlie was threatening to blow the whistle, and whatever he knew, it sounds like it'd ruin Freundlich if it came out."

Ted had his duffel on the bed and was rolling his new ski sweater into a log shape. "If I'd caught the case, he'd top a very short list. What girl was he talking about?"

"I'm not sure, but I think it could be that girl who worked with Scarborough, Janet Wiley, I think her name is. Geissing met her. She told him Kate had buried Charlie. Patrick should talk to him—here, let me do that. You're wrinkling it." I took the sweater out of his hands, folded it neatly and handed it back.

Ted straightened up. "Did you tell Patrick about this girl?"

"I didn't think of it, but Steve said he told Mayer and God knows they've grilled Geissing, so he must know about her."

"Don't take anything for granted. Tell him."

"Okay, but let's get back to Freundlich. He had a motive, but no

opportunity. How do you account for his being seen at the lift line when Charlie was killed?"

"Elementary, my dear Carrie. There's a third person."

Ted's hired gun theory was looking more and more plausible.

"Where'd you go when you said you were going to the men's room?"

"What makes you think I went somewhere else?"

"I know where the men's room at The Cove is. So unless you were planning to pee in the kitchen..."

He laughed and rumpled my hair. "Can't put anything past you, can I? I called Patrick on my cell. Didn't want Nadine to hear." He dumped a couple more sweaters and some T-shirts onto the bed in front of me. "Here, smarty-pants, you can do the rest."

"I hope you talked him out of using her."

"Tried. No go. He's even moved up the timetable. The note to Scarborough's being sent later this morning, and the operation's set for tomorrow."

"Tomorrow?" I repeated. "When?"

"Morning. I hope your friend enjoys her rendezvous tonight. It may be her last."

A T-shirt hung slack in my hands. "Don't say that."

His brow furrowed. "It's unbelievably stupid, what she's doing."

I dropped the shirt I'd been folding onto the pile, and started for the door. "I'm going to talk to her again."

"You'll waste your breath. And Patrick's hell-bent on nailing this guy before something else happens. He's getting a lot of pressure from the top and I know what that feels like."

I came back and perched on the edge of the bed. "Where is it happening?"

"Outside the warming hut on top of Bristol."

"For heaven's sake," I exclaimed. "Why on top of the mountain?"

"Because he doesn't want Scarborough to make the exchange. Scarborough's never been on skis in his life. They checked. The perp is a skier. There's apparently no other way to get to the warming hut on Bristol except to ski over from the top of Stonycreek, so the killer has to show. And they'll grab him."

"How can Patrick be sure that Freundlich or whoever will take the bait?"

"He's counting on your theory that there's a disk or a tape out there somewhere, and if there isn't, that whoever-it-is will believe there is."

I looked for flaws in the plan. "What if the perp insists on a different place for the exchange?"

"Patrick made it clear in the note that the time and place weren't negotiable. He's asked for twenty-five grand—"

"Why so much?"

"Had to be enough so it sounded realistic, but not so much that it couldn't be raised in a day. The bills are to be packed in a backpack. In return, Nadine will hand over the disk. If no one shows, the note says, she'll turn the disk over to the police."

It sounded good, almost foolproof—till I came up with the fly in the ointment. "Disks can be copied."

"Aha. You bet, which our killer is very well aware of. Now you understand why I didn't want you involved. He'll need to take her out like he did Donovan. He can't afford to have her coming back for more."

I caught my breath. Nadine would be crazy to go through with this. Granted, the only time she'd be vulnerable would be that one face-to-face moment in the open when they made the exchange. And Patrick would have men all over the place ready to swoop in. But a lot can happen in sixty seconds. "It could work," I said, "if the killer hasn't any other accomplices but Scarborough. There'll be nobody to have her in his sights."

"Such an important little word—*if.*"

I sat on the edge of the bed, picked up the T-shirt, started to fold it, and put it down again. "We can't leave today. If we do, I'll be a nervous wreck not knowing what's happened to Nadine. And so will you."

"Carrie, we did everything we could to talk her out of it."

"She doesn't realize what she's getting into. She's not thinking clearly."

"Oh, she's thinking clearly." He shook his head, a rueful grin on

his face. "Problem is she thinks with her—uh, without getting too explicit, is there a way to say a woman thinks with the female equivalent of a dick?"

"I don't think so. Nadine's unique."

I kicked his duffel off the bed, pulled him down, and nuzzled his neck. "Know what we could do if we stayed?"

He grabbed me and swung me on top of him, his hands creeping under my sweater. "You'd use your feminine wiles to get what you want? So our Nadine's not unique."

"I was going to suggest we go skiing so I could show you where all this is going to take place. But if you insist on your pound of flesh first..."

He dumped me off him. "Later. And I'll want more than a pound. But okay, we'll stay."

I planted a kiss on his cheek. "You're a sweet man."

"Hell, I'm as worried about her as you are. Let's go case the joint."

Chapter Twenty-six

"SINGLE," called out the attendant who was loading skiers onto the chairlift.

"Here," called a girl from the back of the line. "I'm single."

"Nice way to meet people," Ted commented, appreciatively eyeing a pretty young thing wearing a Western ensemble complete with fringe and turquoise and silver buttons, as she snaked her way through the lift line. She joined a fleece-jacketed, stretch-pant-clad stud who was two couples ahead of us. "How come they didn't pair people up like that when I was single?"

"You are single," I said, "but the point isn't to match-make. It's to shorten the lift line. Those two just lucked out. No chair at Snowridge goes up the mountain in season carrying only one person."

"Ah," he said, "two birds with one stone."

A light snow was falling and the frosty flakes stung our cheeks and noses. At the base of Stonycreek the temperature was in the teens and it dropped even lower as the lift ascended the mountain.

Strong winds gusted through the trees, blasting the mantle of snow from the topmost boughs. It sliced through our down-filled ski jackets as though they were stuffed with grape leaves.

Twenty minutes later we'd reached the top of Stonycreek, and took a trail called Treasure Run, which meandered over easy terrain to the base of Bristol Mountain. By the time we reached the summit of Bristol, after another fifteen-minute lift ride, my nose was running again, and my fingers and toes felt like those little crescent-shaped cubes my icemaker spits out. We skied down a small incline to the warming hut. A warming hut is exactly what it sounds like, a place for skiers to warm up with hot soup or cider, or energize with a power bar before tackling the challenging trails.

"Tell me about the different trails," Ted said as we stood in the clearing outside the hut.

"Let's have some soup first," I replied through chattering teeth. "I need to defrost."

We took off our skis, rested them and our poles against the ski rack, and went inside.

The hut was bare bones, three picniclike tables with benches lined up in a row, and a counter stacked with candy bars, bags of chips, and a black cast-iron soup pot on a hot plate. A gangly, sandy-haired kid who didn't look much over sixteen was munching on chips and perusing a *Playboy* magazine. Carafes of coffee, hot water, and hot chocolate rested on a shelf behind him. One of the tables was occupied by a group of college kids who, incredibly, were skiing in jeans and ski sweaters, no outerwear. A couple of the girls wore only earmuffs on their heads, the better to display shoulder-blade-length, sun-streaked tresses. At the second table, a more mature couple whose red noses and cheeks mirrored our own, were drinking hot chocolate. Opposite them sat the Western-attired young woman in animated conversation with her chair-mate.

Ted poked me. "See? It's a slam-dunk. Love blooms."

"Lust, anyway," I replied, chuckling. We dropped our hats and gloves on the empty table and went up to the counter. The kid standing behind the counter ignored us, so we went ahead and ladled out two bowls of soup from the steaming pot.

"What kind is it?" I asked the kid. He could've said colored dishwater, and I'd've gobbled it just for the sensation of hot liquid sliding down my gullet.

"Chicken noodle," he replied without looking up.

"How much?"

"Three bucks a bowl."

Ted reached in his pocket and dug out a five and three ones. "Business looks good," he commented, dropping the money on the counter.

"Nah, it sucks," the kid replied glancing at us for the first time. "Two murders in one week, this place is deader than those stiffs. This is the biggest crowd I've had all day. Shoulda closed up hours ago."

"I'm glad you didn't," I said, doing my best to ignore his comment. "This is going to hit the spot."

"Won't be open tomorrow, though," the kid said.

"How's that?" Ted asked.

"Dunno. Usually here seven days. Guess Management decided it don't pay to keep open for so few guests."

"Patrick," Ted whispered under his breath, as we carried our bowls back to the table. "Bet he's using this as his base. Wants to get his people in place early."

"I'm sure things'll pick up by next week," I said over my shoulder to the kid.

"Better," the kid grumbled. "I work for tips."

Work?

Despite the nonexistent service, Ted added another dollar to the already over-generous gratuity.

Outside, the snow had stopped, but the sun glare almost obliterated the groomed trails from view. Eventually, our eyes adjusted to the blinding whiteness, and I pointed out the three trails where Patrick would need to post men.

"This one's the most difficult," I said as we stood on the edge peering downward, "and the most logical escape route for an expert skier. It's called Snakeline. It's narrow, lots of moguls, very little wiggle room. I usually ski either of the other two. Nature's Path is a

beginner-to-intermediate trail. It's wide, not too steep, with no surprises. When I'm feeling ambitious, I ski this one." I moved to the other side of the hut. "It's called Chamoonga. It's intermediate level, and has a couple of sections that are fairly challenging."

Ted's eyes swept over the area. "If I were Patrick I'd have Nadine wait in that little gully just below where you get off the lift. She'll present less of a target, and there'll be the added protection of other skiers dismounting. And I'd have my men all over those trails to block off any escape route."

"I'm sure he'll be at the condo with Nadine tonight. Why don't you talk to him?"

"He knows his business," Ted said. "But I feel better for having seen the setup. Chances are, she'll be okay. Come on, race you to the bottom. Snakeline or Chamoonga?"

"Chamoonga, you fool," I shouted, planting a pole and pushing off. "You couldn't get me on Snakeline for all the money that'll be in Nadine's backpack!"

We took several more runs before the lifts closed. Relaxed and famished, we decided to have wine and appetizers at The Cove before going back to the condo to change for dinner. As a result of our workout I felt invigorated, and better than I had in days. We were on a crazy high, probably, even though we weren't directly involved, having to do with that edge athletes and soldiers feel the night before an important event or mission. Like the beginning of a love affair when all your senses are enhanced, the air smells sweeter, colors are brighter, food melts in your mouth, and the touch of your lover makes your skin tingle. I might have stayed on the high, if it weren't for the conversation that followed our polishing off two shrimp cocktails each, and a full bottle of Châteauneuf du Pape.

A half-full glass was still in my hand when Ted leaned forward, took it from me, and put it down on the table. He enveloped my hand in both of his. "You made a speech this morning. Now I'm about to make one," he announced.

"Okay," I said. I was feeling no pain.

"This is not the wine talking."

I blew a kiss in his direction. "Okay."

"Marry me."

My stomach flip-flopped. The shrimp did a little dance. That was a speech? I swallowed hard. Then I smiled, trying to joke my way out of it. "Oh, hey, if this is about last night, don't feel obligated to make an honest woman of me."

He didn't smile back. "I'm crazy about you," he said, "even though you make me crazy half the time. And you love me, fight it though you will. I've come to care for Allie and Matt, and I'd be a good stepfather to them. My parents are gone, I have no one, and I'm going to be forty-seven my next birthday. I've said it before. I want a family, Carrie. I want a wife and I want it to be you."

That was the speech, and wouldn't most women, after such a romantic proposal, be ecstatic and calling for the champagne? They would. No question about it. What was wrong with me?

"I—wasn't expecting this," I said.

"I would've thought my note this morning made my intentions pretty clear."

"I didn't think you were serious. You also hinted about wanting a baby which, of course, is—"

"That, too."

Oh, God.

I wanted to withdraw my hand, but I knew that would be a bad move. "We already live together," I said, squirming in my chair.

"I'm aware of that. And it's worked out real well, wouldn't you say?"

"If it ain't broke, don't fix it," I quoted weakly.

"I don't want our child to be a bastard."

That's when I sobered up and pulled my hand away. "You're serious about a baby."

"Yup."

"Ted, I'm almost forty-two."

"A veritable chicken."

"Nice of you to say, but it's not true."

"You're not an elderly primipara."

"A *what?*"

He grinned. "I got that from a doctor. That's a woman who has her first baby after thirty-five. You've had your two well before that."

"You asked a doctor about this?"

All of a sudden the marriage part didn't sound so daunting. But a baby at this point in my life? Maybe that was his plan, sneaky, like the girl who tells her parents she's pregnant so they won't freak out when they learn she isn't, and the bad news is only that she's flunked out of college.

"I need to think."

"Take your time. I'm in no rush." He grinned. "You're the one with the biological clock."

I picked up my wineglass and emptied it, then regretted that I hadn't dumped it over his head.

As if that little tête-à-tête wasn't enough to make my day, when we got back to the condo we found Nadine and Patrick sitting in the living room, glowering at each other. We said hi, got a couple of grunts in return, and were taking off our ski boots before the sizzle in the air penetrated our self-absorption.

"Whoa, what's going on?" Ted asked, looking up. "Something the matter?"

"Yeah," Patrick growled, his eyes shooting laser bolts in Nadine's direction. "Yeah, something's the matter. Your friend here has fucked us but good."

"Screw you. It's not my fault," Nadine shot back.

She's decided not to do it, I thought. Good. "What happened?" I asked.

"Plan A is in the crapper. We're set to go, everything's meshing, we get a response from Scarborough, and all of a sudden, she drops it on me."

"Drops what?"

"He should've checked with me before he sent the note," Nadine said angrily. "I stuck my neck out to help him, and this is the thanks I get. How the hell would I have guessed he was going to set up the meeting on top of a goddamned mountain?"

"What difference where it is?" Ted asked.

"The difference is there's no way I can get there. I don't ski."

I stared at her. "But you just bought skis," I said. "I saw them."

"I planned to learn. They gave me twenty percent off."

"Jesus, Mary, and Joseph," Patrick howled. "You bought skis you don't know how to ski on because they were a bargain?"

"How about taking her up on a Snowcat?" I asked, and then realized the unfeasibility of conducting an undercover operation with your messenger making an entrance on a noisy machine. "Sorry. Bad idea."

"Goddammit, goddammit," Patrick muttered, his head in his hands. "We've gone this far. I've gotta fix this. I've got to find another way."

"Why can't you pick up Scarborough again?" I asked. "He's implicated himself by responding to the note and I'm sure he's ready to crack."

"His lawyer won't let him say a word." He raised his head and looked straight at me. "I need to go to Plan B."

Ted's ski boots dropped from his hand and thunked on the floor. "Forget it. No way." He got up and pulled me to my feet. "Come on. We have to change for dinner."

"She wouldn't be in any danger," Patrick pleaded. He was on his feet now and grabbed my wrist. "I'll have people on the lift, on the ground, in the trees. There's no way anything can happen to her."

"Out of the question," Ted said, his grip on me tightening.

They were doing it again.

"Let go!" I said, jerking my arms free.

Patrick was shouting now. "What the hell kind of cop are you? There's a killer going to walk because you don't have the guts to risk something that belongs to you. It was okay when it was Nadine—"

Something that belongs to him?

"It wasn't okay when it was Nadine," Ted bellowed. "But I can't control what she does. Carrie, I can—"

He had the sense to stop before he finished that sentence. He knew he'd made a fatal error.

"I mean," he amended, his tone moderating, "Carrie has more sense than to allow herself to be used as bait for a killer."

"Excuse me," I said through gritted teeth. "But you're both pissing me off. If there's a decision to be made here, I'll make it."

"There's no decision, Carrie," Ted said. "We talked about it. You agreed it was too dangerous. You agreed that Nadine was being foolish."

"I know I did. But that was before you and I looked at the site. You, yourself, said that you felt better after having seen the setup."

"I said that if Nadine insisted on doing this, her chances were better if she stayed in the gully—"

"No, you said you thought that if Nadine stayed in the gully, chances were she'd be okay." I turned to Patrick. "Look, I'm not saying yes, but if you can convince me that the plan is foolproof and that there's no other way to catch this monster, I guess I'd be willing to think about—"

"Oh, shit," Ted groaned. "Oh, shit."

Neither of us got much sleep that night. Ted had barely spoken to me all evening. He'd listened quietly as Patrick went over the plan, interrupting only twice; the first time to insist that the exchange take place in the gully, and again to tell Patrick that if I were crazy enough to agree to do this, he'd be riding the lift behind me, whether Patrick liked it or not.

"What if, when the perp sees me instead of Nadine," I'd asked, "he takes off?"

"Scarborough was told Nadine would be wearing a multicolored Nordic hat with a pom-pom on the braid," Patrick said. "My mother knitted it for my sister. It's one of a kind. By the time the perp knows it's you and not Nadine, you'll be making the exchange."

"So why not use a detective, then?" Ted had asked.

"Carrie's a familiar face. If I used someone the killer didn't recognize at the moment of exchange, he'd realize it was a trap and we might lose him."

"What if he sends someone else, someone Scarborough's paid, like the kid who bought the jackets?"

"We have to hope he doesn't." I knew what he wasn't saying, and

so did Ted. This was business the perpetrator would want to take care of himself.

Toward morning, after we'd tossed and turned most of the night, I'd reached for Ted, needing to touch him, needing his warmth. He turned away.

"Don't be like that," I said, hurt.

He rolled back. "I'm not punishing you," he said, quietly, "but I'm not feeling loving. When you said you were going to make your own decisions, I understood that. But I thought we were a team. I though you'd respect my input, especially when it involves my kind of work."

"I couldn't stand to let that bastard get away."

We were quiet for some time after that. Then he said, his voice cracking, "I can't stand waiting for something to happen to you. You asked me if I could live with it, your making these kinds of decisions. To be absolutely honest, Carrie, I'm not sure I can."

There was nothing I could say. I'd crossed over a line in his mind. It wouldn't have done any good to remind him that I was also frightened, frightened for him every day of the week; that I couldn't stand waiting for something to happen to him, and that was one of the reasons I had such reservations about marriage. From the way things were going, though, I probably wasn't going to have to worry about it anymore.

I turned over and tried to sleep. As dawn crept through the blinds, I dozed off.

I dreamt I was skiing Snakeline, and I was skimming the moguls with the ease and grace of a Jonny Moseley. Suddenly I realized someone was on my tail. I wanted to look behind me to see who it was, but I didn't dare take my eyes off the trail, which was getting icy and more difficult to navigate. I could hear the person gaining on me and I was suddenly afraid, although I didn't know why. Somewhere way at the bottom of the mountain, I could make out Allie and Matt, and they were looking up at me and yelling, "Hurry up, Mom. Put your skis in the fall line!" But my skis had turned into snowboards, and I couldn't control them. A tree loomed in my path and Kate was leaning against it. She smiled at me. "Put your skis in the fall line," she said,

"or the bogeyman will get you." And Ted was sitting in the branches holding a rifle and he called out to me, "Screw up, screw up. The money's in Nadine's backpack." And I looked ahead of me, and a Snowcat was rumbling down the mountain, and Nadine was sitting on it waving a backpack in the air. Then the trail dropped away and my children disappeared and there was nothing, and I was falling through space.

I was awakened not by the motor of a Snowcat, but by the din of the snow-making machines spitting out ice particles on Lower Stonycreek. I glanced at the clock. Six forty-five and Ted was already up. I could hear the drumbeat of the shower in the bathroom. No point in trying to go back to sleep. My legs felt leaden as I dragged myself out of bed and into the kitchen to make coffee. As I waited for the kettle to come to a boil, I went over Patrick's instructions in my mind.

Ted and I were to dress and go to The Cove for breakfast, as if everything were normal. I would carry one of the Snowridge shopping bags that Nadine's purchases had come in. At some point, the bags would be unobtrusively switched, and the hat and a small backpack would be in the other bag. We would return to the condo after breakfast. I was to take any computer disk and put it in the backpack. At ten o'clock, I was to be in the lift line at the base of Stonycreek. Ted would follow five minutes later wearing goggles and a ski mask, and a different jacket. He would stay well behind me as I skied across Treasure Run to the Bristol lift.

The rendezvous was set for ten forty-five. Many of the skiers on the Bristol lift would be detectives. Patrick himself would be concealed somewhere at the summit.

It was a good plan. Nothing, of course, is perfect, and I'd have to be on my toes, but I really didn't see what could go wrong.

Chapter Twenty-Seven

JOSEPH'S FAMOUS coat of many colors paled by comparison to Patrick's sister's wool-knit hat. It came to a point at the top, had straps that tied under the chin, and a braided tail with a purple, green, and orange pom-pom on the end that trailed halfway down my back. No way could anyone miss it.

As I was tying the chin straps, Ted pulled me roughly to him and kissed me, a hard kiss that unnerved me, a mixed message, sort of a cross between "I love you" and "So long, it's been great."

Then he held me away and said, "Be careful. If anything strikes you as the least bit not kosher, dive for cover and yell blue murder at the top of your lungs."

I was still shook up when I got on the lift line a couple of minutes before ten.

"That's some hat," commented the man who slid in behind me. "They don't carry anything like that in the ski shop."

Every muscle tensed as I swiveled my head around, thinking he might be *the one*. But I didn't recognize him, so I figured he was either one of Patrick's men letting me know he was on the job or an ordinary vacationer. Or he could've been Ted's "third man"—the hired gun.

I forced myself to smile back. "No, it's homemade," I said.

A quick glance behind him revealed Ted snaking through the line. He was wearing goggles, a ski mask, and a gray jacket I'd never seen before. If I weren't so familiar with the way he moved, I wouldn't have known it was him. I couldn't see his eyes behind the goggles, but I knew they were on the move, searching the crowd. I sensed them resting on me, but when I looked his way he was gazing at the mountain.

I moved up in line, one couple closer to the lift. When I arrived at the chair, a little girl, about nine or ten dressed all in pink with white fluff around her hood, was waiting by the side.

"Single?" inquired the attendant.

"Yes," I said.

"She's getting off at the mid-station," he told me. When the lift came around, he swung her onto the chair.

I angled my poles across my lap and lowered the bar.

"You skiing all by yourself?" I asked the child, attempting to calm my frazzled nerves with normal "mommy-type" conversation.

"No," she said. "My brother and I take turns riding with my mom. They're a few chairs ahead. I had to wait for a single." Gazing up at me, she wrinkled her nose. "That's a funny hat," she said.

"I know."

She giggled, and with the frankness of the very young said, "It makes you look like a clown in a circus."

That's me. Always good for a laugh.

A fine mist was blowing, tingling my cheeks and coating my goggles. I rubbed the tiny particles away with my mitten. As we approached the mid-station, I raised the bar and signaled the attendant to slow the lift.

"You going to be okay getting off?" I asked the child.

"Oh, yes," she replied. "I'm a very good skier."

And she was. Like my Allie at that age. She skied down the ramp waving a pole in farewell, and joined a smiling woman and a small boy waiting at the top of the slope. Looking at them took me back to the years when I'd skied this same mountain with my children. And in a rush came the unwanted thoughts I'd been trying so hard to keep at bay. Like this woman, I was a mother with responsibilities. Mothers who love their children don't deliberately put themselves in harm's way. Why had I agreed to do this? What was it in me that made me flirt with danger? Was it some perverse personality flaw that made me want to fly in the face of authority, or of anyone who represented that? Had I done this because Ted hadn't wanted me to? What if everything didn't go according to plan? What if something happened to me? What would happen to my children?

We were approaching the top of Stonycreek now, and I was struck with an overwhelming urge to get off, put my skis in the fall line, and ski straight down Stonycreek back to my condo.

"Put your skis in the fall line, Mom." My children, calling a warning to me from my dream.

Too late. I lifted the bar, scooted forward in my chair, pushed myself off, and pointed my skis toward Bristol Mountain.

As I started down Treasure Run, I could hear the *whoosh*ing sounds of other skiers in my wake, any one of whom might be the person I was to meet. What if he intercepted me and forced me off the trail? The hat ID'd me, but it also made me a target. I might as well be waving a flag saying, *Here I am, killer, come and get me.* Why hadn't I thought of that possibility? Why hadn't Patrick or Ted? If they hadn't anticipated what could happen on Treasure Run, what else hadn't they anticipated? I swerved to a stop, pulled off the hat, and shoved it in my pocket. It was close to zero, but better frostbitten ears than a bullet in the back.

Pushing off again I picked up the pace, putting distance between myself and those following. Treasure Run was flat in some spots, uphill in others, and I had to pole hard to gather speed for the final downhill spurt. I was out of breath by the time I arrived at the foot of Bristol, out of breath and out of sorts.

Out of your mind, that's what you are.

There were only a few couples in line ahead of me. A minute later I saw Ted ski up and take his place in line behind a woman in a blue-and-yellow ski suit. So far, so good. I rested my poles against a post, took out the hat, and put it on, letting the chin straps dangle untied.

"Single?" asked the attendant as I coasted up to the chairlift.

"Yes," I replied, automatically.

"Single," he called, and two voices responded, "Here."

The skier in the black ski suit who came from behind me and glided expertly to the left of the oncoming chair, was tall and could've been either a man or a woman. I poled forward and took my place on the right just as a woman's voice called out sharply, "Wait!"

I looked in the direction of the voice, but the chair was under me by then, forcing me to either sit or fall to the side and get whacked in the head by the oncoming chair now swinging around the bull wheel. I sat. The lift took off. Peering down, I saw the woman in the blue-and-yellow ski suit frantically waving, and Ted pushing his way to the front.

Something was wrong. My heart started hammering against my chest wall. Don't freak, I told myself. Keep calm. This is not a life-threatening situation. You hope.

I sneaked a glance at my companion, who seemed unaware of the disturbance below. The face was almost completely hidden by a neck gaiter and goggles, the hair covered by a hood and earmuffs. Tightening one hand around my poles, my only defensive weapon should I need one, I reached up to lower the bar.

"Leave it."

"What?" My heart lurched. A muffled voice, somehow familiar. Zimmer?

A gloved hand went to the face, and raised the goggles. Flinty blue eyes bore through me.

Gerta!

A flicker of embarrassment because of the punching incident, followed by a nanosecond of relief that it wasn't the punchee himself; then, heart-stopping terror as it penetrated that this was indeed

a life-threatening situation, and it was okay for my fight-or-flight response to kick in. Problem was, no way was I in a position to either fight or flee.

The puzzle pieces fell into place. My mind flashed back to Tuesday—Gerta taking my jacket to hang in the hall. If I hadn't dropped the Xerox, and I didn't see how I could have—my jacket pocket was a deep one designed to accommodate bulky mittens—there was only one person who could have removed it.

Thoughts tumbled one over the other. The killer would have had to be an expert skier.

"The doctor and I teach all our children to ski in Switzerland."

The killer had known that I, not Nadine, had been the target of the ski-by shooting.

"Your friend should go home soon as possible. You, too, after your experience."

After *my* experience. Why hadn't I made the connection?

"I know the note iss from you, not Dr. Claughton," she said, confirming my fears.

She must have become suspicious of me when I'd asked so many questions about Charlie. Then, after she found the Xeroxed page, she'd known I'd checked out Charlie's safety deposit box.

Get her talking.

"Why?" I asked, my hoarse whisper disappearing into the wind. I tried again. "Why'd you do it?"

"Gif me the disk," she commanded.

I needed to stall for time. "It's in the backpack," I said. "I can't get at it till we get off the lift." I grasped at a straw. Maybe she didn't do it. Maybe her husband had sent her. "Why didn't Dr. Freundlich come himself? It's cowardly to make you do his dirty work."

She laughed, a harsh, rasping sound. "You think he do this?"

"Didn't he?'

"He know nothing. I take care of things. Me. Always, me."

All the saliva in my mouth dried up. She was admitting she'd killed two people. "How could you—you told me—you said you liked Charlie."

"He vas a drunk. He would have spoil everything. Ruin the doctor, destroy children's futures."

Family, she'd said. *Family is what's important for a woman. Family is the only thing worth fighting for. And,* she'd added, *security.* Meaning money. What would happen to Gerta and her children, of whom she was so proud, if Freundlich were discredited? And who was a loose cannon? Who could have taken away everything that meant anything to her? Charlie, because he'd been about to blow the whistle. And by extension, Joe and me, because she thought Charlie had blabbed to us. But blow the whistle about what?

Let her brag. "How could Charlie have ruined Dr. Freundlich? He's so brilliant, so highly thought of by everyone in the biofeedback field."

"He stir up Paul. Make him crazy. And he vas talking too much. I tell the doctor he iss dangerous, he must go, so the doctor fire him. Make things worse. So I know I must take care of things."

Stirred up Paul? We were almost halfway up the mountain now. Patrick and his men were waiting at the top. "I'm curious about Paul," I said, pretending I knew what was on the disk. "Why—"

"You have the expression about curiosity and the cat?" The menace in her voice froze my blood. "I warn you, no? Why do you not listen? I use Kate's scarf to warn her what happen if she vas not quiet! Why did she not pay attention?"

She'd taken my scarf thinking it was Kate's!

"Both of you, greedy. And Charlie, stupid. What difference if the ideas were Paul's? Just luck. And the results the same."

I got it then. Paul Scarborough was the guru! The psychologist sisters hadn't been far off, except they had thought Charlie was the brains behind the research.

I kept my voice level, soothing, saying what I knew she wanted to hear. "No difference at all. The results are what counts and Dr. Freundlich is a genius at presentation. Scarborough couldn't do that, and he agreed to let Dr. Freundlich have the credit, right?"

"Yess. Paul iss not a doctor, like Hubert. No higher education, no standing, no money for research. And ve keep him happy."

"Of course. And he got his money, didn't he?"

"And sex," she said, her lip curling. "More women in a month than zat *trottel* would haf in his lifetime."

The Roofies! Ted had guessed right about what had happened to Nadine, and he was right on as to how the killer had gotten Charlie into that ski outfit and onto the lift, boots, skis and all. A walking zombie, he'd said, until the drug took effect. I wondered if she'd given him enough Rohypnol to be certain that the combination of it and the alcohol he'd consumed earlier would kill him, or if she had actually strangled him.

"How did you—" I began, but she cut me off.

"Enough talk. Gif me the backpack."

"Where's the money?" I said, with a bravado I was far from feeling. "This is a business transaction."

She smiled, a twisted smile, and it transformed her striking face into something frightening. "Where you are going, you vill not need money."

If something doesn't look kosher, Ted had said, dive for cover and yell your head off.

I looked down, and my stomach cartwheeled into my ski boots. We were a good twenty feet in the air. After a dive from this height, I wouldn't be yelling anything.

I feigned anger to cover my panic. "We had an agreement. No money, no disk."

Her hand shot out and shoved me to the edge of the chair. It happened so fast I barely had time to save myself. As she went for the backpack, I grabbed the arm of the chair, wrapped both my arms around it, and hung on for dear life. My poles tumbled to the ground, bouncing off the snow below, one of them ending up sticking out of a snow bank like a javelin.

"You are not in a position to bargain," she hissed. "You want to lif to get off the lift, gif me the disk now."

Sweat broke out on my forehead and froze there. My hands inside my mittens were shaking so badly I could barely cling onto the chair. Her plans didn't include letting me get off the lift alive no matter what I did. She'd make it look like an accident, as though she'd tried to save me. With Ted and Patrick's detectives as witnesses,

she wouldn't get away with it, but that wouldn't do a helluva lot for me if I were dead. I saw a Snowcat pull out from the shoulder and begin crawling up the mountain. Ted must be talking to Patrick on a walkie-talkie. They knew I was in trouble. If I could stall her, maybe someone could get off a clear shot.

"You'll have to get the disk out yourself," I shouted. "I can't do it from here."

I could feel her tugging at the backpack trying to unzip it. The lift continued crawling much too slowly upward. Hurry, I prayed. Speed it up! As though by mental telepathy, the lift accelerated, and we were going faster, higher, then dipping, getting closer.

And then I remembered my key chain with the canister of pepper spray in my jacket pocket! Which pocket? The left. How to get it out? Not with a mitten on my hand. I needed to lose a mitten.

"Wait a minute," I yelled to Gerta. "I'll take it off but I have to do it one arm at a time." Letting go of the arm of the chair with one hand, I slid one shoulder strap down, then did the same with the other. At the same time, I scrunched up my hand inside the mitten and stuck out my arm. Gerta gave a yank, jerking the backpack off me, taking with it the loosened mitten. In an instant I went for the spray, found it, and let her have it full in the face. She howled in pain, both hands flying protectively to her eyes. The backpack sailed to the ground.

"Bitch!" she shrieked. And shouting something in German I didn't understand, she lunged at me. The chair wobbled, tipped forward, and I felt myself sliding, losing my grip. I grabbed wildly for anything solid, and as the safety bar came crashing down, I let go of the chair's arm and caught the footrest. I was dangling in midair, clinging desperately to the slippery metal as the chair swung crazily back and forth. The lift shuddered to a stop. Someone was screaming, probably me. I saw Gerta's ski coming at me about to slam down on my hands. I let go with one hand, and grabbed her ankle.

More screaming. Not me. I couldn't get the breath. Then a shot.

"Don't shoot!" I heard someone shout.

Flailing and cursing, tearing at her burning eyes, Gerta managed to raise her other ski. I saw it coming but there was nothing I could

do to ward off the vicious kick. Pain, flashing lights, the blurry beginnings of darkness, my hands slipping. In a last-ditch effort to save myself, I released my hold on the footrest and threw both arms around Gerta's furiously convulsing legs, clinging to them with every bit of strength left in me. Unable to take her hands from her eyes, she began to slide through the opening. Fused like Siamese twins, we plummeted, falling, falling, the snow rising up, slamming into a hard icy hole.

He who iss digging a hole for another may fall in himself.

Blackness.

From somewhere way far away, through a fog of pain, a beloved voice. "Carrie? Can you hear me? Let go of her legs, sweetheart. They need to lift you onto the litter. You're going to be okay. You did it. You got her. It's over."

Epilogue

WE BOTH survived. By the time I lost my grip on the lift, we were close to the summit and only about ten or twelve feet above the snow bank that cushioned our fall. I got away with a broken leg, two painful cracked ribs, and a few ugly bruises. Gerta fared far worse because she had the bad luck to be run down by a skier who lacked the expertise to dodge a falling body. She ended up with a shattered pelvis, several broken ribs, a broken arm and leg, a lawsuit from the skier who'd fractured both his legs, and my guess is, ultimately, jail for life.

The whole story came out when the autopsy report confirmed Ted's theory about the cause of Charlie's death, and Paul Scarborough agreed to turn State's Evidence in exchange for immunity from prosecution. He was one of those brilliant nerds who hadn't the academic credentials or the charisma to get funding for his research. Gerta had convinced him to let her husband, who possessed

all the qualities he, Scarborough, lacked, reap the fame and glory, in return for which they would see to it that this unattractive, frustrated little man was rewarded with all the wine, women, and money his heart desired. Another twist on the Faust theme.

She hadn't counted on Charlie becoming a loose cannon. Working as closely as he had with both Scarborough and Freundlich, Charlie had soon discovered the truth. Freundlich's mistake was in allowing his libido to affect his business decisions. When he wanted Kate, he'd first demoted, and ultimately fired Charlie, and that had triggered everything that had followed. Joe and I had gotten caught up in the imbroglio just by being in the wrong place at the wrong time and lending a sympathetic ear. Gerta had played on Charlie's antipathy to gays to incite an inebriated Charlie to insult Joe the night of the parade. If Joe hadn't taken the bait and hadn't gotten into a knock-down-drag-out with Charlie, the plan would have failed. But by then, Charlie had dug his own grave. Gerta would have found another way, as she had when Kate, failing to heed her "speak no evil" warning, became a threat.

To give two of the three devils their due, neither Dr. Freundlich nor Scarborough were involved in the murders, although by their behavior they were indirectly responsible for what happened. When Scarborough paid the young man to buy the jackets, he hadn't known what Gerta wanted them for. By the time Charlie was killed—not by strangulation, but by the combination of Rohypnol and alcohol—he was in so deep he didn't know how to get out. Freundlich, though obviously a participant in the fraud and the use of Roofies to keep Scarborough happy, had been completely blind to his wife's villainous machinations. His ego hadn't let him see that the lioness would never allow anyone to endanger her cubs and everything she'd worked so hard to achieve. I'm not sure what the sentence is for purchasing and dispensing a dangerous and illegal substance like Rohypnol, but I imagine Dr. Freundlich will have to be celibate for a rather long time to come. And that, for him, will be a punishment worse than death.

The bad publicity did give Zimmer and DAHM some ammu-

nition against the biofeedback community, but the protocol *does* work, so their campaign soon lost momentum.

Dr. Geissing lost his job as president of the IABP. Poor guy, his only part in the whole mess was making a deal with Freundlich to keep his knowledge of Freundlich's university dismissal from the committee, in exchange for Freundlich's silence about his AC/DC lifestyle.

There actually was a disk. Patrick found it in the disk box under the name of Charlene Anderson. I couldn't believe I'd missed something that obvious. Whether or not Kate had found a duplicate in the safety deposit box, no one will ever know unless it's discovered on Rolly's Peak when the snow melts in the spring.

As for Ted and me, our relationship has also survived. It was touch-and-go for a while, but I think I presented such a pathetic picture, limping around on crutches for weeks, he didn't have the heart to walk out on me. He even managed to bite his tongue and keep quiet about my taking off the hat on Treasure Run, which was why the detective in the blue-and-yellow ski suit who was supposed to ride the lift with me, hadn't ID'd me until it was too late. What's really clinched it with Ted, though, is my tentative agreement to trade in "Wonder Woman" for "Sadie, Sadie, Married Lady." Despite the relentless ticking of my biological clock, however, I haven't agreed to another go at "Rockabye Baby." To quote one of my dad's right-on proverbs, "Those who know when they have enough are rich."

* * *

Stephanie Violette Photography

ABOUT THE AUTHOR

Nancy Tesler is the author of four previous *Other Deadly Things* biofeedback mysteries. She was formerly an actor and has appeared off-Broadway and in film. Following a hiatus to raise a family, she became a biofeedback practitioner and wrote for the stage and television before turning to fiction.

Tesler lives in Tenafly, New Jersey. She may be e-mailed at nanmys@aol.com and visited at www.nancytesler.com.

The Tumbleweed Murders, A Claire Sharples Botanical Mystery
by Rebecca Rothenberg, completed by Taffy Cannon
ISBN 1-880284-43-X
Microbiologist Sharples explores the musical, geological, and agricultural history of California's Central Valley, as she links a mysterious disappearance a generation earlier to a newly discovered skeleton and a recent death.

Keepers, A Port Silva Mystery
by Janet LaPierre
Shamus Award nominee, *Best Paperback Original 2001*
ISBN 1-880284-44-8
Patience and Verity Mackellar, a Port Silva mother-and-daughter private investigative team, unravel a baffling missing-persons case and find a reclusive religious community hidden on northern California's Lost Coast.

Blind Side, A Connor Westphal Mystery
by Penny Warner
ISBN 1-880284-42-1

The Kidnapping of Rosie Dawn, A Joe Barley Mystery
by Eric Wright
Barry Award, *Best Paperback Original 2000*. Edgar, Ellis, and Anthony Award nominee
ISBN 1-880284-40-5

Guns and Roses, An Irish Eyes Travel Mystery
by Taffy Cannon
Agatha and Macavity Award nominee, *Best Novel 2000*
ISBN 1-880284-34-0

Royal Flush, A Jake Samson & Rosie Vicente Mystery
by Shelley Singer
ISBN 1-880284-33-2

Baby Mine, A Port Silva Mystery
by Janet LaPierre
ISBN 1-880284-32-4

Forthcoming—

Silence Is Golden, A Connor Westphal Mystery
by Penny Warner
Amidst the biggest gold rush since Sutter yelled, "Eureka!" Connor copes with stray gold nuggets, gold teeth, old mining claims, a body in a mineshaft, and the cochlear implant controversy.

The Beastly Bloodline, A Delilah Doolittle Pet Detective Mystery
by Patricia Guiver
Wild horses ordinarily couldn't drag Delilah to a dude ranch. But when a wealthy client asks her to solve the mysterious death of a valuable show horse, she runs into some rude dudes trying to cut her out of the herd—and finds herself on a trail ride to murder.

**Available from your local bookstore or from
Perseverance Press/John Daniel & Co. at (800) 662-8351
or www.danielpublishing.com/perseverance.**

MORE MYSTERIES
💀 FROM PERSEVERANCE PRESS 💀
For the New Golden Age
Available now—

Death, Bones, and Stately Homes, A Tori Miracle Pennsylvania Dutch Mystery
by Valerie S. Malmont
ISBN 1-880284-65-0
Finding a tuxedo-clad skeleton, Tori Miracle fears it could halt Lickin Creek's annual house tour. While dealing with disappearing and reappearing bodies, a stalker, and an escaped convict, Tori unravels the secrets of the Bride's House and Morgan Manor, which the townsfolk wish to hide.

How To Write Killer Fiction:
The Funhouse of Mystery & the Roller Coaster of Suspense (nonfiction)
by Carolyn Wheat
ISBN 1-880284-62-6
The highly regarded author of the Cass Jameson legal mysteries explains the difference between mysteries (the art of the whodunit) and novels of suspense (the flight from danger) and offers tips and inspiration for writing in either genre. Wheat shows how to make your book work, from the first word to the final revision.

Another Fine Mess, A Bridget Montrose Mystery
by Lora Roberts
ISBN 1-880284-54-5
Bridget Montrose wrote a surprise bestseller, but now her publisher wants another one. A writers' retreat seems the perfect opportunity to work in the rarefied company of other authors...except that one of them has a different ending in mind.

Flash Point, A Susan Kim Delancey Mystery
by Nancy Baker Jacobs
ISBN 1-880284-56-1
A serial arsonist is killing young mothers in the Bay Area. Now Susan Kim Delancey, California's newly appointed chief arson investigator, is in a race against time to catch the murderer and find the dead women's missing babies—before more lives end in flames.

Open Season on Lawyers, A Novel of Suspense
by Taffy Cannon
ISBN 1-880284-51-0
Somebody is killing the sleazy attorneys of Los Angeles. LAPD Detective Joanna Davis matches wits with a killer who tailors each murder to a specific abuse of legal practice. They call him The Atterminator—and he likes it.

Too Dead To Swing, A Katy Green Mystery
by Hal Glatzer
ISBN 1-880284-53-7
It's 1940, and musician Katy Green joins an all-female swing band touring California by train—but she soon discovers that somebody's out for blood. First book publication of the award-winning audio-play. Cast of characters, illustrations, and map included.